# Art & Technology in the

# Nineteenth and Twentieth Centuries

# Art & Technology

## *in the Nineteenth and Twentieth Centuries*

Pierre Francastel

Foreword by Yve-Alain Bois

Translated by Randall Cherry

ZONE BOOKS · NEW YORK

2000

Published with the assistance of the Getty Grant Program. The publisher would also like to thank the French Ministry of Culture for its assistance with this translation.

Foreword © 2000 Yve-Alain Bois.
Originally published in France as *Art et technique au XIXe et XXe siècles* © 1956 Les Editions de Minuit.

Printed in the United States of America.

Distributed by The MIT Press,
Cambridge, Massachusetts, and London, England

Library of Congress Cataloging-in-Publication Data

Francastel, Pierre.
   [Art et technique. English]
   Art and technology in the nineteenth and twentieth centuries / Pierre Francastel; translated by Randall Cherry.
       p.   cm.
   ISBN 1-890951-02-1 (cloth).
   1. Art and technology — History — 19th century.
2. Art and technology — History — 20th century. I. Title.
N72.T4F713   2000
709'.03'4 — dc21                                    99-01274

# Contents

# Foreword[1]

*Yve-Alain Bois*

It would be difficult to maintain that Pierre Francastel followed a particular method of historical analysis. The strength of his writings — almost twenty books — seems rather to derive from his extraordinary intellectual curiosity, as well as from his revolt against the tradition of a positivist, "philological" history of art that was dominant in France in his day (and, to some extent, still is). Of course, he recognized this tradition's relative importance; yet he never ceased to expose its limitations. *Interdisciplinary* was not an empty word for him: genetics, child psychology, mathematics, sociology, economics, philosophy are but some of the disciplines from which Francastel drew while analyzing a work of art. This diversity of interests accounts for the richness of his work, and for his being ostracized by fellow art historians.

Apart from a few articles, Francastel's work on architecture consists of two books: *Art and Technology in the Nineteenth and Twentieth Centuries* (*Art et technique aux 19e et 20e siècles*, 1956), which had an enormous impact on French architectural culture, and *Les Architectes célèbres* (1959), a compendium that he edited.

In *Art and Technology*, Francastel studies the way in which the technological developments of the nineteenth and twentieth centuries profoundly modified the symbolic systems of the Western

7

world. This book — the outcome of a seminar at the Ecole Pratique des Hautes Etudes, where Francastel taught from 1948 to his death in 1970 — is presented as a series of readings in which the author challenges the interpretative schemata of preceding historians of modern architecture. (One of the main reasons for the initial success of *Art and Technology* is that it introduced the work of a vast array of foreign scholars to French readers.)

The main thesis of the book is that the Industrial Revolution of the eighteenth century did not occasion a fundamental rupture in the cultural sphere of the Western world. Francastel, therefore, rejected the "mystique of progress" outlined by Lewis Mumford, who believed the machine represented a revelation (pp. 58–67) and who thought its espousal by art inaugurated the golden age toward which the history of mankind had been steadily advancing. He also rejected the Rousseauesque "catastrophism" of Sigfried Giedion (pp. 67–78) and criticized Giedion's idealism and transhistoricism: "he imagines an eternal man-type, a standard-man who could possibly serve as the ideal of a certain America, but who should never be considered the king of creation" (p. 72). To those like Nikolaus Pevsner whose bias for England led them to overemphasize the Arts and Crafts movement, Francastel replied that it was but a version of nineteenth-century "eclecticism superficially enlarged by the discovery of non-Western art" (p. 40). He similarly questioned the significance that, according to some historians (Giedion in particular), the Crystal Palace in Europe and the development of the balloon frame in America had in the formation of the modernist sensibility. (About the Crystal Palace: "Rather than searching for forms that could be generated from the arrangement of large plates of glass, the architect remained faithful to the greenhouse model. He did not realize that the glass panel cleared the way for new types of volumetric systems" [p. 91].)

In fact, the seriousness of Francastel's book is badly tarnished by his inveterate chauvinism. It is this affliction that leads him to say of Frank Lloyd Wright (whom he calls Victorian [p. 83]) that in the guise of architecture he offers us psychoanalysis (pp. 76 and 84). Contradictions abound in *Art and Technology*. Francastel speaks eloquently about Giedion's *Mechanization Takes Command*: he agrees notably with the view that when "the aim of the machine was no longer to reproduce or simply enhance manual gestures...a new representation of man's power at work confronts the purely quantitative concept of production growth" (p. 100); and he highlights the use of Bessemer steel for the raising of the Carnegie Phipps Steel Company building in Pittsburgh as "the real step forward" (what Francastel had in mind was in fact William Le Baron Jenney's Home Insurance Building, whose beams were produced by this firm [p. 114]). Yet he tries almost obsessively to demonstrate the backwardness of American production and theory (not to mention offhandedly characterizing the American people as a whole as unsophisticated and cynical [p. 322]). This leads him, for example, to deny Henry Richardson's modernity (p. 113) and to list Eric Asplund as a "precursor" of Wright (p. 237).

But America is not the only target of Francastel's chauvinist piques: according to him, Bruno Zevi's enthusiasm for Henry van de Velde is due to the fact that both are "European propagandists for foreign influences" (p. 201). After lamenting the meager portion devoted to art nouveau in books tracing the history of modern architecture, he is almost vicious toward Victor Horta and van de Velde (pp. 198–201). After remarking that Chicago's architecture is less audacious than the Eiffel Tower, the Garabit viaduct, the Galerie des Machines, the Bon Marché, and the Meunier factory at Noisiel (p. 114) and that American historians should pay more attention to Viollet-le-Duc — after saying, in short, that

9

Europe invented it all — Francastel declares that Eiffel and Albert Contamin lag "far behind" Monet and Cézanne. He adds that their realizations are nothing but the prolongation of principles dating from 1850 (p. 179), or that Hendrik Berlage, despite his moralism (while "Richardson and Sullivan were caught up in the decadence of the historical styles"), is not a "precursor" (p. 198). Francastel is hot-tempered, which is often refreshing — but sometimes chilling. Quick to spot the ideological contradictions of other writers, he does not always watch his own language: after an acrid but not altogether unjust diatribe against Le Corbusier (whose universe is called *concentrationnaire*, an extremely charged adjective in the immediate aftermath of the Holocaust), he calls for the "virile happiness" of mankind (p. 53).

Francastel's brash tone and hypernationalism are dated (he wrote this book while the effects of the Marshall Plan were conspicuous, and not always welcome, in France). But his conceptual apparatus is far less constrained by the ideology of his time — though the concept of precursor, which he abundantly used, has since been castigated by Georges Canguilhem for its epistemological ineptitude, and the "totalizing" vision of history that he promoted (one in which Eiffel is to be judged by the yardstick of Cézanne) has been definitively condemned by Michel Foucault. Paradoxically, one could even say that such shortcomings elicited a new mode of historicity: since he believed that all historical ruptures had to be global and synchronic (p. 179), he concluded that technological problems had to be solved before a truly modern architecture could rise. (According to Francastel, this moment of technological mastery only occurred with the European, French even, use of reinforced concrete, an account he revised slightly in *Les Architectes célèbres*, which is less overtly nationalistic.) As a result, he refused Henry Russell Hitchcock's myth of a "first generation" that fixed the grammar of modern architecture as well as

Giedion's periodization (according to which a rationalist genera-
tion is followed by an "organicist" one and so on. [pp. 85 and
241]). For Francastel, the true rupture, which he saw as theo-
retical, occurred when the new technology of concrete construc-
tion was combined with the pictorial preoccupation of cubism:
Adolph Loos, praised for his sense of exterior surface and volu-
metric displacement, marks for him the advent of modernism
(pp. 204–11).

Cubism thus becomes the model and category with which
Francastel periodizes and judges modern architecture (his rare
elaborate descriptions of specific buildings always bring a discus-
sion of cubism to the fore). For him, the first epoch of modern
architecture (from the end of the nineteenth century to circa
1930) was directly indebted to cubism (needless to say, he has a
loose concern for chronology in this case), and its second epoch
(that represented by Eric Asplund, Alvar Aalto, Richard Neutra,
and Wright in the second phase of his career [pp. 238–39]) coin-
cides with cubism's decline. If Loos belongs to the first (Cézan-
nesque) phase of cubism, Gerrit Rietveld, who still refers to the
"simple cubic volume" (p. 210), belongs to the analytic phase,
while Le Corbusier's Villa Savoye, which introduced a sense of
movement, partakes of cubism's last moment (p. 210). This peri-
odization is somewhat terse, and invalidated by Francastel's very
conventional conception of the goal of cubism (offering a syn-
thetic view of the different aspects of an object), but it has the
merit of casting some doubt on Giedion's hollow chatter, held in
such high esteem at the time, about "space-time" and the "fourth
dimension" (p. 213).

One of the most fruitful aspects of Francastel's work, how-
ever, is its anthropological dimension. In spite of a blatant mis-
reading of Marcel Mauss — Francastel thought that art was a
mere supplement for Mauss (p. 147) — his inquiries, based on the

11

notion of *objet plastique*, led him to make a case for the study of the history of perception. He never clearly defined *plastic object* (almost anything can be perceived as a plastic object — though such a perception might affect its original meaning or function, as when we choose to see only the object in a given work of art). Yet he suggested practical tools for its investigation, including a vast miscellaneous archive of contemporary objects that would, for example, mix various series as Giedion had done in *Mechanization Takes Command* (pp. 151–57). For Francastel, "there is a common background of sensations and activities that serve as the basis for all specific modes of human activity within a given historical period" (p. 160). Such a common denominator might be, for example, the feel for polished surfaces during the Stone Age (which Brancusi wished to revive [p. 160]); the use of iron during the Middle Ages (in chivalry, for stone cutting); or the importance of numbers in the Renaissance (p. 160). In modern times, "notions such as fatigue and precision have changed both their meaning and form" (p. 157–58), and the nature of attention went through a quantum leap as the reality of rhythm gradually invaded the experience of contemporary man (p. 158).

Speaking of the constructive innovations of modern architecture — the process of serialization or montage — Francastel makes observations similar to those of Manfredo Tafuri a decade later ("The most original contribution made in the field of construction during our times is a particular conception of montage that is dependent less on the possibility of transport or rapid manufacture of raw materials than on the general comprehension of the mechanical processes involved in the production of the object" [p. 225]). But he does not reach the same conclusions as Tafuri: what for the latter would constitute a "crisis of the object," Francastel saw as announcing a potentially new relationship of man with technology. His work, however, is marked by omissions sim-

ilar to those of Tafuri and most contemporary historians of architecture: one rarely comes across formal analysis of a building.

In *Les Architectes célèbres*, published soon after *Art and Technology* and in many ways its illustrated complement, Francastel returns to a number of issues raised in the first book: the secondary role of technology; the failure of a modernist mode of borrowing from the past (Viollet-le-Duc, Arts and Crafts, art nouveau); the appeal to cubism in order to compensate for this "aesthetic vacuum"; the rejection of the periodization of modern architecture into a rationalist (Le Corbusier and Gropius), an organic (Wright), and a neo-functionalist phase (Mies van der Rohe). But the two most interesting features of *Les Architectes célèbres* are Francastel's more precise thoughts about the nineteenth-century "break" and his choice of illustrations and entries following his general introductions.

Francastel describes the "birth" of modernity during the nineteenth century in much the way Tafuri would later analyze historical ruptures such as the Renaissance and the Enlightenment: the exhaustion of forms borrowed from tradition, the reappraisal of Gothic style, historicist eclecticism, and technological innovations — all these contributed to the formation of a consciousness of history that led to a critical upheaval of architectural norms (it is amusing to note Francastel's praise of the picturesque revival on this score). In fact, Francastel maintains that while for centuries the architect had been the servant of a prescriptive ideology — that of the Church and of the Crown — the ideological uncertainties of the nineteenth century created a situation in which architects were asked to define the architectural programs themselves (to facilitate his demonstration, he omits the utopian projects of the Enlightenment, a noteworthy omission in that the standard view of the time — that of Emil Kaufmann's *Von Ledoux bis Le Corbusier* — would have perfectly suited Francastel's French chauvinism).

The illustrations in *Les Architectes célèbres* are of two kinds. First, after a general heading, there are illustrations accompanying entries written by specialists — some of whom Francastel had severely criticized in *Art and Technology* (Giedion and Mumford, for example): Henri Labrouste, Viollet-le-Duc, Eiffel, and Louis Sullivan are discussed in the wake of the general chapter on technology; the entries on Antonio Gaudi, Loos, Robert Maillart, Erich Mendelssohn, and Auguste Perret follow the chapter on style; those on Wright, Eugène Freyssinet, Gropius, Mies van der Rohe, Le Corbusier, Aalto, and Pier Luigi Nervi make up the main body of the chapter titled "Masters of Our Time." Second, the book ends with a series of illustrations whose goal is not to underline the authorship of particular architects but to point to an anonymous diffusion of modernist traits. Thus lesser known works such as Lafaille and Peirani's Engine Shed (Avignon, 1946) and Wallace Kirkman Harrison and Max Abramovitz's Alcoa Building (Pittsburgh, 1952) are illustrated side by side with Eero Saarinen's MIT auditorium and Kenzo Tange's government building in Kawaga. Francastel does not comment on this sequence of images: being able to sort out the common features of a modernist architectural language is to be the reward for those conscientious readers who have digested the preceding sections of the book.

The diversity of Francastel's knowledge and his anthropological interests, as well as his passion for discovering underlying categories of aesthetic thinking, should provoke architectural historians to be a little more adventurous in their discipline. His ability to establish comparative categories of analysis enabled him to propose new historical periodizations and to place a new emphasis on works that had been generally ignored by architectural historians. His interest in the impact of painting and aesthetic theories on architecture and his insistence on the secondary

role of technology constitute a serious refutation of the techno-
logical determinism that had been the prominent historiographi-
cal tool for the analysis and explanation of architecture ever since
Gottfried Semper.

NOTE

1. This essay was first published almost twenty years ago in a special issue of
*Architectural Design* (vol. 51, no 6/7, 1981) devoted to historians of architecture.
But it was dramatically altered by the editor without my consent: not only was it
shortened and poorly translated (at one point it had me saying that Francastel's
main thesis was that the Industrial Revolution had represented a major historical
rupture — the exact opposite of what I had written), but also it added a long
apocryphal development in which Francastel's method was likened to that of
Foucault, in spite of my having specifically opposed the two in the text. I was
furious, needless to say, and I am now particularly grateful to Zone Books for
allowing me to straighten the record.

# Introduction

For a century, art has become the object of wider and wider interest. Today it occupies an important place in the life of modern societies, from museums, expositions and urban planning to education. And so it is only natural that art has come to stir certain passions, not all of which are a product of aesthetic theorization.

During this same period, art has undergone radical change, undoubtedly as both a cause and a consequence of its having taken root in society. There is more that separates Delacroix from Matisse than separates Veronese from Delacroix. After a century, art can no longer be viewed as several bold experiments by a few *enfants perdus*. Various forms of avant-garde art have triumphed from generation to generation, while becoming, each in its turn, tomorrow's commonplace. Without a doubt, there is an art of the end of the nineteenth century and of the twentieth century — an art embracing all disciplines, from painting to sculpture, from architecture to the decorative arts, and even utilitarian objects, which, in appearance, seem far removed from traditional aesthetics.

This enormous revolution occurred during a period when other decisive changes were taking place in different fields of human endeavor and knowledge. Developments in mechanization and industrialization, on the one hand, and progress in speculative and

applied sciences, on the other, led to a complete transformation of the world. And so the question before us is one of determining what new relationships have been established in contemporary civilization between the arts and other fundamental human activities, particularly technological activities.

The common response to this question is rather perplexing. Critics and historians tend to argue that art has broken away from the human. They do not deny its revolutionary aspects, but they refuse to take it seriously. They turn it into a monster that many readily defend — a truly thankless and somewhat paradoxical task — and that others, less concerned about values and more self-important, stigmatize with vengeful imprecations. In truth, everyone tends to consider abnormal whatever he does not fully understand. Jean Cassou, representative of the first tendency, and Gabriel Marcel, representative of the second, have provided us with the spectacle of the stunned and discontented philosopher who finds himself faced with a shift in the theoretical bases of his analysis. A third category of art critics and historians, who are more conscious of art's stable forces than of its inventive and relative values, want it to become the road to salvation for modern societies. They want man to be rehabilitated by the widespread practice of certain art forms, which are seen as issuing from spontaneous awareness. Then there is a final category of art moralists, who believe that the true work of art is an absolute shield from the superficial influences of an era. For them, a distinction must be made between mass production, which is considered a kind of popular art functioning on a societal level, and the sporadic appearance of masterpieces, which transcend time and space, existing in the immutable, eternal realm of pure Beauty — that mysterious universe where Phidias is a contemporary of Raphael and Chagall a contemporary of Giotto.

I felt it would be worthwhile to reexamine this problem of the

relationship between art and a technologically based civilization from newer and more analytic perspectives. As we shall see, this will in no way entail adopting the point of view that art reflects the lifestyles and activities of a society, taken as a reality that lies beyond individual consciousness. The artist does not merely concretize the sensibilities or thoughts of his milieu through his temperament, thanks to his mastery of an instrument, which is his particular technique. Nor does he draw on immanent values in order to give them concrete form. He is essentially a creator. Art is a construct, a power to give order and to prefigure. The artist does not translate; he invents. We are in the realm of imagined realities.

It does not follow, however, that the imaginary realm has no relation to human reality or to the forms of activity — whether material or imaginary and figurative — that are explored by the human mind. Mathematical theorization is also imaginary par excellence, but it is nonetheless closely linked to the ongoing and permanent reality of operative experience.

The purpose of this book is, first and foremost, to show that art is one of man's permanent functions and, accordingly, it must be studied as such, in and of itself, as well as in relation to other functions, such as the speculative and the technical, which are now better understood and may thus help us to decide how best to approach this subject.

However, the plastic function — one of many figurative functions, such as language and mathematics — must not be viewed as a category of thought. Although I attempt in this book to show that the plastic function has been relatively stable, I also attempt to highlight important changes which have taken place — both in figurative forms, as reflected in products or works of art, and in the relationships between plastic activity and other societal activities. In the face of mechanical production, which is both objective and

functional, modern artists have undergone a transformation, as
have their repertory of forms, their tools, and their mental frames
of reference. A modern painter does not use the same colors
David did any more than, a fortiori, he might use those employed
by an Egyptian or by a man from the Renaissance. Moreover, he
does not think in the same way about the relationships between
his work and the material world. It hardly bears pointing out that,
for primitive man, plastic representation was a matter more of
rendering a concrete form than of representation. But it is impor-
tant to highlight the major shift that, for a century, has affected
the very notion of the object. By presenting objects in detail, the
painter in the Middle Ages presented the attributes of a unique and
immutable reality, in short, essences. The Renaissance painter
strove above all to capture the reciprocal position of objects de-
scriptive of a picturesque and varied spectacle. The modern pain-
ter, in keeping with the general trend of the times, gives more
importance to the close analysis of his sensations — while ad-
hering to the equally general trend of fashioning the universe in
keeping with his renewed power to manufacture.

We shall see that this goal is all the more difficult to attain due
to a lack of information in most fields. One of my aims is to show
the need for extensive research not only into the ways modern tech-
nological methods have changed objects, which has attracted the
attention of artists, but also into figurative objects themselves.
While paying homage to the works of several pioneers — who have
been cited by name whenever any information, even fragmentary,
is borrowed from them — I have also taken care to stress the enor-
mity of the work that remains to be done. But I felt that, before-
hand, a brief overview of methodology would be indispensable.

To avoid any misunderstandings, and superficiality, some basic
points need to be clarified. I believe that certain artistic expres-
sions, often grouped under the vague term *avant-garde*, constitute

the liveliest and most creative part of modern art. I do not claim that the artists and works I cite are destined for eternal glory. However, it is clear that some general trends link certain artists to each other and to the general movement of modern civilization, whereas other trends perpetuate fixed forms of art that originated from other life situations and are tied to the past. Any idea of progress is absent from the latter works. In the past century, human society has grouped closer together, and there are fewer differences in behavior. For the first time since prehistory, there is a universal art. It would be as absurd to deny this as to think that there is an art echoed in our era that harks back solely to the legends or imaginary forms characteristic of another moment in history. To paint a Botticelli or a Corot in 1955 would, by definition, constitute a pastiche. To assign art the task of preserving outworn historical values would be to deny its life value.

Nor do I wish to suggest, even remotely, that avant-garde works are necessarily destined for a long survival. Intentions alone do not originality make. We are currently witnessing a shift in the material and social forms of life. We are in a period of upheaval. If we look to other periods of history, we can see that, under similar conditions, it took several decades before any real stability could be established. The Renaissance took at least six generations to reach full bloom, and no human city was ever built according to set plans. Some efforts succeeded, others failed. Today's world will reach a state of equilibrium only when the tremendous surge in the application of new scientific and technological principles has been slackened — either by a lack of man power and materials or by the inability of societies to reach accord or make peace. The world of tomorrow cannot be foreseen any more than future art or science can; however, no activity can disregard certain attitudes that, in our times, are the impetus behind each new awakening of human consciousness. The Egyptian or Byzantine conception of

space is unthinkable in the age of wave mechanics. The dignity of art requires that artists adjust to the general requirements of modern thought.

In no field do new structures eliminate old ones; they replace them. They provide other, more rapid and surer approaches and give rise to new systems for assimilating sensations. Euclidean geometry continues to hold true, but its underlying assumptions are now incorporated into other, far vaster systems. The new physics and the new mathematics are not taught by requiring students to retrace the cyclic development of the underlying hypotheses. Similarly, art offers us routes that are more direct and more adapted to a new psychological as well as practical experience of a world completely transformed by technology. When there is a true innovation in man's power to transform materials, a corresponding innovation in figurative thought is necessary. This innovation is justified by a change in habits, ideas, and every form of human activity, based on a reshaping not only of frames of perception but of knowledge. Plastic forms have always served as evidence of a change in moral and intellectual concepts. Artists, along with scientists, have always envisioned attributes and values in an ideal framework before later generations placed them in a living, human context. We are currently in a phase of simultaneous destruction and creation that is rare in human history. We need to learn how to take advantage of it in order to analyze, more sympathetically, the efforts of those artists clearly attuned to the dominant forms of modern life. Instead of announcing the end of the world — which is all too easy — let us try to understand how we might create a *new* world. It should no longer be possible for a man of the stature of Piaget to write an epistemological manual in which, alongside thoughts on physics, mathematics, sociology, and so on, there is no mention of plastic thought, which has been present at every stage of history. The infamous conflicts between

Art and Society and between Art and Technology mask the real problem: that of incorporating a particular function into the life of societies in spite of the boundless versatility of created works. This is an attempt not to vindicate a superfluous or secondary activity but to affirm the place of a mode of thought that, now as in the past and in varied forms, has generated a way of thinking. The often intuitive understanding of Beauty is an incontestable form of knowledge.

Having already written a book on the problem of Space, I now offer this study on the figurative Object. Other studies will follow, dealing with Color and with other long-standing or short-lived problems arising from plastic understanding, which is, first and foremost, a construct. But the work can only be conceived as a collective effort: this book, for which I am greatly indebted to discussions held as part of my lectures at the Ecole Pratique des Hautes Etudes and to my audience, is aimed only at showing the reach and importance of a method.

My hope is that it will help in some way to establish the meaning and human significance of the work of art, which, in spite of appearances, has never been more threatened. The great rush for museums or monuments is not without risks. Undoubtedly, tourism and museography offer as many risks as benefits to works of the past. Art education, as it is taught in France and particularly in the secondary schools, will foment a scandal when the problem is finally brought to light. I am thinking in particular of the role played by the *Inspection Générale du Dessin*, which has caused France to lag behind countries like Egypt. The Second World War, more so than the First, proved especially contemptuous of the values of art. The crime committed at Reims brought a jolt of universal awareness. The English, on written instructions from highest-ranking authorities, deliberately sacrificed monuments under the false pretexts of humanitarianism and preservation of human life.

Furthermore, the same people refused to sign agreements to protect one of the most vulnerable and precious landmarks of humanity, seemingly contented to encourage the creation of photographic files.

Nevertheless, I do not share the opinion of those who believe that our fate is crueler today than in the past. Nor do I believe that humanity is on the road to guaranteed happiness; but I feel that man has kept his creativeness intact in numerous areas and he is not lagging behind in the arts, the least understood area of them all. Tomorrow, like today, a new humanism will come about only through a more lucid understanding not of abstract and immortal man but of the ephemeral beings of flesh and blood that we are. It is up to us to gain insight into ourselves by addressing one of the most fascinating endeavors down the ages.

At the outset of this project, I reject the idea of a fundamental antinomy between Art and Technology. Rejected as well is the idea that art has been incorporated secondarily and superficially into other products of human endeavor. After more fully defining the notion of the plastic object, I then embark on a clarification of the dual representational and operative nature of art. This done, it is no longer a question of trying to contrast the values of two parallel series of human activities. The opposition between Art and Technology is reconciled as soon as it is acknowledged that, to a certain extent, art is itself a technology in the dual perspective of figurative and operative activities. By claiming to explain art according to its capacity faithfully to depict reality, critics and historians have obscured the problem. A language cannot be explained on the basis of what it denotes or on the basis of the relationships between the ideas it expresses. The goal of art is not to provide a flexible double of the universe; its goal is both to explore the universe and to reshape it. Plastic thought, which exists alongside scientific or technological thought, belongs to the realms of both

24

practical activity and the imaginary. Art does not free man from all his constraints; it does not offer him the means to apprehend his sensations and translate them into the absolute. It is a mode of understanding and expression mixed with action. In the realm of the imaginary, there is also a marriage between logic and the concrete. Through images, man discovers both the universe and his need to organize it. Thus art and technology are not set against each other, nor are they in an all-encompassing correspondence. The conflict arises when the realm of the imaginary is supposedly shielded from reality. It is in technology that art and other human endeavors converge. Art's domain is not that of the absolute but that of the possible. Through art, societies make the world a little more livable or a little more powerful, and they sometimes extricate it from the ironclad rules of materiality or social and divine laws to render it, momentarily, a little more human.

Finally, there is another point that needs to be stressed regarding a question of vocabulary, which underlies a question of principle. Throughout this text, I have used the word *figurative* in a very broad sense, which differs from the way it is currently used. Those who champion a certain — literary — form of abstract art have tried to suggest that there exists a nonobjective and, consequently, nonfigurative art. This book is aimed at proving, on the contrary, that contemporary art is objective in all of its forms and that the dispute surrounding abstract art centers on an arbitrary correspondence between the notion of the subject and the object.

On this point, it will be seen that another misconception has helped to promote an ambiguity that has had a far-reaching impact not only on art criticism but on contemporary epistemological thought. Borrowing the idea from certain art historians, such as Heinrich Wölfflin and Emile Mâle, that works of art must be interpreted symbolically, numerous philosophers today stress the symbolic value not only of art, by equating it with language, but

of all languages in general. It is beyond the scope of this work to delve into the history of nineteenth- and twentieth-century critical thought on aesthetics, from Lessing and Kant to Benedetto Croce. Instead, there is merely a chapter giving a brief outline of the history of taste, which would have been impossible without relating the study of art to the examination of other literary, scientific, and technological activities in the last century. My aim is to present a basic study intended to help gain a clearer insight into our times — that is, an insight, if only fleeting, into a kind of philological and plastic neo-humanism, in hopes of preparing a modern reflection on society's advanced activities. And so it is important to emphasize that the term *figurative* in its broadest sense is used intentionally, in an effort to reject any purely symbolic interpretation of the language of the plastic arts, which may be associated with, or give rise to, the somewhat arbitrary signs that are part of purely intellectual and imaginary systems of reference to a reality beyond man, with immutable principles and laws. *Symbolic* means a substitute, an equivalence, an allusion, or a conventional sign that may act as an arbiter upon a thing. *Figurative* suggests structural or organizational relationships between the system of signs that represents and the object represented. Art should not be made into the fragmentary translation of a reality. Art is not only a symbol; it is creation: both object and system, a product and not a reflection. It does not comment on; it defines. It is not only a sign; it is a work — the work of man and not the work of nature or of divinity.

# PART ONE

## Art Meets the Machine

# The Myths of Mechanization

Like all forms of human endeavor, art has been profoundly influenced in the past century by the extraordinary growth of mechanized civilization. The goal of this book is, first, to retrace the circumstances surrounding the encounter between a historically frozen view of art and the material transformations that altered man's goals, values, and means of action. Then I shall point to some still uncertain forms of a new concept of art, bearing in mind that now more than ever art is a fundamental function of society.

There is a widely held belief that the most momentous event of our times is the machine's sudden and absolute ascendancy over the conditions of human existence. To my knowledge, there is no work on the history of the arts and sciences or on society that is not based on this assumption. Jean Cassou recounts the triumph of industrial mechanization. Pierre-Maxime Schuhl and Alexandre Koyré examine the historical relationships between man and machine in order to elucidate the abrupt realignment of civilization with technology starting in the nineteenth century. André Varagnac stresses that the rupture in the historical development of cultures came with the advent of the machine, setting ancient civilizations, laden with anachronisms, against contemporary civilization, which was abruptly deprived of its traditional

29

supports. Whether it was the French or others — the English, like Sir Herbert Read, the Swiss, like Sigfried Giedion, or the Americans, like Lewis Mumford — each viewed the problem from a perspective that often contradicted that of his neighbor, but no one doubted that there had been a complete upheaval in humankind's lifestyles as a result of the two-century-old rise of the machine. Jean Fourastié — following Spengler's example — expressed an all-but-universal point of view when he wrote that man became Faustian after the French Revolution, from the moment he discovered that the transformation of Nature was the primary goal of human action.

The repercussions of this attitude are considerable, affecting not only the way we judge modern times but also our understanding of the historical process through which the machine was introduced into human activities. Contrary to the generally accepted opinion, I am not certain that this phenomenon was without historical precedent nor that the encounter between man and nature is a simple fact that controls all others.

In *La naissance de la civilisation industrielle*, John Nef attempts to show that the movement which led to the current world crises began not at the end of the eighteenth century but much earlier, in the sixteenth century. Asserting that there existed an "incipient industrial civilization" — which he does not significantly distinguish from our own — he situates its origin in the period immediately following the abdication of Charles V. Setting the two great, preceding bursts of Western civilization — that of the eleventh through twelfth centuries and that of the fifteenth century — in contrast to the third, the rise of Europe, he asserts that during the first two the vital force was tied to quality and the arts, whereas toward the middle of the sixteenth century, there was a form of growth tied principally to quantity and technology. Of course, Nef acknowledges that, at the same time, major innovations led to

a scientific revolution, fostered by a few scientists who had set down speculative values in the seventeenth and eighteenth centuries; but he considers the qualitative and quantitative developments independent and believes it was the latter that gave form to the world as we know it.

I shall not venture any further onto Nef's terrain. Despite the extreme appeal of his thesis, it is debatable on two grounds. First, it is questionable whether earlier forms of Western civilization made an absolute distinction between arts and technologies. It has by no means been proven that in medieval civilization the arts were solely viewed as part of the leisure pursuits of a privileged few and not linked to their active life. Cathedrals were as much the work of stonemasons as of clerics and chevaliers. Second, it is clear that Nef's work was part of his design to find, at any cost, the oldest possible sources of a form of civilization that did not seem to have been constituted until relatively recently. Just as in the past there were attempts to show that the Renaissance began to manifest itself in the Middle Ages, there is now a desire to show that the modern age was prefigured by the Elizabethan period. Without denying the existence by that time of an industrial movement based on a high regard for quantity, it does not seem possible to accept the idea that from that moment on the theoretical and practical conditions for an industrial civilization — our own — had been met, taking shape, at first partially, in certain regions, while in other countries there simultaneously developed a qualitative civilization, reflecting a leftover from the past. In reality, the situation is more complex. Since it is not possible to enter into a more detailed discussion here of Nef's very dense work, I shall merely examine the facts as they stood just before the period when mechanization — which, as we shall see, is neither technology nor the machine — spread throughout the West, that is, on the eve of the French Revolution.

31

The essential idea of Nef's work is that the development of technological skills and the Enlightenment did not overlap in the beginning and, moreover, did not necessarily involve industrial progress, or, more specifically, mechanization in the form it took in the nineteenth and twentieth centuries. We should also bear in mind that at the beginning there were many highly complex phenomena at work that were impossible to consider independently; and in all likelihood, they cannot be easily set into a clear cause-and-effect or one-to-one relationship. Indisputably, the rise of scientific or mechanical inventions was at the root; but, in fact, even though these inventions do not appear necessarily linked to the development of a socioeconomic situation that they would eventually undermine, they were part of an order of phenomena that seemed in no way revolutionary. The discovery of iron oxidation by coal carbon and the invention of the loom appear the starting points of a series of inventions, such as the clock and the barometer, that multiplied from year to year, starting from the Renaissance, and were the impetus behind a society that was still alive and well in the eighteenth century. What is most striking is that, among the many inventions in common use in modern times, some appeared that did not support the accepted system of the universe and affirm the social hierarchy but transformed them.

Although some inventions, on the scale of imaginativeness, did not appear in any way exceptional — such as the loom and the coke oven — they nonetheless were highly successful and not only because of their scientific originality. It was because they provided timely solutions to economic and social problems. In particular, it is now clear that in the eighteenth century, England was suffering from a shortage of wool and wood; it attained its new prosperity because of the practical results yielded by the loom and the coke oven and not because of the technological or theoretical developments to which such inventions gave rise — although England

would not have profited from them to the same extent if the development of economic doctrines had not endowed the country with a sense of foresight, which, in turn, would prove a creative advantage in the technological realm. It can thus be easily observed that we are dealing not with purely technological or speculative progress but with a joint evolution of social and technological activities. Hence, we must wonder if the true originality of the eighteenth century resides in the development of a new system of human relationships or in Western societies' coming upon technological discoveries, each derived from a preceding one and with a more or less intrinsic application. Indeed, Nef spoke cautiously of a "first" Industrial Revolution. He showed how the development in England, by the sixteenth century, of quantitative industrial production was linked not solely to technological factors but to general conditions that sprang primarily from political and demographic circumstances. Nevertheless, he underestimated the difference between isolated factors that ultimately lead to the reorganization of culture and the definitive formation of new human environments in which diverse elements meet and converge — artificial environments in which society believes it has rediscovered Nature — all of which makes for a lack of distinction between a genesis and a structure.

Starting at the end of the eighteenth century and especially in the first half of the nineteenth century, the development of key industries brought about profound changes in European living conditions. It would be intriguing to trace the progression of the parallel but independent developments in technological, mechanical, economic, and sociological concepts of the ancien régime that, while taking different forms within each area of activity, provoked the overall evolution of human society between 1780 and 1850.

There is a tendency today to exaggerate the role of English

industrialization in this process. Although this phenomenon played a decisive role in resetting the world's economic pace, the influence of French ideologies should not be underestimated nor should the illustrative value of preliminary experiments carried out in countries like Prussia. It seems certain that the modern form finally adopted depended as much on other countries' reactions to English industrialization as it did on industrialization itself. Even if Elizabethan England did set the precedent for later developments, its practical, constructive impact only was felt in conjunction with the Continental System and in the framework of the social transformation of Continental Europe. Here, we come to a page in history where literature and the arts blur into politics and economics, making it difficult to describe precisely, on a worldwide scale, the passage from the societies of the seventeenth and eighteenth centuries — the last societies of modern times founded on the mechanics and geometry of the fifteenth and sixteenth centuries — to the society of the 1850s, marking the debut of the modern world.

## Arts and Industry: From Harmony to Antagonism, 1850–1890

Only between 1800 and 1850 did men become fully aware that they had embarked on a new, common system for processing materials. As always, the discovery was made simultaneously in all disciplines. It was then that the idea — or, rather, the myth — of the machine appeared. The first clear realization occurred in connection with the great economic events of the nineteenth century. By the final years of the eighteenth century, and especially by the beginning of the nineteenth, France had begun to make its industrial products available on a more or less regular basis. The movement had been encouraged by the French empire, which was anxious to create an ideal economic autocracy, which was to dissi-

pate during the Restoration. There was full resistance throughout the country, bringing it to a general standstill — thanks to which England took a considerable lead. Midway through the century, however, an idea was born, spawned by the development of riches made possible by the July monarchy's international expositions, which brought together all the nations of the world. With that, the nature of international commerce underwent a complete transformation. On the basis of knowledge of sea routes, a parity developed between countries, causing earlier commercial motives to disappear. A complete reversal resulted: instead of seeking light, expensive products to furnish to advanced countries, nations sought low-cost products to supply to poor countries in large quantities. Commerce was tied no longer to luxury but to labor. Such an upheaval was possible only when the masses were viewed as clients. The ideology behind the noble savage and an egalitarian society helped to develop colonialism and the mystique of productivity. Heavy industry and bulk transportation took the place of trade in rare products.

Here again, the rivalry between France and England takes center stage. At first, the tide of events favored London, which, in 1851, inaugurated the first international exhibition for industrial products. However, Paris would retaliate in the following half century. Simultaneously and almost in parallel in the two countries, a new ideology developed, giving rise to the ideas of the mechanization of the modern world and the conflict between art and industry.

*Laborde: Conciliation*
In France, the first great ideological work was the report drawn up for the French delegation to the 1851 London Exhibition by Comte de Laborde. Published in 1856, this work laid out views characteristic of the liberals of the period. Despite his liberalism,

Laborde was an aristocrat who retained ties to the social and religious order of the past. Accepting industrial development as a given and as a future source of wealth for individuals and nations, he stated the need in principle to "reconcile" art — representative of older values — and industry. In short, he transferred the political doctrine of his milieu to aesthetic and economic philosophy: accept the Revolution as a given, but reconcile it with the superior and immutable forces that are art, the ideal, and religion — in a word, aristocracy. If an exclusively hereditary aristocracy were not possible, there should at least be an aristocracy of ideas and wealth. While the former aristocracy was forming an alliance with banks and heavy metallurgy, Laborde was advocating a natural union between art and industrial production. Art would, in his eyes, naturally remain superior in this association, in much the way the elite would remain superior in society. Laborde viewed industry with the same loathing and the same desire for atonement as Villermé, who was discovering the sordid horrors of industrialization during this period. Neither of them imagined an alternative, more organic solution, that is, one stimulated by living, productive forces. They thought in terms of regeneration and felt it self-evident that industry, like the proletariat that issued from it, was an acceptable evil, if not a necessary one, in the world of sin and redemption.

For generations, creative activity in the modern world had no champions. The proletarian masses made poor champions because, in the end, they suffered from an inferiority complex and only dreamed of someday attaining the same advantages and outward lifestyle as their exploiters — at a lower price. While, in France, Laborde was teaching that in order to "uplift" art the number of artists must be increased by selecting from among the masses, with a view to individual redemption, and while he celebrated the final union between arts and industry in the form of a quasi-mystical

holy marriage of the new divinity, earning his access to paradise or to the Olympus of traditional civilizations, Henry Cole and John Ruskin were preaching similar doctrines in England.

## Cole and Jones: Eclecticism and Functionalism/Reality and Fiction

One merit of Sigfried Giedion's book, to which I will make frequent reference, is that it refocused attention on Henry Cole. Cole was an organizer of the Great Exhibition of 1851 and was then viewed, along with Laborde, as a pioneer of the spirit of the new age. Around the same time, he edited the *Journal of Design* (1849–1852). In 1884, two years after his death, his notes were collected under the title *Fifty Years of Public Work*, but this massive anthology went almost unnoticed amid the vogue for Ruskin. However, in many respects, Cole's work was ahead of Ruskin's and Laborde's. By 1851, he had formulated the fundamental principles of functionalism insofar as he had admitted the possibility that the slow process of enhancing the value of labor and education might destroy the traditional principles of taste. Moreover, after discovering arts newly arrived from the Far East, he became aware that it was possible for his age to discontinue its devotion to the mechanical production of earlier forms of the Beautiful and, instead, set out the principles of a truly creative originality, expressing a new, universal mastery of action. He also wondered — along with Laborde — whether America, a newcomer among producing nations with a capacity for mechanical production adapted to new needs, would soon teach Europe a lesson. In short, he foresaw a potential way of bridging an era of heavy, worldwide industrialization and a creative spirit liberated from traditional standards of the Beautiful. Despite Cole's premonitions, it was not his work that would ultimately influence the development of taste and industry in his country, or elsewhere for that matter.

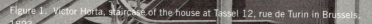

Figure 1. Victor Horta, staircase of the house at Tassel 12, rue de Turin in Brussels, 1893.

Aesthetics should not be confused with writing. The development of architectonic elements, using purely ornamental arabesque lines in creating the iron structure, did not lay the foundations for a modern style. Adding ornament to technology does not create a style. (© 1999 Artists Rights Society [ARS], New York / SOFAM, Brussels. Photo: Musée Horta, Brussels.)

Figure 2. Daniel Hudson Burnham and John. W. Root, Monadnock Building in Chicago, 1891–94.

The plastic arts necessarily accompany technological development. As technology made it possible to increase the size of buildings (sixteen stories as opposed to the earlier eight or nine), problems cropped up in associating surfaces with new volumes and in finding a new sense of harmony for wall openings. (Chicago Historical Society, ICH:-13475.)

In 1856, in *Grammar of Ornament*, one of Cole's collaborators, Owen Jones, held himself out as the prophet not of a style directly issued from machine-made objects but of an eclecticism superficially enlarged by the discovery of non-Western art. In fact, at that time, Jones was the theorist of a linear style that took liberties with traditional perspective and relief to create a descriptive art, accentuating the contrast between the material and the style so as to enhance applied decor. And so, whereas Cole came very close to laying down the principles of an art directly linked to the production of new utilitarian objects, his immediate circle produced the floral style of 1900. The gap between reality and fiction was widening. Ruskin was triumphant.

## Ruskin: The Absolute and Intuition

Was Ruskin's success due to his talent as a writer or to his flattering the instincts of his contemporaries? He was the worldwide spokesman for the religion of Beauty until the War of 1914. In an impressive article in *Revue d'esthétique*, Etienne Souriau recalled the words of one of his classmates from the Sorbonne who, in May 1914, ended an oral presentation with the words: "Durkheim or Ruskin? Choose."

Today, it is difficult to understand the secret of Ruskin's influence. I remember picking up one of his books on numerous occasions, in an attempt to assess it and, in particular, to understand it as it had been understood by earlier generations. In these enlightened times, it is unnerving to see the accumulation of archaeological errors that turn a book like *The Stones of Venice* into a veritable museum of scientific horrors. But I must also admit that I am not receptive to it as literature per se. It has a pompous, pontificating style and a strained poetic tone that has lost much of its appeal. But that has by no means stopped it from having an impact. To the contrary, it is the source of an impressive series of opinions that

are accepted as gospel: that despite all the ill that might be attrib-
uted to the mechanization of work, it is redeemed and expiated
under the custodianship of skilled manual labor; that the changing
and uncertain values of the present are set against the unwavering
serenity of Beauty; that art is, above all else, an intimate commu-
nion with an eternal, infinite, unchanging, consoling, and, if need
be, redemptive Nature; and that man's encounter with this quasi-
religious mystery of Art must transpire through a surrendering of
the soul through contemplation, which, to a certain extent, equates
taste with prayer and allows the artist to participate in creation.
Even though the Ruskinian form seems dead, and even though
Ruskin no longer seems to have a direct influence, his spirit is still
present among us.

This is the case less because of Ruskin's literary talent than
because he was the exponent of the general sentiment of several
generations. Denouncing ugliness, Ruskin also denounced prog-
ress and decried, outright, all modernist attempts. In that regard,
his role was easy to play. Throughout history, the ruling classes
have wanted poets to celebrate nature and the pure joys of con-
templation. The lute player is less embarrassing than a black-
smith's apprentice. The nineteenth-century captains of industry
did not promote harmonizing modern means of production with
the new universal education offered to the masses, who — because
their labor was needed — were already too implicated in the crea-
tion of wealth. Adapting the production of aesthetic values to new
standards would have meant a commingling of property. What
difference did it make to an industrialist in 1850 that a locomotive
was ugly, difficult to steer, dirty, and noisy if it enhanced his
power, albeit at the expense of a huge waste of energy, and if he
himself stood on the sidelines, in an artificial solitary retreat
resplendent with all the prestige of earlier civilizations so exalted
by Ruskin. Far more reactionary than Laborde — who advocated

the idea of reconciling arts and industry — Ruskin limited himself to *l'art immobile*.

Far be it from me to portray Ruskin as a faithful servant of large-scale industry. His good faith and sincerity are not in question, any more than Laborde's or, for that matter, that of high-minded people who, then as today, regard progress in taste as the complete refusal of material servitude and of the modern world and who place the noble realm of art in radical opposition to the base domain of action. The heart of the problem is to know if art is truly a higher mode of knowledge, which dare not sully itself by coming into contact with the material world, or if there is truly a natural opposition between art and the products of human enterprise developed by machines.

The irreducible opposition between industry and art, the belief in the inspired nature of aesthetic contemplation, the conflict between Faustian man and nature — these were the primary themes debated at the middle of the nineteenth century. They are easily explained by the ideas prevalent at the time and the milieu in which the first theorists of industrialization appeared. Many of my contemporaries have not yet gone beyond this attitude.

It is not my intention to give a detailed inventory of the works, dating from Laborde and Ruskin, that helped to form the basis of the aesthetic philosophy of the machine. To be done thoroughly, such an undertaking would require a comparative analysis of numerous social history texts, such as those by Saint-Simon, Proudhon, and Marx. In effect, it is impossible to understand how the current relationships between art and the machine were established without taking into account the intellectual attitude of engineers, on the one hand, and the reaction of the working classes, on the other hand. The latter were simultaneously faced with an extraordinary surge in mechanization and a fervent desire to partake in all of civilization's material and intellectual offer-

ings. Whereas Saint-Simonian utopists were prepared to adopt values they had previously thought superfluous, the proletariats were more tempted to initiate themselves into culture, that is, the so-called culture of the upper classes, than to create a new culture that served their own purposes and was in keeping with the labor of their own hands. The ideological superstructure and frustration are thus as equally applicable to the aesthetic of the propertied classes as to that of the working classes.

Under the sway of today's polemics, we regard Gustave Courbet, for example, only as a realist, as the man who recorded what he saw almost mechanically. However, there is no trace in his work of a concern for analyzing the fundamental elements of vision. As we shall see, the true Courbet lies elsewhere. He must be sought, rather, in the preface to his celebrated exhibition of 1867 where he presented *Painter's Studio*. There he emphasizes that he is striving above all to invent a "true allegory." His goal is to strip away all incidentals. He would do so by drawing on his familiar surroundings instead of relying on the accessories of an outmoded Olympus. Although he intends primarily to give his compositions a poetic value, he does not alter the figurative relationship between the real and the imaginary. His revolutionary contribution is limited to the narrow realm of the "subject." In fact, his attempt was a failure, both artistically and socially; neither his contemporaries nor later generations understood him. He continues to be viewed and judged in light of the term "Percheronnes" used by Napoleon III to lambaste his works, which were seen as symbolizing common forms that aspired to aesthetic dignity.

As was the case with Courbet and Cole, everyone who, toward the middle of the nineteenth century, attempted to defend the idea of a reality-based aesthetic was misunderstood and excluded. People either conformed or disappeared. Earlier, Caravaggio, too,

had been held up to public obloquy for trying to establish a direct connection between the symbol and everyday events. In society as it is constituted, the ruling classes do not like it when the reality of their ideals is laid bare; nor do the classes of more modest means wish to acknowledge the all-too-material side of their aspirations. The former prefer to view culture as a restricted domain, inaccessible to the masses. The latter dream of uplifting themselves rather than of creating a figurative universe through their own labor. Thus social forces in the nineteenth century conspired in every way to reinforce the belief in the elevated stature of art and the evil of modern labor. And so, yet another basic theme took shape, one which held that a civilization stemmed from leisure pursuits and not from human labor.

The divorce between art and the machine, Nature, aesthetic contemplation, leisure — these are the themes that, as we shall soon see, formed the bases of the myth of mechanization that colors all of our judgments.

Between 1850 and the end of the nineteenth century, no great movement offered a systematic interpretation of the relationship between art and the machine. We shall see that numerous practical experiments, especially in architecture, led to a vast reconfiguration of the de facto relationship between industrial production and the aesthetic precepts of modern society. But no system replaced the theory on a necessary union between the arts and industry or the theory on the absolute incompatibility between nature and practical values. William Morris's Arts and Crafts movement in England, the Union Centrale des Arts Décoratifs, followed by the Gallé style, in France, and the Dusseldorf school in Germany only helped to propagate the themes developed in the mid-nineteenth century at the time of the first encounter between arts and industry. There was no possibility of creating an original aesthetic based on the transformation of

human activity caused by new tools and equipment, except by adhering to conservative attitudes that had governed ideals since Antiquity. In short, from the outset, the notion was posited that mechanization had modified the relationships connecting human action and theorization — and, consequently, art — without reviving them.

### From Integrated Art to Organic Beauty, 1890–1940

Toward 1890, following the triumph of the machine, which was marked by the Paris Exposition of 1889, a new attitude developed not only among those who used machines but among theorists and society in general.

In the wake of their incontestable successes, engineers began to claim title as creators of beauty, following the example of Alexandre-Gustave Eiffel. But it would be more accurate to say that the word *beauty* disappeared from their vocabulary and was replaced by the word *utility*. Now that they, too, associated beauty with something final and immutable, technologists intended to become creators of another form of expression that would reflect their triumph over matter. Quickly, however, a new theory was formulated in which, rather than identifying their output with classical beauty, they lay down the principle whereby beauty was no longer immutable, because it varied over time, according to technological means, customs, and social ideology.

### Integrated Art

In a provocative article in *Revue d'esthétique*, Etienne Souriau described this doctrine first postulated by his father, the aesthetician Paul Souriau. It was the latter who set down the basic tenets of industrial functionalism in a work titled *La beauté rationnelle*. Paul Souriau wrote in 1904: "An object reaches perfection within its genre when it fulfills its intended purpose. There can be no

conflict between Beauty and Utility. An object is beautiful if its form is the full expression of its function." At the time, Adolph Loos's crusade against ornament was also growing. It was believed that the elimination of superficial decor was the key to the problem of modern art. Ornamentation, which is incidental and superficial, would give way to the clear expression of an object's intended function. The soul of the machine would become apparent and would reflect the grandeur of the new human enterprise.

This is how the widely accepted opinion grew that the genuine inspiration of modern art had been discovered by attributing a plastic quality to the direct manifestation of a machine's power. From this concept sprang an aggressive and self-confident industrial aesthetic — which differs, but less than one would expect, from the most esoteric artistic theories of our times — that spread to a large audience the idea that art could be reconciled with modern society, provided it rely on values determined by the internal logic of technology. Since it attributed aesthetic values to the power of the machine, this belief was embraced by industrialists, insofar as "experts" seemed to attest to the quality of products obtained by using more exacting and surer calculations. In this way, a concept developed that attributed a partial, albeit fundamental, aesthetic value to aspects of industrial labor; as a result, engineers today reserve a place for art in their universe, because, above all, it helps create a ready-made public for their output. It was this situation that Etienne Souriau so well characterized when speaking of "integrated" art.

Here was confirmation of the vitality of the theories of Paul Souriau and his time. It was through him via the Nancy school, giving rise to art nouveau on the one hand, and through men like Henry van de Velde (whose exact role will be addressed later), on the other, that a movement took form that continues to influence thinkers even today. The Industrial Aesthetic movement in France,

like the Industrial Design movement in England, is the extension of this reappraisal of machine products. In *Technique, Art, Science: Revue de l'enseignement technique*, in an article titled "Esthétique et economie," written by a leader of French industry, Georges Combet, the general manager of Gaz de France, there was an enthusiastic endorsement of all of the ideas that had been set forth around 1900 in favor of an "organic" style closely modeled on biological life. Within a span of sixty years, the same doctrinal arguments were used to justify the aerodynamic form of locomotives and the floral style of the entrances to the Paris Métro. Moreover, Combet's article includes another highly practical and more convincing thesis: that of linking the quality of man-made products to a strict economy of means, that is, to the strict adaptation of the object to the materials and technologies used. However, on reflection, there is a marked contrast between theories that advocate a direct understanding of the economic imperatives of the machine and those that enthusiastically embrace a new naturalist ideology symbolized by the playful juxtaposition of adjoining illustrations of a flower and an electric motor.

From Paul Souriau to Combet, much speculative activity was generated. And two diametrically opposed attitudes existed in this new period of aesthetic attention to mechanization. For some, the aesthetic values that emanated from the industrial activities of modern society were, above all, rational; for others, these values were primarily irrational or, more precisely, biological. These two major currents prevailed simultaneously during the first half of the twentieth century. They reflect a new stage in the aesthetic interpretation of mechanization, for they jointly dominated many of the most respected theories. I shall present them in the context of some of their most brilliant representatives.

*Nature and Leisure Pursuits: The Rationalist Interpretation*
I believe that no one, at least not in my generation, will be able to
say enough, good or ill, about the influence exerted by the theo-
rist and artist Le Corbusier. I do not agree with those who believe
that Le Corbusier the theorist overshadows Le Corbusier the archi-
tect. First of all, it is not possible to separate the two activities.
What is more, the provocative theorist often may have obscured
and constrained the architect. The day Le Corbusier wrote that
modern architecture should not so much design or construct as
organize, he put his finger directly on his own predicament. I feel
that, at times, he unfortunately forgot that organizing is, precisely,
constructing and designing.

I shall refrain from giving in to the all-too-easy temptation of
making a case against Le Corbusier's writing style. His work so
abounds in examples of self-righteousness and fundamental over-
sights that they scarcely warrant comment. Le Corbusier wanted
to be a modern Vignola. It was perhaps not necessary to use the
Tour de France style to present the problems of modern architec-
ture to the general public, although the approach did have an
impact. Le Corbusier attracted an extraordinarily diverse interna-
tional following to the problems of architecture and town planning.

Le Corbusier's influence must be judged not only by the fact
that what he wrote was read but by the fact that he served as
the spokesman for the international avant-garde architects of his
generation. It would be truthful and respectful to say as much for
him as for the other members of the group that became famous
under the name Congrès Internationaux d'Architecture Moderne
(CIAM). In truth, a sense of perfect harmony never fully prevailed
within the group. It nonetheless held meetings from the moment
of its inception in 1928 in La Sarraz, Switzerland. Although it
appears that opinions frequently clashed, the major participants
generally remained in agreement on central issues. But after each

CIAM meeting, everyone left to pursue his own interests. Most often, differences of opinion were ultimately expressed in architectural works, and only Le Corbusier put into writing what was, in some instances, a virtually unanimous opinion and, in others, the feelings of a majority — or even a minority — but always related to problems that incontestably preoccupied modern architects in all countries for more than twenty years. Some have begun to wonder if Le Corbusier's theses today seem something out of an academic manual and if new architecture should be built according to other models. But nothing better illustrates the value of the problems he raised and the import of the solutions he proposed than that he continues to be praised and attacked. Of course, Le Corbusier appears, in the eyes of today's youth — and I am not alone in this opinion — a man of 1918. Like Giedion, Le Corbusier reasons like a disciple of Cézanne and Bergson; but who among us would not be overjoyed to be considered, in 1980, the leader in his field for the current generation? Le Corbusier is a major figure who is perhaps losing some of his reputation. Although his reputation has no doubt suffered from a perceived crudeness of temperament and from the popular form of his statements, I am not among those who hold that against him. In my view, one compensates for the other. I admire him not so much for having written that the earth was like a poached egg as for having defended a system so brashly, with all proper reserves, of course, as regards the system.

One day, the earth, this spherical liquid mass covered by a wrinkled shell, found itself beset by a new plague: the machine. Say what he will, Le Corbusier had, from the very beginning, a slight penchant for academicism, even before he was a cabinet minister. After all, it is somewhat paradoxical to place a theory of modern architecture, or, rather, a theory of modern art as a whole — for Le Corbusier is a painter, albeit of debatable talent

perhaps but nonetheless an arranger of forms, an occasional sculptor, and an architect on his better days — under the dominant theme of a crusade against mechanization. Why does Le Corbusier harbor such feelings of hatred, which are superficial, against the machine? "What was produced throughout the world at the start of the machine age is simply the product of a glitch in thinking. It is all destined to disappear. Nonetheless, the illness is not incurable: the force from which these monsters sprang — our so-called modern cities — will soon drive out inconsistency. It will bring order; it will put an end to waste." In a word: the machine botched its entrance into the world, but it has not lost its chance definitively; it can shift its appeal from misinformed artists and administrators to others who are better informed. Who was responsible for this tragic mistake? The engineer. Who comes along to fix his mistake? The constructor. Le Corbusier is such an irritating and intriguing figure, I find myself writing like him.

How does the poet-constructor — and more specifically, Le Corbusier — intend to put things back in order? By following three fundamental principles: bringing order to every aspect of the city; returning men to natural conditions; and giving men the means to engage in leisure pursuits.

Le Corbusier is a man of orderliness. He sees order as part of the internal logic of a building's structure as well as an element of social discipline. He demonstrated great human dignity when the partisans of a "new order" occupied France. And on the whole, he deserves all the more credit, since he had militated for a quarter of a century in favor of authoritarian policies. Twenty years before Philippe Pétain, he dedicated one of his books, *La cité radieuse*, to "Authority." When one considers that he had been a proponent of the regionalist and family policy, one cannot accuse him of having paid docile obedience to the slogans of servitude. This is rather astounding. For twenty-five years, Le Corbusier had em-

braced paternalism, regionalism, authority, and the family, without losing sight of the fact that under certain circumstances each individual's right to express his opinions can be temporarily withdrawn. It should therefore not be forgotten that, however scathing the criticisms lodged against him, his integrity and honor remain intact.

According to Le Corbusier, the machine took its revenge on modern man by inflicting him with two major scourges: speed and the pub. It is against them in particular that I am incited to react. His first offensive is directed against two evils: the city and nomadism. Mechanization changed everything: it destroyed regional units; it gave the family newfound mobility, with all its adverse effects; it expanded communication. Let me note in passing that, all value judgments aside, entirely gratuitous assumptions were based more on social myths than on empirical observation. For example, the notion of provincial regional units emerges from the completely false assumption that, until around the 1850s, the political and economic groups of the past remained stable. Criticizing the development of transportation assumes that, until the same period, men did not venture beyond their immediate surroundings, which is also totally false. Our ancestors devoted at least as much effort to traveling as we do, although they moved less quickly, to be sure; yet travel disrupted the rhythm of their lives much more than it does ours. As for the family, it is well known that in the ancien régime many family members were forced to leave home at a very young age to make a living, be it the youngest member or the apprentice. The development of means of communication, on the other hand, harmonized certain practices. These notions all originate from a series of pseudo-historical clichés.

Unfortunately, Le Corbusier adopted propagandist themes that, apparently, appealed to his taste for order and control. To

reconstruct a world, it is necessary to convince oneself, first, that the old one has been destroyed. In all sincerity, I find it disturbing that Le Corbusier starts from the "wasteland" ideology espoused by the turn-of-the-century right-thinking bourgeoisie. I am as suspicious of those who claim to be looking out for the good of the people as I am of those who claim to make a distinction between legitimate pleasures and the overly stringent norms of respectability. The scourge is not so much the pub as excessive alcohol, although it is perfectly acceptable to drink Pernod on the terrace of a chic café. Le Corbusier is horrified by the poor man, and, to cure him, he intends to use not only coaxing but proper training. There were to be floor inspectors in Marseilles's *unité d'habitation*. In the world as dreamed by Le Corbusier, happiness and cleanliness were mandatory — not to mention all the rest. Did he realize that one entered Buchenwald to the sound of violins?

Indeed, this is a very serious indictment, but these words are not without basis. Le Corbusier's universe is that of concentration camps. At best, it is the ghetto. Let me again stress that my intent is not to make Le Corbusier into a propagandist on the order of Pétain and Hitler, men whose hands are stained with slime and blood. But it is a sad reflection of the evil that gnaws our era that this monstrous new order is the distorted version of an ideology that seems to pose an infinitely more dangerous threat to man's future. No one has the right to impose happiness on his neighbor by force. That is what is called the Inquisition. And the Inquisitors, like all executioners, are only the exaggerated reflection of the weaknesses of a society. Waxing lyrical, Le Corbusier recounted how he arrived at the idea of the house as a machine for living in — the buzzing honeycomb of 1,001 obligatory and made-to-measure happinesses. He never felt so liberated as during his transatlantic trips — at a time when traveling was still done by steamship. Nothing gave him a greater feeling of total self-fulfillment as seclusion

in his compartment, where he found himself at the center of a universe that functioned according to a perfect order that was as regulated as the movement of the clocks at La Chaux-de-Fonds. Later, in the Carthusian monastery at Ema, near Florence, he also felt in his element. And the sight of the small ancient cities in Flanders gave him a third moment of bliss. Le Corbusier wants to be at the center of his own little universe, much like the poet whose mind is freest when transported from everyday contingencies. I feel, on the contrary, that man attains his virile happiness only when he fully assumes his responsibilities.

As his own testimony undeniably shows, Le Corbusier saw the creation of dwelling "cells" as the key to human happiness. He embraced the myth of the human hive, the beehive in the style of Maeterlinck's *Vie des abeilles*. With him, it takes on the proportions of an entire system. It is based on the idea of the mother, the cellular unit, and the family. A group of cellular units forms an *unité d'habitation*, which forms a city. Cities form a world. Everyone is in his appointed place and is kept there if need be; and everyone is happy, extremely happy. Revitalized men swoon in gratitude to those who prepared their environment; they bask in luxurious reveries in the middle of Nature — a little home on level 17 with a view of the sea and a well-ordered roof garden of carrots — or engage in activities — monitored — that are called leisure pursuits.

Of course, Le Corbusier's concepts — and those of many others — represent a strong push toward modernity, but the aspiration for collective living — which, like it or not, is an aspect of our times — would be much better served in the form of ordered living than in that of a universal concentration camp. But the analogy is inescapable. Of these ideological constructs, the one that wins out is not the natural order but the military system — the barracks — the paramount form of communal living, which

calls for each person's spiritual capitulation to those in charge of ordering the collectivity and of overseeing healthy leisure pursuits and interactions with nature. Barracks, cloisters, camps, prisons, phalansteries. Le Corbusier belongs to a long lineage that, across the ages, has sought to make people happy, even at the expense of their freedom.

Lastly, in the author's own words, nomadism will be put to an end, and happiness will be mandatory. Just as humankind's ancient history was supposedly the history of villages and roads, its future history will be the made-to-measure happiness that standard, well-studied living modules will bring. Le Corbusier's doctrinairism is consistent with his thinking: he applied the same principle of modularizing and hierarchizing to the style of the house in Marseilles, which is entirely modeled after the human-scale unit, the module. Thus aesthetic principles and social principles, by necessity, intermix.

It is not possible to address all of the arguments needed to challenge Le Corbusier's hypotheses point by point. Let it suffice to show how his theories, as characteristic as they may be of our time, derive from social myths of the nineteenth century. No polemic can entirely refute such well-constructed arguments. In the following pages, I shall revisit the question of the merits of some of his assumptions. But first I will focus on the scorn he heaped on the City and his desire to return to the conditions of Nature.

Le Corbusier presents himself as the spokesman for those who wish to pour scorn on Paris. Generally, when he speaks about the ills of the City, it is Paris he has in mind. This myopia and lack of insight into what the modern city par excellence represents — the city that possesses a greater mix of qualities than most others — is mind-boggling. It eventually prompted Le Corbusier to design a plan completely to transform Paris — in progress, alas! — in which

Paris as we know it would disappear. Only certain monuments would be kept, as museum pieces. The poor Louvre! It was going to be "conserved" in the middle of a forest of vertical city buildings that would have dominated it. In the end, Le Corbusier only accepts the past if it can be put under glass, clearly labeled, and compartmentalized. He also refuses the modern way of life. He works not for his contemporaries but for men of the future, whom he would mold to fit his vision — not their own. It is in these terms that this ideology of Nature should be viewed — as part of the role assigned to the arts in order to realize a large-scale improvement of humanity, by force.

The environment makes the man. Le Corbusier was among the first to understand that the way technology was applied to housing could serve as a powerful lesson both for works and for humankind. Here, we resolve the first point of debate that arose in the nineteenth century, dating from 1850: the irreconcilable opposition between art and industry. The compromise theory that put the machine at the service of art struck a balance by associating art with contemporary technology. Incontestably, the CIAM movement represents, from this point of view, an important moment in the history and development of the myth of the machine.

What is remarkable is that the solution itself changed rather than the basic elements of the problem. At issue was a change in the combination of elements: the men of 1918 did not question the fundamental aspects of the problem. The real values at issue in this ideology involved an opposition that set industrial civilization against art and Nature and sought a way out by bringing man into pseudo-contact with Nature and the countryside — the last vestige of Rousseauism, steeped in arrogance — and technology. Another of Le Corbusier's fundamental attitudes is exemplified in his theory on leisure pursuits. A guiding principle set forth in the

Athens Charter is the idea of the three-part city — the city seen as a signpost when the road from the past becomes hazy and uncertain — in which human activities are separated according to their function. Housing, recreation, work, and circulation will be cited in all of the urban design projects inspired by the doctrine, and a diverse palette will be used to color the varied shades of human conditioning.

These functional zones are crucial. They determine the layout of buildings throughout the city as well as the interior arrangement of the *unités d'habitation* and their organization in vertical blocks. They not only guide Le Corbusier's personal concepts but are yet another factor he uses to comply with the general attitude of his era. An artist like Frank Lloyd Wright, the leading exponent of a new architecture that stood at odds with the functionalism of Le Corbusier and Walter Gropius, shared this point of view. Throughout the world, specialized districts are accepted as the norm. Le Corbusier's contribution was his emphasis on uniting dwelling and leisure in the general structure of cities. In his view, happiness must be dissociated from work. Man has two sides: he earns his living by the sweat of his brow; and he becomes himself again and is elevated only when he is free, in his leisure pursuits. When not engaged in his daily tasks, man sets his thoughts beyond his work. One wonders, however, if there is a contradiction between this concept and another principle, according to which man must be within walking distance of his place of work. The *unité d'habitation* is in the happy medium. Nonetheless, the worker must live in an industrial sector, far from the commercial center; and his dwelling must be a few hundred meters from his factory, well protected by a screen of trees that mask the view and the smoke, even farther from the central areas than the civil servant or the tradesman. Of course, there will be no need for him to go to the center of the city any longer — except to get married

or to register the birth of his children — because everything, swimming pools, movie theaters, meeting halls, and terraced gardens, will be within close proximity: each group will be tied to its place of work by a golden — and thus all the more solid — chain, while its members see or read only what is deemed appropriate. He will be trained, in his *unité d'habitation*, from the cradle to the grave. Indeed, men will no longer have any reason to envy the bees. In Le Corbusier's system, however, the queen bees will not even be killed periodically. They, too, will have their residences, their clubs, and their amusements. It is a safe bet that they will not be the same as those assigned to the common man.

Not only do these concepts have a direct correlation to humanity's horrifying march toward enslavement; more blatantly than anything witnessed in generations, they resuscitate castes and class systems, while going against the basic conditions necessary to produce works of art, at least on the collective human level. In Le Corbusier's city, there would be a form of art adapted to each type of activity. But the whole dream for the modern era, beautiful though it was — this mirage in which all men would come together and culture would be expanded to its limits — would be destroyed.

Ultimately, Le Corbusier privileged two basic problems that had their source in the modern debate on the relationship between art and the machine. The first problem is based on the idea that man is by nature a divided being. But why, then, reject the myth of original sin? The myth is indeed there, let there be no doubt about that! This fundamental problem involved determining the correlation between thought and action before addressing the relationship between art and industry, historically and in the present. The second problem is to know if man can determine the contents of his art independently from form. In response to these two questions, Le Corbusier and others propose solutions that

imply the commonality of all humans — and, no sooner that done, they propose that individuals be segregated. In a world ordered in this way, work will be a curse, whereas art and leisure pursuits will be the only escapes. But only a privileged few will be able to benefit. The human community will be compartmentalized, under the pretext of disciplining and organizing it. But that will not be the fault of the machine; it will be the result of naive, self-interested concepts that revive ancestral taboos.

By his art and doctrine, Le Corbusier is representative of a first group of new exegetes of mechanization. In spite of concessions to man's natural needs and the hymn to leisure pursuits, these exegetes tie all aesthetic and human values to rationalism. In contrast, despite its concessions to a technological rationale, a second group of theorists vehemently denounced the new servitude that technology placed on man and focused on so-called human values — in fact, the irrational.

### The Three Ages of Technology

Two works by Lewis Mumford, *Technics and Civilization* (1934) and *The Culture of Cities* (1938), have enjoyed considerable success. Mumford published another book, *Roots of Contemporary American Architecture* (1952), which, though more specialized and inspired by national concerns, was a direct outgrowth of his previous works. It clearly presents us with a body of doctrine. Mumford is a notable figure within the circle of American architects and urban planners. His articles appear regularly in journals and reviews and are considered authoritative. Through his books, he has helped set the tone for the tastes and ideas of his country. I shall focus especially on *Technics and Civilization*, a trailblazing book in 1934.

(As we shall see, books by Sigfried Giedion — *Space, Time, and Architecture* [1941] and *Mechanization Takes Command* [1948] —

would also garner considerable attention. Each was reprinted approximately ten times over ten years. They are read not only in English-speaking countries, but in Latin America as well. For a large number of young people around the world, they constitute a kind of introductory breviary for sociological problems of modern architecture.)

Mumford intended to examine the consequences of the machine on man's public and daily life, primarily in the context of urban planning and architecture, through a perspective that traced its evolution in modern times. Here we recognize the Anglo-Saxon taste for General Surveys that take a broad overview of human experience.

Mumford begins by affirming the link between the development of technology and a general change in man's way of thinking over the course of one and a half centuries. The machine, in his view, is a meeting point, the common denominator between individuals and groups — between cities, regions, and countries. The machine altered or reoriented man's desires, and, for better or worse, it is deciding his fate. It conditions the culture that produces instruments, without which life and practical activities would not be possible, and makes them usable. Mumford thus posits the absolute ascendancy of the machine. From there, he attempts to retrace the machine's steady progress through history. He states, in effect, that technological progress became possible only when a mechanical system had been isolated from the fabric of man's general activities. He does not claim that neither technology nor machines existed before the technological age; but he contends that a new age opened when certain basic activities were impelled in a new direction by technology. He suggests that, unlike ancient periods, when the world of ideas and aesthetics was governed by magic, the modern era is governed by empirical experience. Conjecture gave way to experience, rationalization to

demonstration — all of which developed in parallel with mechanization. Mumford claims that a mechanical universe burst forth suddenly. He states that, in ancient times, a basic understanding of mechanics existed. He contends that the machine and technology came about not through sheer discovery or a final realization but through the rapid development of a latent function inherent in human activities.

On that argument, Mumford presents a three-part history of the machine. First, there is the embryonic phase, which runs, more or less, from the tenth to the eighteenth century. During this phase, numerous technological practices developed, and their individual importance should not be underestimated, because they truly transformed the material conditions of large groups of humanity. Mumford calls this phase the eotechnic period.

He owed this theory to an Englishman, Patrick Geddes, who, between 1900 and 1920, authored the first works outlining a sociological theory on urban planning and who first advocated the garden city. Geddes's theoretical work is significant. He is responsible for the theory on the progressive assimilation of cultures, in opposition to Spengler's theories on illumination, and he made the distinction between the palaeotechnic and neotechnic phase of the modern world — a distinction that Mumford would borrow and use as the basis of his notion of an earlier eotechnic phase.

The eotechnic phase was marked by productive inventions. Western man learned to use the world's physical forces to achieve a given purpose. He learned to harness and shoe horses, and, more importantly, he harnessed wind and water. The eotechnic phase is characterized by a decreasing reliance on human effort. The primitive tool, a direct extension of the arm and the hand, was supplanted by instruments that made it possible not only to augment man's physical power but to utilize it indirectly or defer it.

Geddes had put forth the idea that the palaeotechnic and

neotechnic phases could be concretely situated in history, according to their region, materials, basic resources, modes of energy usage, means of production, types of workers and intellectual developments. Mumford stated that the centuries-long eotechnic period that preceded the other two must have been much more heterogeneous. But he stressed the fundamental similarity of eotechnic civilizations, in spite of their heterogeneity. He believed that they were the same culture in different forms and that this culture's central concern was the problem of energy sources. Following a period of relative decline, brought about by the deterioration of the Roman world's refined agricultural systems — which had led to a temporary equilibrium in the exploitation of the planet — there appeared a civilization centered on wood, water, and wind; then manufacturers and ships made it possible to transport raw materials and luxury goods. Even as folklore flourished, societies developed an objective science as well as an art that was both descriptive and introspective. The sense of order that was shaped and finally set in place toward the middle of the seventeenth century was based on the idealization of Nature and was simultaneous with an analysis of man's inward powers. It is the civilization of the clock, the printing press, the smelting furnace, and the mirror. Refinement of the senses, identification of the guiding concepts behind speculative and practical activities — a French garden is a reflection of the scientific method and the moral law of the times. This profound symmetry between man's spiritual and material activities would be definitively undone by the machine — that immense force that operated according to its own, seemingly inhuman, norms.

According to Mumford, the passage from the eotechnic phase to the palaeotechnic phase can be viewed as the bursting forth into the universe of a material state or an autonomous force that acts according to laws external to those governing the human

mind and body. Human experience ceases to be universal because it is confronted by forces that do not obey the same laws as the human body and mind. It is a universe where only the machine is real, where power is exercised according to physical laws independent of those governing the workings of the mind. This universe exterior to man easily justifies the universally condemned opposition between art and man's daily social conduct or practical activities.

Moreover, in Mumford's view, the groundwork was laid for this disturbing phase of human history during the eotechnic centuries by a series of partial discoveries. In a somewhat disordered presentation, the author attempts to pinpoint the moment during the eotechnic period (tenth to eighteenth century) when man's active and speculative lives were brought into balance; then he draws up a list of the human inventions that made it possible, suddenly, for the machine to burst forward, fully equipped, into the field of human activity and unmake humankind physically and morally.

A great part of Mumford's book is devoted to drawing up a chronological list of discoveries that thrust man into his most formidable adventure. Unfortunately, this strictly chronological picture of human inventions from the tenth through the twentieth century leaves much to be desired. The very notion of assigning an exact date for each invention is debatable. The discovery of the windmill, for example, is set in the year 1105, although its underlying principles were known well before then; and so it is a question not so much of an invention as of an application or dissemination of a concept for economic and social purposes. On this point, I should refer to André Leroi-Gourhan's excellent book in which he lays out the vast difference between the discovery of a technological invention and the sociological problems entailed in adapting technology or a tool for practical application in a human

environment. Sometimes it takes just as much ingenuity to make a principle or invention usable as it took to create the invention itself. Indeed, there is not an absolute correlation between the discovery of principles and the concrete forms of their utilization. It is difficult to assess the value of theoretical invention alone, because there is a constant interaction between the speculative and the practical. Mumford's description confuses two orders of phenomena, giving more attention to applications than to the formulation of laws and principles. Granted, his outline of technological inventions and scientific discoveries was intended only as a research aid and, as such, must be viewed as preliminary. What is more serious is his stance on the sudden consequences that this capital of accumulated inventions had on man at a given moment.

According to Mumford, the Machine suddenly became a kind of thinking being, an ultrahuman force that threatened to impose its laws on man. Here, Mumford is following the generally accepted view that the Machine is a monstrous adversary that enters the domain of human activity by a blind stroke of Fate. Certain paintings by Piero di Cosimo reveal that the antithesis of the demoniac blacksmith and the inspired poet of the gods was present in the minds of men at the end of the fifteenth century.* But there is currently a very popular tendency, which fits in well with the modern hominoid's ideas on the development of humanity, toward hypostatizing the somewhat mysterious work of the engineer. It is widely believed that the Machine appeared, fully equipped, at a certain stage in history, creating new functions and transforming the human condition on the outside and on the inside. In short, we arrive at a partly fascinating, partly terrifying vision in which man, at a given stage of history, is bestowed with

*Cf. Erwin Panofsky, "The Early History of Man in a Cycle of Paintings by Piero di Cosimo," *Journal of Warburg and Courtauld Institutes* 1 (1937).

an instrument he lacked, which, to a large extent, soon becomes his master.

Behind this theory, which considers the appearance of the machine an entirely new event in history, distinct from man, its creator, there is still the belief in a Nature exterior to man, which he discovers successively in each of his parts. In short, human history continued to be viewed as a revelation. What Mumford rejects, specifically, is the mystical medieval vision of the universe, replacing it with a rationalist or rationalist-inspired doctrine; but his rationalism is tainted by mysticism, due to a truly practical and operative conception of the relationship between thought and action — which is the whole problem posed by mechanization of the modern world. It is a vision grounded in an allegiance to the idea that human history always emanates from the discovery of a great secret, with the mechanical universe corresponding to notions such as Space, Time, and Movement, which heretofore had not been fully grasped, and from a faith in the development of an automated universe intended to enhance and then replace human labor.

Mumford wrote elegantly on the new conceptions of modern man. He contrasted the modern imagination, which impels man to conquer new phenomena and instruments, with the ancient imagination, which inspired man to conquer souls through religion and bodies through war. Nonetheless, this hypostasis of technology, which is artificially isolated from contemporary activities, risks placing into the hands of humanity new gods as murderous as the ancient ones. One might well believe that the era of myths is still flourishing.

Indeed, the new era, the neotechnic — which follows the eotechnic and the palaeotechnic, according to the theories set down by Geddes and taken up by Mumford and Giedion — marks a return to the mystical cult of Progress, which is not very different

from the ancient dreams of the golden age. The triumphant era of the machine, Mumford, Geddes, and Giedion suggest, is about to end. The limited world that it engendered — an iron age, depopulated and brutal, turned against beings of flesh and blood, and beyond man's power to control — is already condemned. The return to intuition, biological certitude, and the fantasy promised by the development of the natural and human sciences since around 1890 will open a new cycle in the history of humanity. Man will break free from the machine. He will take command. Although the reasoning of the mechanized world is to survive at least in part for the next few decades, there is no doubt that the new era has begun.

The palaeotechnic phase of human history began around 1750 and developed over the course of a century, just as the neotechnic phase is currently taking shape. It was the age of the steam engine, urban agglomerations, and industrial concentration. It led to the deterioration of Man and Nature — a deterioration aggravated by education and the exigencies of a capitalist society which gave rise to a sexless and directionless *homo economicus*, who finds atonement only in aesthetic evasion. The impressionistic world of halftones, haze and ambiguity, and tonal distinctions had, through the poetry of rebellion and misery, given rise to the art of this sad period.

The neotechnic phase, on the other hand, is preparing the way for man's reconciliation with his activities. It will restore values that are not subject to strictly time-based calculations. It manifests itself by the desire to rehabilitate. In keeping with the law of slow, progressive development, it has been in progress for a thousand years; but, until now, it has had only a few isolated individuals to give it expression; it could not yet found a society. The two Bacons, Leonardo da Vinci, Porta, Glanvill, Cellini and Michelangelo were the first to reach the shores of what will soon be man's

new tradition. A civilization based on the exploitation of materials, electricity, and film and on the tragic sacrifices of war, which had proved fatal to peoples who had lost the values of true culture, will no longer be possible. Every individual will create his own environment according to his abilities and his imagination.

No longer a slave to his universe, man will in the future be better armed to dominate it, and the marvelous diversity of his creations will protect him from all social upheavals and war. The new world, which will be no longer that of the machine but that of continuous creation and free and direct individual expression, will be dominated by the mind. It is art that will command the universe after having long been the poor cousin. The art-based society will draw on human and organic concepts in the face of the mechanized order, which represents the modern era. After subduing the machine, man will surmount it by utilizing creative efforts inspired by the laws of life. Society as a whole will pass from an era of disorder to an era of planning.

To understand the importance attributed to Mumford's book, it is necessary to recall its date of publication: 1934. Many of the arguments in this work not only were used to support theories but were the stimulus behind actions undertaken within many of the most influential circles. It may even be said that Cole's and Laborde's views from the 1850s, which placed the machine at the center of traditional civilization, were supplanted by Mumford's perspectives, which identified the machine as a traditional element in modern life. Henceforth, it would be a question not of making a place for the machine within human activities but of making a place for man in the civilization of the machine. At the same time, it was a matter not of finding a way to reconcile the products yielded by mechanized society with the arts but of defining the necessary conditions for new art in a civilization in which machine products would constitute natural surroundings.

Thus the approach to the problem was entirely different from what it had been a century earlier. Yet it was not any more objective. New absolutes, new myths merely took the place of older ones. It was no longer believed that an immutable, eternal art could be reconciled with industry; rather, art was seen as a sum of practices. It was no longer thought that the laws of mechanical equilibrium were the reflection, in plastic terms, of the supreme laws of Nature. Now it was thought that a biological and organic rule constituted the norm for all valid constructions. It was also thought that the emergence of sensations at the threshold of consciousness guided man along the paths to wisdom and led him spontaneously to the supreme aesthetic expression of himself. In the final analysis, the opposition between art and technology turned in favor of technology. The opposition between man's Faustian activities and Nature also benefited Nature — which was now seen through a more biological than mechanical perspective. However, aesthetic activities, as well as the belief in the virtues of leisure, were increasingly seen as the source of humanity's superior development. It therefore seems useful to examine more closely the new attitudes adopted by theorists on the function of art in mechanized society. It will then become apparent that individuals working in these domains — who include some of the greatest contemporary architects and urban planners — exercise significant influence over our ideas and customs.

*History of Architecture and the Object: From the Mechanical to the Irrational*

Two books by Sigfried Giedion — *Space, Time, and Architecture* and *Mechanization Takes Command* — are serious indictments of the works of the nineteenth century and of the mechanization of all human activities. But, like the works of Mumford, they also herald humankind's turn toward the road to regeneration.

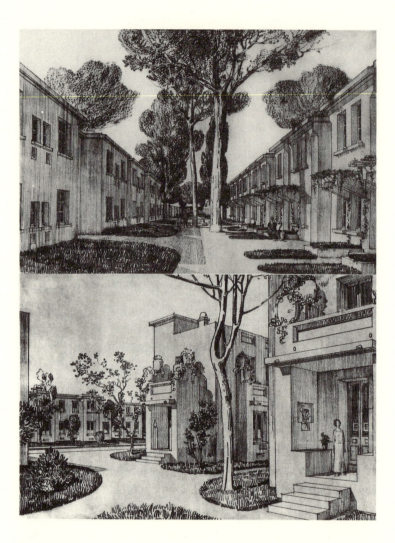

Figure 3. Tony Garnier, project for an industrial district in Villeurbanne, 1901–1904.

The modern plastic arts are linked to a new representational concept. A decorative concept based on the molding design on a single facade, viewed from ground level in imaginary lighting, gives way to a design that consciously strives to achieve an effect by using contrasting surfaces and a receding view presented in a real-life setting. At the dawn of the century of town planning, composition dealt with the whole, not the fragment. (Archives Municipales de Lyon.)

Figure 4. Frank Lloyd Wright, Herbert Jacobs's second residence, Middleton, Wisconsin, 1944.

New technology and plastic attitudes suggest, materially and mentally, new operative links. One point of departure: the surface disappears, the house blends entirely with the space. The house must have its own style. Style developed through specialization. Formal distinctions vary according to the technical problems encountered: the house must hold its own, internally and externally, as a complete expression, while becoming a companion to the horizon. (Ezra Stoller © Esto. All rights reserved.)

Giedion's work makes two clear contributions: he was the first to have attempted to write a general history of modern architecture from the middle of the eighteenth century to the present; and he simultaneously attempted to give an aesthetic and psychological interpretation to what he saw as the vital development of the modern form of art.

As for the historical elements of Giedion's works, I shall only stress their undeniably new insight. Most notably, alongside a history of architecture — some of which tangentially involves America — he included a history of the transformations undergone by the everyday Object in the modern world. To be sure, one could express reservations about the validity of any number of the developments he describes, such as those relating to the chair or the wagon; but there can be no doubt that he was the first to understand the importance of the changes in the materials used in everyday, utilitarian objects — changes that paralleled the development of major art forms and the entrenchment of the machine in the modern world. Thanks to him, the notion of the decorative arts became clearer, and one sees a way of conducting specialized research, outside the circle of aesthetes and art professionals, that deals directly with issues touching on the relationships between new products of human creativity and the intellectual attitude of a society.

Unfortunately, an absolute objectivity was not exercised when separating the documentary section from the theoretical section of these works. When I later address the historical sections, we shall see that, very often, the facts have been subordinated to doctrine. Insofar as doctrine is presented as a system and developed in parallel with the facts, it will not seem arbitrary to examine it first. It is doctrine, after all, that guides material investigation and is used to justify underlying assumptions.

Giedion considers the alienating effect of mechanization as a

given, since, in his view, it was unprecedented in human history. And he places great emphasis on modern man's confrontation with a tragic dilemma brought about by humanity's complete internal breakdown. He uses striking, even moving words to describe the internal upheaval undergone by mechanized man. The machine's replacement of manual labor to produce everyday objects supposedly provoked schisms — within man himself as well as society. Giedion deserves credit, in particular, for having shown that inventions of seemingly minor importance, such as the Yale lock, led not only to the industrialization of lock manufacturing but to a complete reversal in mechanical concepts. Whereas earlier lock mechanisms made it possible to press a bolt or lock into place more easily or push it more forcefully, Yale's concept of rows of interlocking cylinders replaced the action of the fingers with a system that transformed a rectilinear impetus into a circular movement. Here and in other instances, the machine replaced age-old methods with new ones that transformed the way man mastered his surroundings. A new way was found of converting concepts into practical means for executing them. The machine did more than give man increased power; it made it possible for him to put new intellectual solutions into action. New designs were used, in theory and in practice, to make materials stronger and more pliant. Little by little, the daily triumphs of the machine inevitably transformed man's most profound sensibilities. His fundamental concept of how to exploit materials was transformed — not only in terms of power or quantity but in terms of method and quality. This quite naturally explains the wide repercussions that the mechanized universe had on intelligence and sensibility. A new human type developed progressively, keeping pace with technological progress, as new types of objects appeared.

What is surprising is that, after focusing on man's profound psychological transformation in the wake of machine production,

71

Giedion holds that this progress — or, if one prefers, this joint evolution of human action and thought — led to a conflict that left man torn between opposing forces and somehow crippled. According to Giedion, the nineteenth century progressively lost its ability to view things globally. The universality of technological solutions was set against the flaws of specialization, which made man blind to the general relationships between his activities and the universe, reducing his participation in the collective life of the world. Because he believes that rationalism implies a world broken down into abilities and activities, Giedion argues that it is self-evident that our era has progressively lost its ability to translate its thoughts and emotional experiences into action, which leads him to deduce that modern man, in perpetual self-conflict, has lost his sense of tranquillity. Giedion sees man as irremediably torn, a hostage to his beliefs and his capacities. Entirely subject to the new law of the machine in the course of his daily activities, man has lost all contact with artistic or moral theorization. Our epoch is marked by an unbridgeable gap separating thought from sensibility. There is no sensibility behind our knowledge.

It may seem surprising that Giedion reaches such a pessimistic conclusion in works that so eloquently address the marvels of modern ingenuity. At the outset, Giedion posits the existence of Man in the absolute. While demonstrating the driving forces behind man's mechanical inventiveness and highlighting the intellectual repercussions of his slightest stroke of inspiration, he nonetheless refuses man the privilege of having undergone a transformation. He imagines an eternal man-type, a standard-man who could possibly serve as the ideal of a certain America, but who should never be considered the king of creation. At bottom, that is the central idea in Giedion's works and in that of a host of his contemporaries. Always on the lookout for outward signs of progress in human activities, he refuses to admit the possibility that

human functions have undergone a significant transformation. Not only does he isolate the development of mechanization from other phenomena of the modern world; he suggests that there was a universal reaction to the progress of the machine. Thus we understand why the man who so admirably analyzed some of the major inventions of the modern world and their impact on human psychology and actions — in particular by shedding light on the role played by genuine intellectual discoveries, such as combinatory arrangements, convertibility, transformability, and the broadening of the multiple forms of movement — had a narrow-minded outlook on the evolution of contemporary thought and sensibility.

Giedion himself was perfectly aware of the impasse he had reached. Unfortunately, the time and creativity he applied to solving this problem did not represent one-tenth of what he had devoted to researching his subject. He was contented to accept the ready-made solution offered to him by his circle, namely, Mumford's solution, Wright's solution, and the solution proposed by most great modern technologists who encounter public resistance at the point where their expectations and their solutions converge — solutions that are often extraordinarily progressive when viewed in detail, but questionable when considered as a whole. An architect himself, Giedion gave expression to the drama of those, past and present, who were conscious of being part of an avant-garde, but not able to come to terms with their predicament within a system of entirely modern reasoning. An artist who produces works modeled on only the spirit of the future would be an unimaginable monster. Progress, in all fields, is realized in parts. The discovery of an innovative principle does not mean that the innovator is capable of foreseeing every consequence of his discovery — consequences only become clear when there is broad application of the discovery. The criticism leveled against Giedion and numerous others who theorize on the rela-

tionship between the mechanized universe and art or contemporary psychology is directed, in sum, at the boldness of their basic assumptions. They are correct within their field of analyses, and it is not their role to address how society and humans will adapt in the long run to their principles.

Given that the goal of this book is to show the reciprocal positions of various groups of individuals who brought about a confrontation between the concrete and figurative activities of our era, it seems useful further to elaborate Giedion's attempts to resolve the pseudo-conflict that he, like so many others, denounced. As mentioned above, the solution he had in mind is the same as Mumford's. It involves man's rediscovering his soul by replacing mechanical rationalism with an organic conception of the universe.

Technological advance led to specialization, the compartmentalization of activities. A highly formal logic imposed itself on our way of thinking, making it impossible for us to comprehend the irrational values of art and poetry. In a way, man's frustration at having less to do with his hands led to an atrophy of his brain. Subject to the laws of rationalism, he lost his peace of mind when he lost his ability to reach the enchanted shores of poetry. Once again we find the themes of Nature — a garden of paradise open to man as long as he remains pure of any overly ambitious logic — of art as inspiration, and of the conflict between good and evil. From the moment it is possible to exacerbate the separation between thought and action, the way is paved for a return to romanticism. We also return inevitably to the theme of man-humanity, immutable in his faculties and forever tied to his immediate surroundings, in which he deciphers only a new syllable.

In modern man's current state of disgrace, one ray of light shines through: man's rediscovery of his soul and art is within view. The era of mechanized rationalization, which almost killed

the planet, is coming to an end; the era of organic civilization is beginning. In the title of his first work, *Space, Time, and Architecture*, Giedion laid down the tenets of this thesis. In his view, two events of crucial importance for the future of the arts and industry occurred around 1908. A fourth dimension, Time, appeared simultaneously in the arts and the sciences; the gap that for a century had separated artists further and further from men of action was suddenly bridged. The conflict between arts and industry — a conflict that had begun to eat away at the human soul — was assuaged; and thus a happy and productive era of human action was opened.

Giedion parallels Hermann Minkowski's work *Space and Time* (1908) with the debut of cubism and futurism. From there, he concludes that the opposition between the rational and geometric, on the one hand, and the spiritual and creative, on the other, has disappeared as a result of the new emphasis on irrational principles in physics and chemistry as well as in mathematics and as a result of art's response to the non-euclidean universe. The introduction of the fourth dimension, Time, making it possible for us to experience and represent multiple points of view as well as simultaneity, overcame limitations on our senses and prompted man to conquer a new universe from various angles all at once. The opposition between reason and instinct was reconciled through newer ways of grasping the world, by exploring and representing technology and art in similar ways, while subjecting both to the new laws of biophysics. Henceforth, artists expressed movement through direct contact with reality, using untold powers of plasticity, within a world totally reordered by man. With disciplines set against each other, the human drama intensified. From this point on, we would create in keeping with Nature — once again! — whether in designing our homes or painting canvases. Attuned to an internal rhythm, aesthetic vision gave con-

crete expression to man's new awareness of the world and more naturally expressed the means of human action. Henceforth, in architecture in particular, man juxtaposed dynamic and colored surfaces that, in certain regards, were an extension of his reactions as well as an externalization of his power. He saw his works no longer as exterior or alienated but as having become an extension of his limbs: a projection of his representations. Now that the individual had knowledge that enabled him to educate his sensibilities methodically, he rediscovered his capacity to act, his happiness, and his sense of unity.

Giedion's thesis is intended above all as an aesthetic interpretation of the development of contemporary architecture. Later, I will return to the major points of his argument, but, as we see from the outset, it is based at least as much on a psychological conception, or a psychophysiological or, better yet, psychopathological and psychoanalytic conception, of the contemporary world. It is not at all apparent, for example, that he supplies the slightest proof that mechanics or mechanization plays a more limited role in the structure of current buildings. In the end, salvation is sought in a surrender to supposedly irrational forces whose virtues are realized only by a truly irrational faith in biology. Essentially, there is a shift in the perception of Nature or, more specifically, an attribution of new qualities to a still hypostatized view of Nature. But the doctrine of surrender is retained as a source of full understanding and total happiness — a surrender to those who know, those who have the means, those who see, act, and create. Here, we enter the realm of the mystical, where appeals are made to the healer and the thaumaturgist in a modern form of trust in God and in those he has called on to represent him on earth. For those who believe that man's dignity, however humble, resides in his ability to decide his own fate, a problem arises, one that, emotionally and intellectually, is even less admis-

sible than clearly characterized: it is the contemporary form of mystical thought.

Nowhere is this attitude better expressed than in several texts by Sir Herbert Read. In *Art and Society*, published in 1936, Read contrasts ideology and economics and states that art is created not to satisfy economic needs or to express religious or philosophical credos or ideas but to set an example for a synthetic and self-contained universe of autonomous values, so as to incarnate eternal aspects of reality or truth through an individual. What better way to highlight how the problems of the relationship between art and technology have led to man's fundamental dilemma and how all current theories start from the idea of a universe/substance in contrast with man, thereby placing the object in relation to the subject. This theory of Nature, this theory of substantive reality, is also a theory of art as a permanent function with which man is endowed by Nature itself: it is always the same from generation to generation, an immutable mechanism that places each individual — who is the incarnation of an identical Form of humanity — face-to-face with the eternal idol, the sphinx that is to be deciphered rather than dominated. And our own era is not let off easily! We are accused of materialism and cynicism. We swim in the waters of myth, in the irrational. Few eras since the Renaissance have created so many fables; few eras have succeeded so well in reviving man's undying obsession with creating gods.

One objective I have set for myself in this book is to show the exact nature of the current forms adopted by the conflict between sensibility and reason. I cannot be contented with the solution proposed by Giedion, who, in effect, arbitrarily isolates these two fundamental forms of human intelligence. If man were capable of undertaking two independent activities, there would be no problem. It is a highly reductive psychology that posits an internal conflict between a now-outmoded rationalism and "feeling," the

emotional basis of our sentiments and actions that triumphs over our current state of turmoil by means of a so-called human conquest. In the final analysis, Giedion seeks salvation not through man's efforts to act upon himself to resolve his contradictions but through a total surrender to an internal intuition, a new form of Rousseauism and all doctrines of intuition. What is more, Giedion is not the only representative of this antirationalist, mystical, and expressionist attitude among architecture theorists and practitioners. The foremost exponent of the doctrine, in theory and practice, is the American architect Frank Lloyd Wright.

## Toward the Organic Era

Wright's reputation has not yet reached a wide audience in France, but he enjoys tremendous prestige among young people on both sides of the Atlantic. In America, he is considered — and deservedly so — something of a national treasure: he is, without a doubt, one of the first truly American artists of international stature. In Italy, his reputation is enormous. An honorary citizen of Florence, he was welcomed there like a sovereign. He considers himself a new Michelangelo — which was how Rodin secretly imagined himself. Venice took a less favorable view of him, and his construction project on the Grand Canal was canceled. His first great consecration came from Germany. In a memorable exposition in Berlin in 1911, he made his mark with the Old World. This exposition crystallized the aspirations of young architects of the period toward a modern style, and it signaled America's entry into the international movement of the lively arts. In France, Wright held a general exposition of his work several years ago, but it was a success only among specialists. He is entirely unaware of French art in every epoch. He seems familiar only with the Gothic period, and he speaks mainly in relation to its English and German manifestations.

Wright's reputation was enhanced by the publication of an important book, the work of a young Italian architect, Bruno Zevi. Having lived in the United States during the war, Zevi became keenly interested in the Wright's work and made it the focus of three large volumes: two devoted to theory, *Verso un architettura organica* and *Saper vedere l'architettura*; and one devoted to history, *Storia dell'architettura moderna*. Although the first two attest to his great talent for explication and exposition, the latter is of considerable importance. It offers, for the first time, an orderly history of modern architecture starting from the beginning of the nineteenth century, with the intention of making it more understandable. While drawing largely on groundwork laid by Giedion but focusing solely on architecture, without treating related developments in engineering and manufacturing, Zevi's book is both more comprehensive and more limited.

Taking up the ideas of Geddes and Mumford, Zevi argues that the architecture of the modern world arose in stages from seventeenth-century theories on the resistance of materials. But he is careful not to give in to the mistaken belief that technological progress alone engendered a new art. Instead, his major concern is to compare and contrast the technological and aesthetic developments of new architecture. The engineer alone could not have spawned it. Thus he simultaneously examines technological progress and figurative vision, without which it would not have been possible to give expression to new mechanical possibilities. In this respect, Zevi stands apart from others, Le Corbusier in particular, who link art too narrowly with ulterior motives. He disapproves of overly rationalist or overly positivist explanations, in favor of plastic and human qualities, which, in his view, have fostered the current development of architecture.

Zevi is thus led to consider Wright the man who best incarnates the possibilities for new aesthetic ends opened to construc-

tors by technological progress. That is why his book presents his hero's theories and practical creations as the culmination of a general trend in architecture in the past century and a half and as the promise of a new future.

Wright took it upon himself to proclaim the importance of the plastic and spiritual message that he had brought to the world. He wrote numerous essays and articles, a monumental autobiography, and several books. The essential elements of his doctrine appear in a book that collects four conferences he gave in London, *An Organic Architecture: The Architecture of Democracy* (1939) and in *Genius and the Mobocracy* (1949).

Presenting himself as a divinity who occasionally visits his people in order to bring them the gospel, Wright delivers to the world a declaration of independence. What he is bringing to anguished humankind is material and moral salvation. He presents himself as a genius and prophet: "I declare, the time is here for architecture to recognize its own nature, to realize the fact that it is out of life itself for life as it is now lived." Architecture must free itself from all material, commercial, and academic contingencies as well as from all outdated aesthetics. In this way, it will offer humanity the practical means to regenerate itself: "We cannot have an organic architecture unless we achieve an organic society." By following Wright's blueprints for urban planning and construction, modern man would reestablish his internal tranquillity and find true freedom. The triumph of organic architecture leads to the triumph of the individual and to the regeneration of society.

This was Wright's message as Zevi interpreted it and as he strove to explicate it for his fellow countrymen after the war. Below I shall consider the place Wright holds among the great modern architects. We shall see how Zevi's veneration of this genius constitutes a polemical attack on every aspect of contem-

porary architecture, represented principally by Le Corbusier and Gropius, and must be situated among the vast current of ideas in the Anglo-Saxon world, which tries to set itself up as the arbiter of human folly. The important thing is to show how the doctrine of organic architecture consecrates the arguments advanced by Giedion and Mumford and how, in contrast with the attitude of Laborde and Cole — which gave rise to the theory of the reconciliation between art and industry and functionalism — and in contrast with the less brilliantly rendered but nonetheless inspiring doctrine whereby modern beauty is identified with the laws of the machine, there is a third interpretative movement of mechanized society, which is presently in full efflorescence.

According to Zevi, by 1908, Wright had set down the following basic criteria of organic architecture: simplicity (which should not be confused with a reduction to essentials and rationalist streamlining, a new quality to be embraced by the modern period); no machine-defined style (avoiding all anonymous and standardized styles, the architect must keep abreast of and express the infinite variety of human needs by relying on ever newer solutions as suggested by ever-changing conditions); the organic quality of the building (as defined by the artist's work, true architecture is creative freedom, that is, poetry, that is to say, inspiration: "*For you Europeans, I am really Earth's emissary inviting you to leap into the future*"); harmonization of color with natural forms (in this regard, cubist Europe can be credited with taking the first initiative, in particular the Swede Eric Asplund who, around 1938, was purportedly the first to incorporate painterly colors into a building's composition; nevertheless, Wright himself was indebted to the teachings of the Chicago school for his sense of organic decoration and for his familiarity with Far Eastern architecture); authentic materials (leading Wright to protest against a French and, to a certain degree, German tradition whereby Man indiscreetly in-

81

sinuates himself in everything); and lastly, the construction of a house with its own distinctive identity (that is, not subject to any preset intellectual representation).

One cannot help seeing this program as a rather naive reaction by the barbarian, disquieted by any constraint and any discipline which may threaten his precarious liberty, against the century's great human experiment in which he is taking part. In the final analysis, what Zevi's books make abundantly clear, as we shall see, is that the works completed by Wright, who is incontestably a great architect, were part of a series of international experiments. The exaggerated and polemical apologia in these works is itself part of the already long history of man's reaction to the machine. If it is used to highlight every other sentence, it cannot be separated from its context, which is as much sociological as artistic.

Wright's declaration of independence presents itself as an episode in the great and legitimate effort undertaken by the United States to endow itself with national traditions, even if in the present and by simply negating its European heritage. It is also one of the most impressive examples of the new ideology that bluntly sets good architecture and good society — that is, architecture and society yet to be constructed — against bad — that of predecessors. Like the theses of Mumford and Giedion — who, along with Zevi, are the best exponents — it is based on the belief in a necessary regeneration of humanity. A good architect, Wright tells us, will resolve the central contradictions that have beset man in the wake of rationalism as a result of the predominance of technology and science in modern education. In short, biology will displace geometry; Wright will displace Le Corbusier. The time has come to give a human sense to beauty.

The romantic age, in which it was impossible to reconcile the machine with human tradition, and the functionalist age of mathematical and geometric purism will be followed by the era in

which man will undertake his liberating return to respecting the laws of life. Zevi develops the essence of Wright's ideas in two theoretical works that define a new age of architectural space. This age will be marked by the interior space of an edifice taking precedence over its exterior space. Instead of being built to fit a rigid geometric plan, a building will conform to the habitable space desired by the user as constructed by the architect — who is no doubt indebted to the psychoanalyst for his ability to discover each individual's needs. Instead of being a closed and constricting framework, the building will serve as a dynamic scene where an open concept of the world can be expressed. As we shall see, it is an ingenious concept in which intellectual anarchism blends splendidly with a faded aestheticism characteristic of Victorian culture, of which, ideologically, Wright is a rare offspring.

Good architecture will make a good society. Too often in the past, Beauty was the opposite of Common Sense. Now the time had come to find the meaning of Beauty. To that end, organic architecture replaced geometric order with biological order. It would reconcile the contradictions between Nature and the human heart because it would appeal to man's instincts. While barbaric Europeans continue to build houses from general blueprints, new American architectural layouts draw on individual and fantastic impulses. American architecture expresses each individual's desire to be at ease in his home. Each functional space, constructed to satisfy the demands of its inhabitant, is designed in relation to other spaces and, ultimately, in relation to the immense space of Nature, according to a law founded on nothing more than one's feelings. Organic architecture is an architecture of man in movement. It strives to achieve a communion between man and nature; it allows man to indulge freely in his leisure pursuits. First, the architect assesses his client's spatial needs according to his activities and tastes. Art is considered the accurate assessment of a sum

83

of relationships that unite the individual with his surroundings. In its simplicity and freedom, the building is an organic structure that achieves its optimal form when it is perfectly attuned to concrete human intentions. The materials are used for what they are: color harmonizes the work with the natural forms surrounding it; the overall design is a free-flowing open plan; and the exterior is closely modeled after the interior — all of which overturns the underlying precepts of execution more than the rules. A house will be a materialization of the psychic state of its occupant, unless, more modestly, the Wright style is viewed as an extension of the colonial style among a nation of extremely rich nomads — without denying that some of his creations were indeed ingenious. Wright's theory espoused the principles of a good and consolatory nature, the house as refuge, the cult of leisure, and attention to the vigorous spirit of life — in short, the whole of romanticism. Imagine, if you will, that in order to assure everyone's isolation and independence, every private house will be situated — in Broadacre City — on a 4,000-square-meter lot of land! In short, a potpourri of nineteenth-century doctrines, set to fit a made-to-measure psychoanalytic scale. This in no way detracts from the quality of most of Wright's creations but places him, theoretically, among those who represent the culmination of experiments carried out over three or four generations rather than among the prophets. Humankind of tomorrow, even with the atomic bomb, is not modeling itself intellectually on the principles laid down by American technocrats. It is unfortunate that Wright and his apologists often do no more than adopt the ideological themes of anti-classicism, although their intent was to set forth the elements of a new aesthetic doctrine.

These judgments derive from an examination of the developmental stages of twentieth-century architecture, not from a critical debate. What is important here is to show the origin of the

ideological stance that currently plays an enormous role not only in the development of theories on the modern relationship between art and technology but also in the positive development of architecture, urbanism, and contemporary sociology.

What is more, the organic architecture movement does not seem very different in principle from the rationalist movement it denounces so vehemently. It takes up the same basic themes on the heterogeneity of art and technology. Art against technology, art reconciled with technology, art associated with technology, always caught within the same circle in which Art and Beauty are considered stable sources of inspiration to be adapted to fit the needs of the moment.

For half a century, the social and aesthetic ideas of the nineteenth century have continued to play a dominant role in theories on the relationship between art and the machine. Never has the relationship between man's modern activities and his aesthetic aspirations been concretely analyzed. There is a desire to continue to explain the phenomenon of art in the industrial development of societies, using a psychological framework from the past. The generations that linked art and technology, like those that divorced art from the machine, those that put their faith in geometric and rational solutions, those that believed in an irrational and biological solution, did not escape the restrictive circle of traditional formulas.

Instead of attempting to determine to what extent and how new technology altered man's means of acting upon and representing the contemporary world, theorists continued to think of abstractions like Art, Society, Machine, and Technology as attributes of man in the absolute. In all of these conceptions, the work of art appeared either as an object that lay outside practical human activities or as the irrational emanation of a mystical function that, depending on the whims of Nature, superimposes itself on

other human activities. Imagination is unpredictable ... Art thus appears as the product of a solitary activity that develops first in the abstract and then sometimes materializes itself. In this respect, the great debates on art for art's sake or on the subject, form, and content appear, ultimately, as variants on the same attitude. Inevitably, questions arose as to how the enigmatic force of Beauty could be spread without sullying itself in man's ever-opening society; and it was wondered whether it was really necessary to integrate art into a society that had no use for it. This was the problem posed in particular by Jean Cassou, who, in his fine book *Situation de l'art moderne*, concedes that the artistic act is something of an anomaly in the contemporary world. On the other hand, there are ever-widening circles of technologists striving to find a concrete link between their specialized disciplines and their interest in past or recent forms of art. Obviously, those in the industrial sector today are far from being the true defenders of a lively artistic culture; for the time being, they mainly contribute curiosities — sometimes prompted by a desire to generate publicity or out of concern for cost-effectiveness — which has very little to do with disinterested theorizing. However, their attitude justifies my intention to establish that, far from being a mythical monster, art is, in these times more than ever, a concrete and necessary form of action — while reserving for a separate study an examination of the meaning and spiritual function of the work of art once it has been created.

# Technology and Architecture in the

# Nineteenth Century

*Functionalism and Architecture*

The preceding overview might give the impression that we are dealing with a state of utopia. On the contrary: the great theories summarized arose from the practical development of a highly material civilization that transformed man's way of life before giving rise to its ideologies. The problem of the relation between Art and Technology was first approached in works that served to support theory. Nevertheless, and even though it was sometimes artists — architects in particular — who formulated doctrines, there was always a lag between original intentions and final creations. Theory and practice did not always proceed at the same pace. To understand the dual lesson of doctrine and practical application, it is indispensable to compare works with principles.

The first part of this book will deal only with the development of architecture. The prime reason is that, quite naturally, builders were the first to be forced to make regular use of industrial products. The relations between technological developments and the figurative arts stem less directly from the spread of technology into daily life. A painter or a sculptor can use the language of his art to express values from contemporary life — as I shall attempt to demonstrate in the following pages. But before analyzing the

new relationship between the arts and other human activities, it is indispensable to point out the impact that mechanization had on architecture, that most primordial form of aesthetic activity.

And so we are faced with a complex situation inasmuch as the evolution in ideas and the development in practical applications of mechanization occurred simultaneously. Man, the artist, did not find himself confronted overnight with an all-encompassing phenomenon — a perfected and full-fledged medium of action. Only little by little did he realize how profoundly his activities had been transformed. It was as much a question of the artist designing the machine and deciding which direction the technologists' inventions should take as a question of the artist himself benefiting from these efforts. There was a continuous exchange between theory and works. And so there is no way truly to assess the problems that beset art as the machine appeared in areas of human activity without also examining mechanization's ideological and practical impact in relation to the artistic technique that makes the most direct use of mechanical and industrial equipment. I shall thus attempt to give a rapid overview of the stages of mechanization in architecture.

Once again, the works of Mumford, Giedion and Zevi are the most complete ever published. To these must be added the slightly older works by Nikolaus Pevsner and Walter Curt Behrendt. It is unfortunate that the French have no comprehensive work devoted to this area. The few architectural historians have continued to entrench themselves in academic doctrine. Though brilliant in many parts, none of the works just cited can be characterized as an objective source of information. As discussed earlier, the book by Giedion focuses on glorifying the role of the machine, while that by Zevi uses history to vindicate Wright's organic functionalism. What is needed is a work that has a broad historical scope and gives an overview of the many published studies. In the future, it

will be difficult to ignore the issues that arise from universal developments in the arts and other human activities. In the past, it was possible to write a history of Roman art or classical art by examining works from regions that were relatively close to one another. But now it is no longer legitimate to present a general survey with a continental perspective; and the assessments by Mumford, Giedion, Zevi, and the like all suffer from an obvious bias toward the New World. Their studies offer a case history of the United States, if not of North America. Knowledge of events affecting Europe is often lacking among these writers as soon as they step out of the strict realm of construction. For example, Zevi passes over the aspects of French movements that led to the Gallé style and art nouveau. Germany is totally ignored. And the important, albeit recent, role of South America is not even mentioned. Men like Loos are totally slighted. In this light, it goes without saying that it is very difficult, at present, to give due regard to the role of each builder and theorist in developing an architecture linked to modern mechanization. At best, it is possible to give merely an overview of the problems and suggest paths of inquiry, which are certain to prove both compelling and precarious.

The theories on the history of mechanization in modern societies betray some basic attitudes: reconcile the arts and industry; integrate the values of the arts and industry, either conceptually, which some denounce as the worst possible mistake, or biologically or organically, which others see as corresponding to outmoded ideologies of Life.

When viewed from the perspective of buildings actually constructed, a more complex reading becomes possible, one that confirms numerous smaller steps in the mastery and interpretation of the mechanized world. In short, it may be said that the machine was discovered by architects on several occasions in the past two centuries, and, with each rediscovery, they derived further

material possibilities from aesthetic laws. Thus there are two parallel histories, that of modern construction and that of architectural functionalism.

### The First Phase: Architecture and Industrialization, 1750–1850

Giedion has described the advance of steel architecture, starting with the molecular research undertaken by Abraham Darby between 1747 and 1750. The first experiments involved bridges: the bridge over the Severn River, 1775–79; Sunderland Bridge, 1793–96; and Marc Séguin's suspension bridge in Tournon, 1824. Also noteworthy are the frames of 1786 by Victor Louis, who discovered the moment of inertia, and the frames of 1811 for the Halle au Blé in Paris. Indeed, bridge projects for London in 1801, storehouses for James Watt's new cloth works in 1801, and, above all, John Nash's Royal Pavilion in Brighton in 1818–21 mark the advance and the limit of the first attempts to incorporate new industrial products into architecture.

The use of iron in place of stone did not immediately lead to profound changes in the general design of the building, its system of equilibrium, or even its appearance. The creative formulas of the past were not rejected. Architects did not yet envision a new type of building. To solve certain general problems, they used metal parts purely and simply as substitutes for wooden pieces. Buildings were not designed on the basis of new materials. The materials themselves were forced to comply with demand. This could not truly be called industrial mass production. In all areas of new production, the overriding notion was that of replacement. The paramount concern was to increase the resistance of materials. The first impetus for industrialization in Great Britain grew from the need to replace increasingly scarce raw materials: wood and wool.

## Solutions and Obstacles

For nearly a century, new techniques were called on almost solely to increase loading and to reduce supports. Two such examples are the Bibliothèque Sainte-Geneviève and the Bibliothèque Nationale built by Henri Labrouste between 1843 and 1868. These buildings were unsurpassed for several generations: the diameter of the dome of the Bibliothèque Nationale is larger than that of Saint Peter's in Rome. They offered solutions to problems that remained unsolved until new materials had been acquired. But they also illustrate one obstacle to invention.

It is easier to make materials conform to earlier forms than to define new programs to meet the needs of a society that suddenly has better materials. In certain respects, the more limited early experiments were closer to a new style: the Severn bridge anticipated the abutment system used in current bridges. Specific technological factors were applied, especially in the beginning. Perhaps the Tournon bridge is the only example of challenges being met by drawing directly on technological elements. The forms created here were logical extensions of the application of mechanical means: the figurative is subordinated to the technological. From this perspective, the extraordinarily bold use of iron to create classical forms, or the Crystal Palace in London (1851), is less advanced. Rather than searching for forms that could be generated from the arrangement of large plates of glass, the architect remained faithful to the greenhouse model. He did not realize that the glass panel cleared the way for new types of volumetric systems.

Even the development of cast-iron frames did not profoundly alter such architecture. The frame continued to be conceived in the spirit of the Renaissance, closer to Philibert Delorme's work than to the construction design of today. There was a faithful devotion to the way the construction was conceived. Giedion

believed he had pinpointed the decisive break in the "balloon frame," which was practiced in the Chicago region around 1835. However, that was a method using mass-produced wooden parts to erect the shell of medium-sized utilitarian buildings. The system is merely the application of the mortise-and-tenon joint methods borrowed from carpentry.

The advent of the cast-iron column, which marked the passage from an experimental phase to the beginning of the industrialized production of prefabricated parts around 1850, was still not enough to liberate modern architecture. Like the Crystal Palace or Labrouste's libraries, neither the Harper & Bros. building, constructed in New York in 1854 by James Bogardus, nor international projects to transform central marketplaces, ranging from Les Halles in Paris in 1824 (project for the Madeleine) to the markets projects of 1855 (by Victor Baltard, Hector Horeau, and Eugène Flachat) and London's Hungerford Fish Market of 1835, alter the fundamental aspects of the problem. The adoption of an iron frame could be reconciled with traditional construction. In 1894, the Renaissance and the Gothic were still rivals, as in the Tower Bridge, which is the masterpiece of this hybrid style born from the application of a new technology to tradition-inspired ideas and forms.

Early-nineteenth century architecture is a remarkable example of a technique used to satisfy needs arising from another body of knowledge, different tools and equipment, and another way of life — the classic first phase of adaptation. Remarkably, this phase cannot be delimited between two precise dates. For quite some time — and almost until today — the desire to preserve the past and integrate it into modern architectural techniques has preoccupied theorists and builders alike. It is easier to increase the production of old-style objects than to design new ones. It is also easier to adapt materials to fit new economic constraints than it is

to find new uses. New technological methods do not immediately lead to aesthetic theorization and a reversal of the existing social and intellectual system.

Labrouste provides an illuminating example of the difficulty of adaptation, for there was a discrepancy between his lucid theorizing and the projects he completed. As a young Prix de Rome recipient visiting Paestum in 1824, Labrouste was undoubtedly the first to have formed an abstract conception of functionalism, that is, of the unyielding opposition between historical styles and the discovery of new materials and technologies. However, he gives only a faint indication of this understanding in his two great Paris libraries. His method of combining technology with historical styles in these altogether masterly works would slow up the rise of modern architecture for a century. The predominance of structure over decor did not rule out a neoclassical exterior. The weak point of this conception, particularly evident in Sainte-Geneviève, is the almost exclusive application of functionalism on the upper section. The Bibliothèque Nationale represents progress in this area, but it does not surpass the Crystal Palace: there is no striving for a new, open plan, articulated to suit needs, but simply an absolute expansion in covered and illuminated surfaces. The glass conservatory system still prevailed.

Thus the theories of Laborde and Cole are testaments of a long-standing attempt to unite art and technology, culminating in the famous conciliation theory — which, in reality, leaves the two forces in opposition, neither one yielding to the other, without proposing a larger vision. Given that iron, which had by now become a revolutionary material, was used for large sections placed on traditional wooden beams, it was only natural that it was first thought of as a substitute, whose chief interest was that it could exceed limits of resistance and therefore be used to construct buildings of exceptional size. Moreover, since iron is generally

linked with glass, the problems posed by walls, surfaces, and decor seemed to have been finally resolved.

The mechanical applications of technology gave rise to far fewer problems than did the social integration of the new possibilities it presented to the outside world. Society's reluctance when faced with the revolutionary consequences of new materials — which broke with the traditional pace of production and altered the living conditions of individuals and communities — acted as a blocking mechanism that was set off whenever there was a potential for humankind to transform the world. The blockages are always social, not intellectual.

## The Advent of Industrialization

Giedion showed how another, purely industrial factor took shape at the very time the doctrine advocating a necessary union between the arts and industry was being formulated, that is, around 1850, at the end of the first phase of the introduction of technology into classical architecture. It was the crucial moment when, as factories manufacturing laminated products were developing, standard forms were being turned out: cast-iron frames, which brought decorative forms to mass production, imposing historical styles on a worldwide scale. This marriage between new technologies and tradition was largely dictated by the tastes and predilections of one social class, which was motivated by conservative social and political nostalgia, even though it would come to realize that in the future the real source of power would reside in industry. By no means was this conflict between the arts and industry attributable to a complementarity between the two. There was no way to confuse them. These activities were carried out on two completely different levels. There was therefore no reason why industry should prevent the modern development of

the arts, provided that industry's ascendancy not be linked to maintaining an outmoded formal tradition. The application of the cast-iron column to the Gothic and then the Renaissance style resulted not from a predetermined harmony but from the fact that master forgers from the mid-nineteenth century sought to benefit financially from mass production while simultaneously seeking to defend the Gothic and Renaissance styles for ideological reasons. Because art was seen as a higher value and as a force to be kept out of the hands of the masses, there was a full-fledged effort to put off the moment when new technologies would express new activities and values.

It would be unfair to suggest that the ruling class's reluctance to embrace modern art forms was due solely to pure self-interest. The economic and mechanical consequences of the discovery of new technologies had obvious practical repercussions: every day, the application of new procedures made it possible to produce new devices and materials; it offered the evident industrial potential of mass production. In contrast, the intellectual, social, and aesthetic consequences of new technology were not clear. Theorists were divided, and artists were not producing works that seemed to bear out a new style. It has already been pointed out that Labrouste did not give concrete expression to the principles he so lucidly elaborated. It has also been shown that between Laborde, who defended a conciliation of art and industry, and Cole, who advocated the idea that in industrial production every object must fulfill an intended purpose, the basic principles were virtually in opposition. The former wished to keep original artistic values intact, in the face of new forces unleashed by the machine, whereas the latter pointed up the gap that separates industrialization and culture, while wondering if the new priority placed on knowledge and work would fatally undermine the principles of taste, thereby suggesting that a break with tradition might occur.

This conflict prompted by new technologies was in evidence well before 1850. The first crisis on the economic front occurred in France during the Revolution, on the day in 1789 when crowds on the boulevards destroyed Réveillon's printed-paper works. Saint-Simonianism developed entirely from an attempt to interpret socially the impact of industrialization. The creation of the Ecole Polytechnique in 1794 and the Ecole des Arts et Métiers in 1799, had already stripped the Ecole des Beaux-Arts of its place as the exclusive center of training for architects in France by setting the ideological and scientific aspects of the art of building in dramatic contrast.

However, a century after the first decisive technological inventions, the situation was wrought with ambiguity, but, on the whole, the common opinion always set art and industry in opposition. On the one hand, technology had made enormous strides: from textiles to metal casting, artisan machinery in the eighteenth century underwent transformation, creating powerful instruments capable of inaugurating mass production. On the other hand, the growth in output, especially in architecture, led to increased demand and enhanced mechanical possibilities, without giving rise to a new style. Just as the masses were denied access to the new city, they were also denied access to revolutionary solutions in the area of taste. Artists themselves did not discover forms derived directly from the possibilities presented by new materials. They only knew how to build on past forms.

In the first phase of his technological experience, man sought more powerful methods through science, without using this force to distill a new way of viewing the outside world. He remained the same man but more powerful. That is why, at first, there was no new style. While engineers were giving society textile works, mechanical mills, and the locomotive, artists continued to depict another universe that did not include the new facets of knowl-

edge. From there stemmed the opposition between the decorative and the structural, which would overshadow building construction as well as the application of the arts to daily life and which not only would spark the rise of functionalist theories but would lead to the success of the great international expositions.

### The Second Phase: The Problem of Functionalism, 1850–1900

Although I set the period around 1850 as the moment when a number of advances in technology crystallized, this date cannot be considered either the culminating point or the absolute starting point of new technology's penetration into economic and artistic life. Although I shall acknowledge successive phases in the simultaneous development of technologies, industrialization, and aesthetic ideologies, I shall not attempt to establish precise dates. We have already seen how men such as Labrouste created projects conceived in their youth that were barely influenced by later events. Thus we cannot define a typical form for 1850–1900 any more than we can for the 1950s; however, it is possible to present representative attitudes and individuals and compare them with a new general attitude toward the machine. It will be seen that in the second half of the nineteenth century new functionalisms emanated from less innovative — though still universal — advances spawned by the spread of technology.

I would surely fail if I sought to explain the evolution that led to the theories of Loos and Paul Souriau replacing those of Laborde and Cole by isolating the development of technology or of aesthetic theories. As I did when dealing with the turn of the century, I shall attempt to present the developmental steps with respect to both ideas and architectural facts.

97

*New Objects*

The central event in the history of practical applications was the entrance of the New World into Western civilization. The principal merit of the works by Giedion — and of studies on the American style by Mumford and several of his compatriots — is that they elucidate this point.

Already in 1854, Laborde had predicted the imminent inclusion of North America among the major industrial powers. The pathetic appeal made by Lucien-Anatole Prévost-Paradol on the eve of the war of 1870 marks the moment when Europe became conscious of the existence of a new country, which had emerged from a merely colonial existence. Over the course of these years, there was an enormous effort in America to point up the features of a new "tradition." This effort was somewhat contradictory, relying on two points of view. Some individuals, like Giedion, emphasized America's absolute independence in the area of invention by showing that around 1860 it had developed unprecedented tools and objects, derived from the application of modern technologies. Others, like Mumford and Hugh Morrison, sought to demonstrate the existence of an older American tradition, dating back to the centuries when the continent was first conquered — a tradition apparent in the general principles of a national architecture. This second view actually diminished the importance of the link between the developments of modern architecture in the United States and modern technological advances. There seemed a greater concern to show the existence of an older national consciousness to attribute to the United States the role of precursor in the realization of the technological possibilities of the modern world.

The pages in which Giedion advances his argument that the United States took the lead around 1860 in applying technology to materials used in everyday objects are among the best he ever

wrote. They are original not only in their conception but also in the abundance of new material presented.

From 1848 to 1870, the use of cast iron for architectural columns developed in the United States and elsewhere. The use of this standard material coincided with the worldwide prevalence of decorative designs from the Middle Ages and the Renaissance. Around 1850 this movement led to the above-mentioned building by Bogardus (the Harper warehouses in 1854, which combined the Venetian style and cast iron) and, prior to 1870, to the docks of St. Louis — the great metropolis for the cotton trade on the eve of its decline, following the Civil War, when the North and industrialization triumphed. Similarly, technology-based inventions such as the Otis elevator (1853) included decorative details borrowed from historical styles.

However, areas of light industry consciously and systematically attempted to adapt forms to utilitarian objects without reference to their traditional look. In the industrialization of everyday objects, there first appeared the concepts behind the logical application of new possibilities in metal casting toward new and well-thought-out ends. Giedion showed how the opening of prairies for agriculture around 1850 led to the mass production of land-clearing tools. These tools were still adapted to work done by hand and to ancestral types of manual production. At a time when everyone was complaining about the disappearance of good craftsmanship and the poor quality of molded objects, America was providing the first examples of tools designed according to the materials used, while implementing modern means of production. Giedion cites two series of remarkable examples. First, entirely utilitarian tools: axes, picks, planes, and such, whose forms were distinct from tools that had been used for centuries. No longer was there an attempt to create cast-iron reproductions of earlier objects whose forms had been dictated by older techniques

and means of execution. Now the aim was to produce objects that complied as closely as possible with the new conditions of human labor and that derived from a recalculation of the user's gestures and from improvements in mechanical production. Second, Giedion contrasted these tools of unprecedented forms with the simultaneous triumph, in America and elsewhere, of the upholsterer's style — which, for three generations, had laden bourgeois interiors with objects, while disregarding the rational use of materials and any notion of economy and balance — inferring that America was the first to define the underlying conditions of a functionalism based on new materials and mass production. As mentioned above, he also stressed the importance of the earlier revolution brought about by the manufacture of locks: the replacement of the simple or reversible cotter pin with a row of pins on springs or a shaft used to transmit motion by rotation, thereby paving the way to a new era in mechanical design. From then on, the aim of the machine was no longer to reproduce or simply enhance manual gestures; its aim was to produce an effect by operating on other levels.

Giedion also observed that around the 1860s two new trends appeared: one trend tended to replace old implements with modern ones, which corresponded to a new conception of potential ways of exploiting materials — be it an elevator or a lock; the other trend was a response to economic theory, foreshadowing "scientific management."

In 1785, when mechanizing the mill, Oliver Evans noted that on the day the worker only directed the autonomous movement of the machine instead of using it as a tool to augment the power of his hands, new relationships between man and materials were defined. From then on, a new representation of man's power at work confronts the purely quantitative concept of production growth. In the automated mill of 1785, wheat moves mechani-

cally by its own weight, without the need for constant manual intervention. The rationalization of biscuit manufacturing around 1804, the transformation of the Bodmer textile works in 1833 and of Manchester textile works in 1839 — through machine tools, the mobile crane, and the traveling platform — and, finally, the Cincinnati slaughterhouses in 1860 also illustrate that there was a growing consciousness that the machine not only augmented man's physical power but also affected tasks in every realm of the imagination. The simple notion of industrialization was outdated; the groundwork had been laid for the notion of rehabilitating man through his practical use of materials.

As the practical uses of the machine were extended, the opposition between invention and organization became more acute. The aim of technology was no longer to procure greater resources in the name of an older practical and aesthetic order; technology was now a rival, offering its own organizational principle, in opposition to older patterns of human activities.

The importance of Giedion's views is undeniable. The question that remains is one of determining whether he was correct in giving credit to America for this intellectual advancement and whether it was truly a simple fait accompli leading irreversibly to a monstrous mechanization of humanity. It is not easy to respond to this point on the basis of available facts. As mentioned earlier, the architectural documentation for other countries is not as complete as that for America. Although I shall return to the problem of the plastic object, I will point out here that there is nothing in Giedion's studies that supports the notion that American functionalism was ahead of European functionalism in 1860. America, in its agricultural development of the Middle West, does not appear, a priori, more advanced than Europe in the appropriation of industrial technology. As we shall see, it was only toward 1880 that America caught up with European industrialization.

Moreover, the best architects and theorists came to Europe for their training.

## The Case of Greenough

It is true, as Mumford claims, that America was home to one of the most remarkable aesthetic geniuses of modern times: Horatio Greenough. Greenough was a sculptor who, at first glance, appears the epitome of classicism and academicism. Although he apparently spent half of his life in Rome, his genius was absolutely American. Moreover, it was not his Canova-style figures of prominent men — a *Washington as a Roman Emperor* that was outdated even for its time — that justify his current celebrity. Rather, it was his writings, in which he is apparently the first to have formulated the rules and laws of utilitarian Beauty. He is seen as having written, along with Leo Tolstoy's *What Is Art?* and Ruskin's *On the Nature of Gothic*, one of the nineteenth century's rare works of genius in the field of aesthetics.

In the history of American art and taste, Greenough thus stands out as a reaction against the neoclassical and Georgian styles emanating from the Roman and Parisian movements at the end of the eighteenth century. He sculpts like Thorwaldsen, but he thinks like Rousseau and Bernardin de Saint-Pierre. His progression from eclecticism to naturalism still did not seem very original or promising in 1850, even if one is struck by the similarities between his writings and those of Georges Combet or between his style and that of Asplund or Alvar Aalto. God's world possesses, he stated, a distinct rule for each function; man does not create forms, he discovers them by following principles that enable him to place himself within the great plan of creation. Beauty and character become one and the same. The artist, and especially the architect, must imitate the functionalism of animals. Monumental architecture must reflect the faith and traditions of the people;

civil architecture must remain faithful to the practices of the masses. There is a final purpose behind every human activity, allowing the artist to liberate himself from corrupting formalisms and place himself, through sympathetic identification and emotion, in close contact with social life. In fact, this was an elemental form of romantic naturalism, a rudimentary compromise between Rousseauism and ideas drawn from discoveries by Cuvier, Darwin, and Lamarck. Greenough's artistic philosophy does not seem at all a forerunner to that of Laborde; and Mumford's argument only holds when it aims to show that Wright had distant forebears in his own country. His argument completely contradicts itself in asserting that the original renewal in functionalism occurred at the beginning of the twentieth century. It cannot be simultaneously claimed that Wright's biological naturalism is revolutionary, characteristic of these times, in reaction against the nineteenth century and that it emerged full-fledged around 1850 as Greenough's brainchild.

While avoiding formal debate, it can be simply stated that, among recent historians of American architecture, opinion seems divided. In 1850, there existed, on virgin soil, men who were shaping a naturalist philosophy of architecture; moreover, America was the first country to devise a new architecture based on the technological imperatives of the machine — an architecture that scored its initial triumph around 1880 in Chicago with the first skyscrapers. This all remains extremely muddled and contradictory. Words like *functionalism* are used alternately and sometimes simultaneously with opposite meanings. It is more like nationalism than history. The idea that should be retained from these studies is that in the United States as well as in Europe the advance of the machine was not promoted by aesthetic thinking, which came only confusedly and belatedly to stimulate the infusion of new technologies into the societal process of construction.

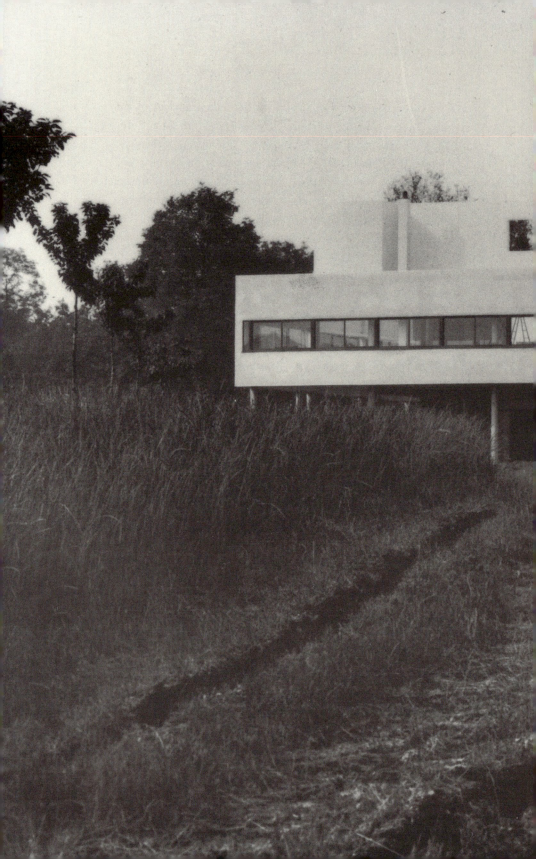

Figure 5.  Le Corbusier, Villa Savoye in Poissy, 1929–30.

Technology gives free rein to the imagination. By the 1930s, surfaces and articulated volumes had transformed the house into a maneuverable and, to some extent, mobile "figurative object" (by placing the viewer outside and inside the system). The new plastic replaced encasement or spatial staggering with articulation. The house became a system of combinatory forms. (©1999 Artists Rights Society [ARS], New York / ADAGP, Paris / FLC. Photo: Fondation Le Corbusier, Paris.)

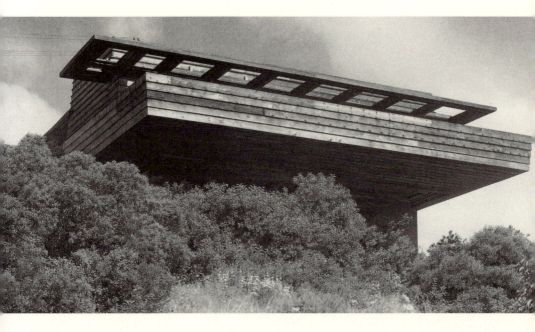

Figure 6. a. Frank Lloyd Wright, Sturges House in Brentwood Heights, California, 1939. b. Frederick C. Robie House in Chicago, 1909.

Twentieth-century architectural plastic art grew from a set of guiding principles, like a style. At the beginning of the twentieth century, for all innovative architects, the house was no longer considered a cube of four rigid sides set at right angles. The first exploits laid the groundwork for theories that have continued to influence certain particularly expressive and striking creations. In Wright's works, dynamism and boldness of expression prevail over static forces. Style allows the expression of artistic temperaments. (a. Special Collections, Stanford University; b. Courtesy the Frank Lloyd Wright Archives, Scottsdale, AZ.)

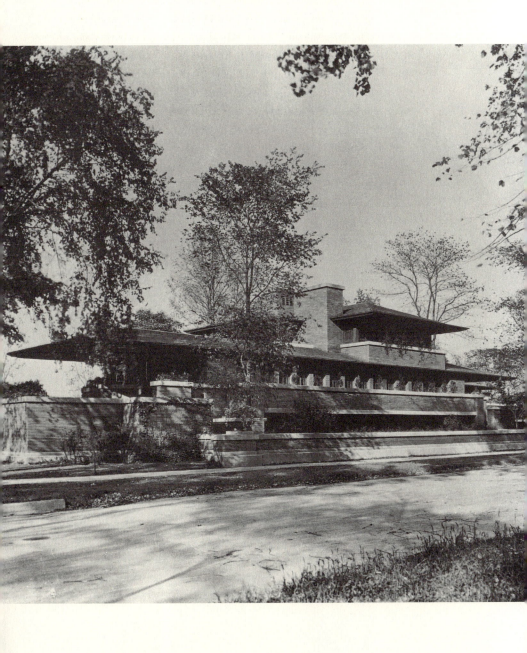

In the 1860s, in spite of several exceptional accomplishments, the New World did not yet play the role of initiator in relation to the Old World. In fact, throughout the end of the nineteenth century, in America and elsewhere, there was a pervasive wave of reactions that perpetuated historical styles, placing forerunners in a constant struggle and frequently forcing them to accept compromise. Giedion and Zevi have convincingly demonstrated that avant-garde architecture, represented by Louis Sullivan, Wright's mentor, was vehemently rejected by America in 1893 at the Chicago Exhibition, where the international historical style, foreshadowing the tastes of Hollywood, triumphed in its most aggressive form. No less in America than in Europe, modernity could not yet claim victory.

The attempts by Giedion and Mumford to identify the decisive moment for modern architecture by focusing on American activities and ideologies of the 1860s are therefore debatable. They are based on a series of assumptions — namely, that present-day organic architecture is the only truly modern architecture, that American precursors from the mid-nineteenth century worked in complete isolation from European influences, and that these Americans scored their victories easily and rapidly, without criticism or reservations. These theories also promote misconceptions of the meaning and role of the term *functionalism*.

In Europe and in America, turn-of-the-century architects wanted to create new forms that were in keeping with technological progress. They used the term and the notion of functionalism to justify their efforts, but few of them were in agreement among themselves, nor did they uniformly embrace the vague theories cited by Giedion and Mumford as representative of the new spirit. It will no doubt be countered that it is we, today, who will finally decide which were the truly vital forces of the past century and in this way identify which were most decisive in determining the

course of history. However, once again, this presupposes that there exists a "good" form of art and civilization that was sought out by those on the side of the good, whereas those on the side of evil took another route. It must be assumed, furthermore, that this form is certain to prevail, thanks to America's favorable standing throughout the world. These Wright-like theories betray not only a sense of national pride but a sense of Crusade. From the perspective of those not wanting to justify an exclusive form of culture but seeking simply to trace historical developments, matters present themselves differently.

## The Teachings of Viollet-le-Duc

It is surprising how little regard is paid to Viollet-le-Duc by American theorists. It is likely that his works are not in the holdings of the institutions where Giedion, Mumford, and Zevi obtained their documentation. In all fairness, the creator of the neo-Gothic style hardly seems, at first glance, an important connecting link in the chain of new architecture. However, it is highly recommended that Zevi, in particular — who had no qualms about writing that the future of modern architecture is tied to Anglo-Saxon culture, founded on engineering experiments — read *Entretiens sur l'architecture*, which comprises lectures given at the Ecole des Beaux-Arts in Paris and has dominated the training of all architects throughout the world for eighty years.

Viollet-le-Duc, much more so than Greenough, was a self-taught genius. By expanding on the principles of Gothic architecture, he believed he had discovered not only the laws that governed the design and equilibrium of medieval monuments but also laws that were equally valid for the modern world. Viollet-le-Duc's contribution to the universal understanding of the problems of architecture is twofold. By examining the principles of equilibrium underlying Gothic cathedrals, he derived a system

that drew more on the buildings of his time than on the cathedrals themselves. A few years before the Second World War, Pol Abraham pointed up Viollet-le-Duc's error in his interpretation of the dynamic Gothic plastic principles: essentially, Viollet-le-Duc based his calculations on factors that could only have been applied by architects using iron-skeleton frameworks. His notion of a building's supposedly active equilibrium does not take into account the earlier rules for counterbalancing stone monuments, which were built using numerous scaffolds; and the monument's pointed arches and vaults essentially rested on vertical piers and were held in place by the convergence of vertical weights and strains. Viollet-le-Duc's idea, in which the flying buttress served as a brace that actively and almost rationally applied a force at the precise point where a pier was susceptible to break, is not so much a poetic vision as a logical concept for an architect using an iron-skeleton framework. Viollet-le-Duc introduced to aesthetic theory a notion of material dynamism, which, in plastic terms, meant that new possibilities were opened up for architecture by technology — namely, the use of iron and the application of mathematical advances. In this way, he surpassed Cole and Laborde because he refused to strike a compromise between the arts and industry. He laid down in precise terms what would become the great idea of the end of the nineteenth century: that a beauty resides in the mastery of technologies. It is he, the restorer of Gothic buildings, who was the pioneer of functionalism as it would be understood by the entire world from 1860–70 until around 1930. He considerably surpassed Greenough, who merely elaborated ideas borrowed from the Old World, slightly updating them to appeal to the tastes of his country.

While developing a theory on Beauty based on the counterbalancing of strains and thrusts across space — thus allowing the scientific notions of force and conservation of energy to enter the

domain of art—Viollet-le-Duc also laid down a concept that presented the Gothic style as the product par excellence of collective labor. In addition to the idea that technology determines art forms, there was now the idea that, behind the activities of a whole period, the craftsman represented the true human values and the idea of the work of art. It amounted to an original mixture of Fourierism and a defense of pre-Revolutionary traditional societal structures. Viollet-le-Duc's functionalism cannot be seen as reactionary, since it was founded on notions that sprang from new scientific postulates as well as practical input from the constructor. However, there is a discrepancy between these ideas and what the inventor drew from them in practice. Viollet-le-Duc is by no means the turn-of-the-century prophet of modern art; yet it cannot be denied that his theses—much more concretely than his teachings—had a worldwide influence on all of the practical efforts that marked the development of modern architecture over half a century.

Bearing this in mind, one is much more inclined to concede that it was in America that the boldest attempts were made to supplant the notion of a marriage between historical styles and modern materials by the notion that style should be subordinated to the logical imperatives of technology.

*The Chicago School*
In this light, the documentation gathered by Giedion on the Chicago school and on the great American architects of the 1880s takes on its greatest merit. The only objection, however, is that the practices of the Chicago school are characterized as preparing the way for the Wright style. What we witness in fact is the application of the international functionalism of which Viollet-le-Duc was the first exponent. This fact establishes that, in one circumstance at least, critical thought appears to have greatly influenced

the way modern technologies spread into the artistic and economic life of society.

Three names dominate this period: Henry Hobson Richardson, William Le Baron Jenney, and Louis Sullivan. The first of these architects, Richardson, who was born in 1838 and died in 1886, is representative of traditional movements. Educated in Paris, and a student of Viollet-le-Duc at the Ecole des Beaux-Arts, he was also influenced by Labrouste. Richardson could be characterized, based on his earliest output, as belonging to the old style. He was a romantic who embodied his era's dual protest against classicism and the machine. In fact, it is he who, in practice, exemplifies the attitudes of Greenough — that legend spawned by an irony of American historiography. Suddenly, around 1880, in the last years of his life, Richardson's work evolved, and he participated in two starkly different projects: he was among the first to build the Chicago skyscrapers; and the first domestic, rustic works that rejected the traditions of the colonial style.

The progression of Richardson's work highlights the rupture in American civilization in the 1880s. This rupture was prompted by two highly significant events: the introduction of Bessemer steel — imported from Britain — after the 1870s, which would ensure Chicago's industrial expansion in a prelude to the large-scale industrialization of the country as a whole; and America's accumulated experience of a cultural Golden Age, as illustrated by Emerson, Hawthorne, Thoreau, Whitman and Melville in literature. Works such as *Walden, Leaves of Grass*, and *Moby-Dick* would appear, destined to become America's first classics. Simultaneously, New England and the Middle West would continue their post–Civil War development. In this period, the country found its new equilibrium.

On the whole, Richardson's work does not contrast with the international movement, which, around 1880, had begun replac-

ing a lighter style with a massive style inspired by Gothic and Renaissance works. The libraries he constructed in Quincy, North Easton and Cambridge, Massachusetts, reveal the rapid spread of the taste for the neo-Romanesque, which in Europe had inspired the style of the Dutchman Hendrik Berlage — who was deeply influenced by a visit to America — and led to William II–style imperial palaces, especially the Haut Koenigsbourg and the Poznan. In addition, the Italian Renaissance is visible in the building that established Richardson's enduring reputation, the Marshall Field warehouse in Chicago (1885–87), not so much for its appearance, which is similar to the Harper warehouses constructed by James Bogardus in New York in 1854, as for its mass. Richardson's work is a latter-day variant of the Pitti and Medici palaces. But there is no longer any sense of proportion, either in the volume, the perforation, or the lines of the exterior. His work is evidence that, at that time in the United States, the Western tradition was indeed dead.

American architecture historians claim to demonstrate not that their country took the lead in defining taste but that it was the first to create new forms derived from the technological possibilities of industrial civilization. But as for the rural style and the discovery of regionalism, as well as architectural laws relating to the equilibrium of new materials, there is no evidence of America's independence before 1885.

Neither Richardson's cottages nor his imitations of Roman and Florentine palaces can be seen as milestones of modern architectural history. There is much more originality in the first true skyscrapers built in Chicago by Jenney around this same period, although it is fashionable among the prophets of organic architecture to discredit their importance, even though they cannot be separated from concurrent developments in European architecture. The Eiffel Tower and the Garabit viaduct are no less

daring than Jenney's Leiter Building (1879) or Burham and Root's Building (1891–94) in Chicago. The scorn that the defenders of the Wright style and intuitive architecture pour on Jenney's works is due to his belonging to the movement that inspired what was called rationalism and that was opposed, with more or less good reason, to the new functionalism — biological functionalism — which, as we have seen, would bring about the redemption of humanity.

The first American skyscrapers by Jenney, as well as Richardson's Marshall Field warehouse, were constructed in stone and so, ultimately, are not nearly as bold and are far less modern than the Galerie des Machines (1889), Boileau's Bon Marché (1875), or the Menier factory in Noisiel (1871–72). As was true in France, it was only with the full substitution of iron for stone, by the successors to Richardson and Jenney in America, that the way was paved for a true modern style. But that event occurred only toward 1890. The first American skyscraper after Marshall Field, the Home Insurance Building in New York, constructed at the end of 1883, still made use of a cast-iron skeleton. The true leap forward came in 1885 with the use of Bessemer steel to erect the Carnegie Phipps Steel Company Building in Pittsburgh, increasing the number of stories from six to ten without adding extra load to the outer skin. Lighter steel provided Jenney with the technical solutions that led to the construction of buildings with lighter-weight skeleton frames. Thus Jenney's principal originality lay in his applying to civil architecture technical and industrial solutions associated with the development of contemporary metallurgy. His role parallels and is contemporaneous with that of Eiffel or Contamin. This was not part of a national movement but a stage in the history of technology applied to social needs. To suggest, as is often done, that Eiffel's theories or increased stories ran counter to the best interests of the human race or to state that Jenney was

impelling architecture along a course that would make it impossible for building plans to accommodate modern needs is not to make an argument grounded in facts. Even if the tide of events would eventually lead to the triumph of organic architecture, and even if all buildings that, throughout the nineteenth century, resisted rationalism's spread into the structure of urban space would one day be viewed as glorious relics, the fact remains that for at least fifty years world architecture — and not merely American architecture — was pervaded by a concern for technological rationalism, which inspired the characteristic works of the period prior to the change in attitude in the early twentieth century. It was during this time that the notion of uniting the arts and industry began to be undermined by a theory linking beauty to form, a form that would be the logical consequence of the laws governing production and the use of new materials. The debate is of utmost importance because it hinges on the reciprocal roles played by technology and ideology in plastic creation.

There can be no doubt that toward 1880 America offered exceptional opportunities for pioneers in industrial architecture. The rapid rise of Chicago — supplanting St. Louis as the leader in promoting formerly agriculturally based, and now industrially based, national prosperity — a city that grew from a population of 500,000 to 1 million between 1880 and 1890, while witnessing the six-story Auditorium being surpassed by the sixteen-story Monadnock Building, is the perfect symbol of America's participation in the advancement of international art. As the great railroad and shipping hub, with a gigantic agricultural marketplace, Chicago offered the first example of an urban site expressly constructed to accommodate the mechanical equipment of the modern world. It would be impossible to overestimate its importance or its phenomenal growth. Yet Jenney, like Richardson, had been trained in Europe; he had studied in Paris, not only at the Ecole

des Beaux-Arts but also at the Ecole Polytechnique. His tempera-
ment was colored by two opposing tendencies, one constructive,
the other decorative, as his proctors in France would note by the
beginning of the twentieth century. One can only strongly con-
demn the lack of research and scientific objectivity in works such
as those by Zevi in which the works of Jenney and Sullivan, who
created an avant-garde style seeking to fuse art and technology,
are set in contrast with contemporary movements in Europe: the
English style of 1860, the Belgian style of 1880–90, and, finally,
the "international protorationalism" of 1900–14. The lack of any
reference to French movements is proof of the polemical nature
of their work. It should be pointed out, in passing, that American
writers have always been either better informed or more discreet
than their overly zealous disciple Zevi.

The career of the third great constructor from the Chicago
school, Sullivan, points up the resistance encountered by modern
art in new countries as well as in Europe. After building several of
the great structures of the period, Sullivan came up against public
incomprehension, as mentioned earlier. The Chicago Exhibition
of 1893 did not guarantee the success of the steel-skeleton con-
struction and of decor limited to the structure's new line of force.
To the contrary: it brought about a revival of historical styles in
their most pronounced form. It refused the development of an
art derived from an engineer's calculations and the countless pos-
sibilities for eliminating surfaces.

In no country were adherents won over rapidly and defi-
nitively to the principles of a modern architecture based on the
technological possibilities that the machine and industry made
available to the builder. But at the same time, small groups of
artists worldwide were convinced of the revolutionary practical
possibilities that new technology offered to the builder. The guid-
ing principles were easily agreed on. It would be sheer sophistry

to claim that there is no international body of doctrine that encompasses structures ranging from the Crystal Palace, to several bridges built at the beginning of the century, to the Eiffel Tower and the Chicago skyscrapers and that links aesthetic principles to the industrialization of buildings. An equally international trend can be seen in the regional, rustic style based on small buildings intended for rural lifestyles. That tradition is now gaining new momentum. But even if it turns out to be the new form of artistic and social progress in the coming decades, its success will not detract from the fact that the fates of individuals and countries were, for eighty years, inextricably linked to the fate of industrial cities; nor will it detract from the fact that urban steel architecture exemplifies the leading edge of progress in the arts at the end of the nineteenth century, and it is such architecture that makes it possible to determine the practical relationships that developed between art and technology in this period.

It is surprising that, in all of these historical surveys, so little attention is devoted to one factor of indisputable importance: neither Mumford, Giedion, nor Zevi attributes a significant role to the discovery of concrete. Only tangentially, regarding the Perret brothers and in a more recent phase of history, is it mentioned. Nothing is said about the revolutionary implications of its discovery, either from an economic — and, consequently, social — or from a technological perspective. Although concrete was not in general use until toward the beginning of the twentieth century, it cannot be denied that it made a slow advancement, though obscured by the triumph of steel, during the critical period of 1880–1900. Giedion has pointed out, however, that by 1824 Joseph Aspdin, from Leeds, had perfected portland cement, for which, by 1829, Dr. Fox had devised an application in connection with concrete flooring, patented in 1844; in 1867, the floors of the Paris Exposition were concrete; in 1867, Joseph Monier discovered

the principle of reinforced concrete; and towards 1890, with François Hennebique, the effects of concrete could be calculated.

Once again, there is the pattern of slow discovery and a burst of rapid adaptation. Discovery alone is not enough to implant a technology in a civilization. Society utilizes not principles but practical solutions. It is the men who devise general-use solutions who effect social transformations. For society and science to interact, there must be intermediaries, namely, technologists. For an era to have a particular style, technologists must relinquish their place to artists, who will incorporate technological principles into previously unimagined forms.

Here we begin to see a possible direction of study. There are various levels — scientific, technological, and artistic — on which repercussions are felt. And there is constant interaction between each level. A technological discovery leads to a plastic interpretation, which in turn leads to new uses for an existing material; these in turn lead to new principles and potential applications. It was the development of steel architecture that attracted the attention of builders, who drove demand and devised potential daily uses for new materials; their new focus opened their eyes to the possibility of designing a structure based entirely on a skeleton frame, while using unfinished, unadulterated materials, without any extraneous elements. Concrete then provided the economic, social, and plastic solutions to the problem that arose from the demand for the use of steel. As a consequence, the period that witnessed the progression from cast-iron flanges, which replaced pieces formerly made of wood, to mass-produced pieces that would make it possible to construct lightweight cages that could be erected to any desired height without the support of a solid-mass wall — an evolution directly linked to Viollet-le-Duc's mechanical interpretation of Gothic architecture — logically culminated in the discovery of concrete. Concrete would solve the problem

of surfaces by allowing for smooth, light walls with glass panels. It is clear how, from that moment on, the idea arose that structural — that is, material — requirements would direct architecture. Hence the engineer's claim to be the veritable creator of Beauty.

## Toward a Third Phase?

In 1899, the Belgian architect Henry van de Velde declared: "Beauty, for the engineer, results from the fact he is not conscious of the search for beauty." More recently, an accomplished architect wrote: "Technology has ceased to be simply a means of creation; it imposes its inflexible laws on the architect: laws of construction, laws of economy." These attitudes derive from a practically based doctrine that was championed, around 1890, by architects all over the world, one that went beyond the simple stage of application. No sooner had possibilities been discovered for using new materials to create unprecedented expressive forms, no sooner had the doctrine dating from 1850–60 advocating the marriage of art and beauty been rejected, no sooner had the Ruskinian paradox promoting an absolute divorce between art and modern society definitively taken hold, and no sooner had the theory of art versus mechanization and modern life been replaced by a theory calling for their reconciliation, than architects and aestheticians found themselves faced with new problems arising from the latest technologies as well as from contemporary applications of older ones. A third phase, which heralded the union between technology and art, also appeared. Giedion and Zevi, who perceived the union as naturalist and organic, spoke of the first phase as protorationalist, and of the second, which corresponded to the period we have just examined, as extending into rationalism, until around 1930.

I have attempted to show that the theory corresponding to universal experiments between 1880 and 1889 is a functionalism

that sprang directly from the theories of Viollet-le-Duc. This functionalism amounted to a belief in the active role of the skeleton, or building framework. However, the problems confronted by theorists and practitioners of modern art toward 1900 are infinitely more complex. As I believe I have proved, they are linked to a new material, concrete, which significantly attenuated the problems and extended the debates beyond the question of setting buildings in equilibrium. Once they had attained the means of constructing buildings whose size, height, and lightness were practically without bounds, builders were expected to attack other problems. Henceforth, they were to chart new directions for their creativity now that they were no longer constrained by material contingencies — which meant that more and more attention would be paid to contacts between technology and the economy and society. As their problems ceased to be technological, the focus of their projects was productivity or financing or how to adapt their buildings to contemporary uses.

To gain insight into the scope of the problems raised in the first half of the twentieth century by new theorization, we need only consider the areas that, according to Alfred Roth, a noted historian of contemporary architecture, fall under the responsibility of the builder, namely, functional organization, technical execution, economic considerations, and overall aesthetic integration — all of which Roth feels can be isolated and can be used by every practitioner as points of reference. To these should be added urban planning, as a science and as a practical activity. I should also mention the problems debated by builders and critics: floating foundations, open ground plans liberated from the constraints of load-bearing walls, the treatment of volumes and light, the elimination of walls, the flexibility of parts, the versatility of interiors — issues that would have been meaningless at the end of the nineteenth century.

We thus find ourselves faced with a new phase in the history of modern architecture, one that is linked to renewed theorization on the impact and use of methods made available by modern mechanization. This phase is characterized by the transcendence of problems posed and resolved by technological means in preceding generations. It becomes evident that social theorization determines, for the most part, the practical orientations of current technology. Steel and concrete were malleable materials that gave architects the capacity to construct buildings with limitless structural and weight possibilities. Thanks to them, economic conditions or taste and modern lifestyles dictated how technology would respond to intellectual and social imperatives.

This third phase of technology in the life of the arts corresponds, at first glance, to the triumph of rationalism — that is, to the search for an as-close-as-possible relationship between the form of works and extra-artistic, -economic, or -geometric requirements. This attitude may only legitimately be considered functionalist if one does not lose sight of the fact that we are not dealing with an absolute attribute. Classical, Gothic, and Renaissance architecture was no less functional than architecture at the beginning of the nineteenth century, or in 1880; indeed, all architectures that set up a fixed relationship between certain forms of action and intellectual and economic principles were functional. To speak of functionalism is to do no more than to point out the existence of a style. Thus the debate on "genuine" — organic or biological — functionalism versus false — geometric or logical — functionalism is pointless. There is no absolute hierarchy nor even a characteristic feature of a period. There has merely been a return to the never-ending debate on intelligence and intuition. To be sure, this debate has been much in vogue, and not only in the realm of art. But this was not the way to illustrate either the originality or the triumph of either of these values.

American theorists on the history of architecture demon-
strated that aspects of the current organic movement hark back to
earlier movements that modestly wended across the entire nine-
teenth century, on the fringes of the great forms of the art of
building. Generally, the individuals who fused art and technology
— as well as those who set them in opposition, those who believed
in the triumph of thought, and those who announced the triumph
of life — did not go beyond the sphere of doctrines debated since
the Enlightenment. Instead of attempting to find out how and
why unprecedented ways of doing things had altered man's ascen-
dancy over the world, they continued to think in terms of abstract
realities: Art, Society, the Machine, and Technology were attrib-
utes of man in the absolute. Thus the work of art always appeared
either an extension of the qualities introduced gratuitously into
everyday objects or the irrational product of a mysterious func-
tion that defies the laws governing matter. Art thus appeared the
result of a solitary activity that developed in the abstract or in the
absolute and occasionally took material form.

This is exactly the problem raised by Jean Cassou, who, as
we have seen, admirably evoked the apprehension felt by those
who believed that the traditional position of art was threatened.
This same issue was raised by a group of historians and aestheti-
cians, beginning with Lionello Venturi, for whom the primary
problem was essentially that of absolute values, and extending to
Sir Herbert Read, who viewed art as serving to reeducate a world
that had lost faith in basic human intuition.

Before responding to architectural historians and aestheticians,
a preliminary examination is necessary. The study of architecture
is impossible when separated from the study of the other arts. To
understand the true situation of architecture in contemporary
society, it is necessary to place building technology in the context
of other artistic technologies. It remains to be shown that the

advent of the machine — or, more precisely, the advent of technol-
ogy — had repercussions on all the arts, affecting thought and sen-
sibilities alike. Only in this way can a valid attempt be made to
study the versatile forms of architecture and art in contemporary
society.

PART TWO

# Metamorphosis of the Object

# Introduction

Instead of asking what role art might play in a society fundamentally opposed to it, I shall turn my attention to the great forms of art that have reflected the world's transformation after the rise of technology and industrialization in the past eighty years.

Let me note in passing that an ambiguity arises from the altogether different use of the terms *technology* and *mechanization*. It goes without saying that, in the modern world, the two are related — more so by their results than by their nature. Technology underlies all the material and intellectual achievements embodying man's ascendancy over the world. Mechanization is an economic and historically limited fact. Obviously, without the development of technology, there would not have been mechanization; reciprocally, industrial mechanization is the practical form assumed by technology in the past century and a half as it rooted itself in society. There is no use belaboring the question of whether humanity would have been reserved a happier fate or merely a different one if it had chosen other paths and pursued its alliance with the machine on other economic and social levels. It is up to the ideologues and politicians to devise new plans to modify, if possible, the current historically determined conditions. In the meantime, let us consider Emmanuel Mounier's suggestion

that anti-mechanization was a social myth of the nineteenth and, indeed, the twentieth century.

Without overemphasizing this aspect of contemporary ideologies, as is the vogue in scientific and industrial circles, I should point out that, in spite of the interdependence of technology and mechanization, technological advances and modern forms of industrialization are fundamentally different. In other words, forms of industrial mechanization are not necessarily the outcome of advancements in modern technology. A given, realized form is merely one of many possibilities. There are also social factors that bear on industrial and technological mechanization; and although such factors are not exactly volatile, they are not entirely stable either.

The current attitudes contrasting Art and Technology, or Art and the Machine, do not generally take this distinction into account. While avoiding compartmentalizing human activities, it must be recognized that man's impulses do not manifest themselves in practice except in the form of independent activities. As Emile Meyerson has shown, all human activities involve the convergence of two phenomena: an activity is all-embracing, that is, it is inseparable from a person's other simultaneous activities; and an activity is specific, that is, it fits into a series and corresponds to a model. An activity characterizes the individual and situates him within a tradition specific to each category of activity. Consequently, on the question of the relationship between Art and Technology, we find ourselves at a crossroads leading toward an examination of man's reaction to his environment and toward a detailed study of some of his most diversified functions.

Recent studies in various areas have provided important insights into the place of art in contemporary society. However, no study has attempted to determine, from a practical analysis of artistic and social factors, the situation of art in the face of the pro-

liferation of technology and mechanical procedures in the nineteenth century. So far, the basis for such an undertaking has been obscured by overly superficial analyses of the original problem.

The transformation of art as well as the proliferation of technology has laid the groundwork for ruptures. Like those ruptures that lead to an upheaval in social practices, ruptures in aesthetic traditions point up questions of preservation and progress. When Ruskin denounced the mechanization of human labor as a sacrilege against Beauty, he was endorsing a line of artistic and social conservatism that had long espoused the belief in an immutable, sacred reality beyond man's grasp or apprehensible only fleetingly. Yet historians have not stopped posing the problem in the same terms. In truth, none of them attributes any great importance to art. As a result, some preconceived notions need to be highlighted before examining the transformation of the plastic object in the century of the machine.

In the mid-twentieth century, historians of modern social and mechanical change focused on three problems: the social implications of technological progress; the transformation of the natural environment into an artificial environment; and the dehumanization of the modern world and the subsequent triumph of ugliness. In my view, these three problems overlap. It is essentially a question of determining if the fundamental process by which works of art have traditionally been created and understood has changed, in substance and in the way it is perceived, as a result of the rupture affecting the underlying conditions of man's way of life.

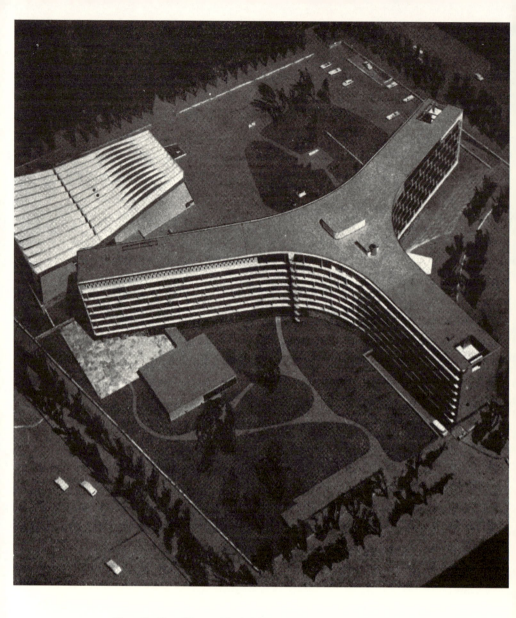

Figure 7.  Marcel Breuer, Pier Luigi Nervi, and Bernard Zehrfuss, Model of UNESCO
headquarters, Paris, 1953–54.

The development of a style takes various routes, drawing on both technological and
representational elements. Style does not rely solely on complex arrangements of iso-
lated forms. New representational objects, made possible by modern technology, are
juxtaposed. Without objects, there is no means of spatial measurement. New objects
create a space that takes on new attributes and meanings. (Lucien Hervé.)

Figure 8. Le Corbusier, main street on columns, *Unité d'habitation* in Nantes, 1952.

Form is a function of the material, but it also complements it and constitutes an autonomous system that becomes integrated into it. Stationary forms are animated by light. The play of sunlight and shadows gives life to the material, but this luminous quality is determined by forms based on technology and studied harmonies. (©1999 Artist Rights Society [ARS], New York/ADAGP, Paris/FLC. Photo: Fondation Le Corbusier, Paris.)

# Versatility of the Object

## Ruptures and Adaptations

### General Activities and Functions

In 1952, UNESCO's the *International Social Science Bulletin* published a special issue titled "Social Consequences of Technological Progress." Georges Friedmann wrote the preface and laid out the program to be followed by the contributors. All fields were represented brilliantly, from technology, the economy, sociology, psychology, to law. However, as a testament to the project's shortcomings, the arts were largely ignored; and, as audacious as it might sound, that oversight justifies the present undertaking. One of the most remarkable contributions to the volume is A.P. Elkin's "Western Technology and the Australian Aborigines," which sheds light on the general relationship between technology and the arts.

Elkin was commissioned by the Australian government to study the impact of the arrival of Europeans on the few remaining aboriginal communities. In a condensation of his lengthy book *Citizenship for the Aborigines*, which appeared in 1944, he gave an account of how the primitive communities that inhabited Australia until the end of the eighteenth century relied on practical

harvesting techniques. He also examined how, on the basis of the knowledge they had acquired, evidencing their attainment of some degree of manual dexterity and a genuine science of plant cultivation, they developed a social and religious civilization founded on an economic, intellectual, and technological infrastructure. Elkin then explained how the arrival of whites led to an upheaval in their ecological conditions, making it impossible to preserve their ancestral way of life. These societies perished as much from the growing scarcity of essential natural food sources — leading to undernourishment — as from the appearance of alcohol, clothing, and diseases to which they were not accustomed and which they could not incorporate into their way of life. Hence, they lacked proper experience and an adequate system of representation — or mythology, if you will. No longer dependent on nature, the aborigine became dependent on the white man. Unable fully to master the newcomers' system, he used certain items empirically. Lacking discernment, and unable to play an effective role in the production of goods, he disappeared.

One of the most interesting facts Elkin reveals is that the introduction of iron into aboriginal society had no beneficial effect: although the indigenous peoples industriously worked the metal collected from the debris left behind by whites, they did not work it *logically*. Believing that the preparation of tools necessitated a long ritual, they attempted to adapt the new material to ancient rites. Ultimately, they failed not because of a lack of absolute intelligence, endurance, or adaptability, but because they were unable to understand which general *system* to apply to the use of the new material.

This experience proved that, once they had been trained, the aborigines could make good technologists and mechanics; it also proved that they could appreciate the superior conveniences provided by the white man's science. However, as Friedmann notes,

the introduction of minor improvements into a given way of life does not modify a human group — nor, to say the least, make it progress substantially. Thus, when a society discovers new technological resources in isolation, there is ultimately a total collapse of former values: no real reconciliation is possible. Any vestiges of the former culture can only take the form of folklore and gestures that are symbolic and, quite often, ambiguous.

The experience of the aboriginal societies of Australia should serve as food for thought. One can only wonder if we are witnessing the fate of our own civilization in simplified form. All the elements are there: the introduction of a new technology and new materials; the destruction of former rituals of fabrication — handicrafts or practices — and traditional symbolic meanings; the attempt to adapt new materials to fit the laws of ancient society; and the collapse of earlier material, social, and intellectual frameworks, including the aesthetic framework. Nonetheless, there are profound differences between our civilization and theirs: the rupture experienced by our civilization was not precipitated by a confrontation between a group of outsiders and an indigenous population; and it is possible that this is not the first time Western society has experienced such a rupture.

I am led to believe that the nonstop progression of the white man — and of him alone — over thousands of years explains his de facto ascendancy over the planet, a privilege he has obtained by virtue not of racial predestination but of historical and societal gains. Only Western societies have proved adaptable; only they have transformed their traditional behavior as well as their psychophysiological structure. Man's entire history teaches that the only great societies are those in which adaptation occurs not by empirical accommodation to exterior conditions, but by well-thought-out domination of materials. The greatness of the European race resides in its once again having assumed power, in the

past two centuries, over technology and the gods — that is, over all collective values, of which art is undoubtedly one means of expressing, though the least-studied.

This general scenario outlining the transformation of human attitudes in the face of new technological possibilities does not pose serious problems. But problems do arise around another aspect of the appearance of modern technology in the field of figurative activities.

Of course, the aim here is not to refute those who think, naively, that the machine transformed contemporary man into a new man. The true problem, noted on numerous occasions by Friedmann, involves the passage from a natural environment to a technological environment.

*The Natural Environment and the Human Environment*
Friedmann posited two slightly different variations of his thesis. In his impressive book *Où va le travail humain?* he persuasively characterizes the change in human destiny brought about by man's passage from a natural environment to a fabricated one. He speaks of the perennial dream of direct contact with nature, of humanity's pre-mechanized period, and of the mechanization of work and leisure pursuits as the unprecedented problems faced by our era. Friedmann does not believe that man will eventually be subjugated to the imperious laws of technology, cut off from his natural roots. His entire text is devoted to finding a way of preserving man's essential human attributes. However, he formally accepts the idea that a rupture has already occurred, cutting man off from his natural relationship to the environment.

In an excellent article that appeared in the same UNESCO publication, Friedmann summarized his position. In his earlier environment, man came face-to-face with animals, elements, and phenomena that he could not bring under his full control, where-

as in his modern environment, man lives in a world of his own making, which he has subdued and subjected, indirectly, to his system of causes and functions — leading to the present drama in which man finds himself at the mercy of the very system he created to satisfy his material needs. Friedmann adds: "What characterizes the natural environment is the use of natural energies," wind, water, animal power. Its activities are carried out in harmony with the elements; the tool serves merely as an extension of man's craftsmanship; labor is geared to the cycle of the seasons; physiological rhythms guide the cadence of movements and gestures. It is an environment in which order, management, and information are overseen by a human presence and in which compassion is an essential factor in relationships. In contrast, "what characterizes the technological environment is the artificial production of energy, the rational organization of work, and mechanization: man only interacts with nature through the intermediary of increasingly complex technology. What is more, it is often through the same intermediaries that he interacts with other men. Of course, there is no such thing as an absolutely natural environment; there is no environment in which human technology has not already more or less transformed nature. Even the most primitive society uses technology, and this usage transforms the appearance and meaning of natural realities. But the development of mechanization occurred so rapidly in the space of 150 years, and the number of transformations it brought about was so great, that one can legitimately speak of an altogether new environment, namely that of technological civilization."

In short, the argument draws on a belief in the salutary effects of slow, gradual progress as opposed to the dangers of a jolt of revelation that would precipitate an abrupt leap into history. There was a glimmer of hope in the belief that technology, inhumane by nature, would be able to resolve the problems it gener-

ated and that it would not impose a new purposive behavior on the human race.

Despite their eloquence, these arguments are built on two highly debatable ideas: that humankind's recent technological leap is without historical precedent, and that the fundamental conditions of modern technology have given rise to, and still determine, all aspects of contemporary civilization. In addition, Friedmann assumes there is such a thing as an original Nature, as it were, that is the basis of all human advancements. Be it Nature, technology, or the machine, we always find the same foundations of contemporary civilization.

*Obstacles and Leisure*

It is beyond the scope of this book to embark on an extended discussion of the history of the machine. Besides, the subject was recently addressed by a number of first-rate thinkers, the most prominent of which included Pierre-Maxime Schuhl and Alexandre Koyré. An expert on Antiquity, Schuhl posed the problem in historical terms. Observing that the ancients, and particularly the Greeks, were familiar with principles capable of allowing at least a partial mechanization of society, he sought to determine why this development had been hindered until the eighteenth century. He thus set forth the idea of the obstruction and unlocking of potentials within a more or less sophisticated system of knowledge. Next, looking methodically at the obstacles that, over the course of two thousand years, caused civilization to veer from the path toward mechanization and industrialization — the latter, he admits somewhat summarily, being virtually the outgrowth of the former — he felt the answer lay in the existence of a primarily servile workforce used during Antiquity and the centuries-old disdain for human labor. The notion of leisure, in contrast with that of labor, led to the opposition between the active life and the

138

contemplative life, which in diverse forms has inspired numerous social systems, ranging from that proposed in Plato's *Republic* to the cloisters of the Middle Ages. From Seneca to Saint Bruno, there was only one step: asceticism and the return to Nature. I should again point out that the myth of leisure and the myth of creation always converge.

The machine has dehumanized human life; it has brought about the ugliness and horror of cities; modern life has turned against culture; civilization is not born from labor. These are the germs of Koyré's argument as set forth in a remarkable analysis in which he proves that, by drawing on the empiricism entailed in mechanized activities, the Greeks created the rational. Later, in the sixteenth century, the return to the ideas of Archimedes enabled the geometrization of nature and the passage from the qualitative universe of Aristotle to the quantitative universe of Galileo and Descartes — leading to the true rupture in the modern world. In Koyré's opinion, the sociological or psychophysiological explanations for the blockage were unfounded, insofar as the obstacles had resulted from technology's dependence on science or were a legacy of the workforce's servile role in Antiquity. He argues in favor of an active and operative technological thinking emanating from accumulated knowledge. This meant that the problem of the belated rise of technology was distinct from the problem of science. The real question is one of knowing why, then, the conceptual link between technology and science did not occur ideologically until Bacon and was not put into practice until the end of the eighteenth century, with the advent of a new figure, the engineer, who seems the modern-day king of creation.

I do not think it is entirely accurate to argue that in the last 150 years Western societies experienced technological progress for the first time when they faced mechanization. It goes without saying that the proliferation of technology was never the same in

the past as it is today. Mechanization, automation, and industry are phenomena specific to our times. They are historic developments, but, in my opinion, it does not follow that they are totally without precedence in human history. It goes without saying that, at bottom, there is no connection between the upheaval created in a primitive society by the discovery of iron or the invention of the adz or the harpoon and the upheavals wrought in the modern world by the discovery of electricity and the atom or the invention of the steam engine. But a distinction must be made between two factors. On the one hand, progress assumes a particular form as a result of the discovery of unprecedented material means and because of the potential for their mass exploitation; on the other hand, there is the ongoing process of man's adaptation to continuous technological upheaval, which always brings about radical changes in the environment. For a population passing from the Stone Age to the Iron Age, or from a nomadic to a sedentary existence, the material and social changes were as real as any we have witnessed in our time. Obstacles and resistance existed not only in the development of superior civilizations throughout history. Furthermore, highly advanced civilizations, like the Chinese or the Indian, relied on systems of interpretation or hierarchies of values that were entirely different from those of the West. Can we honestly say, for example, that because in China and India the idea of the Individual is different from the Western idea that those countries did not play a role in the advancement of humanity? Or can we say that because the Chinese system of writing is based on different relationships that it has no aesthetic, intellectual, and moral merit? It would be nice to think that there was ultimately only one, triumphant route from among all those pursued by human societies as they strove to give man superior means of acting on the world; however, I do not feel that one can subscribe to the principle that humanity has never witnessed a change in its

technological environment nor to the idea that, failing to find the secret of power, humanity may find the secret of virtue and happiness by modeling its actions after nature.

It is hard to imagine that the men of the Renaissance — who one day found themselves able to travel freely around the globe and who had discovered new mathematical relationships to explain the movement of the spheres, just as they invented means of conveying thought in precise symbolic forms, namely, through perspective and algebra — did not experience a renewed confidence in human sight and language and did not also feel that the face of the world and the direction of human action had been totally transformed. The question is not whether they were right to believe that a general and definitive revolution had altered the course of human action and the hierarchy of values. The question we must ask ourselves is, can we be sure that we have not succumbed to the same illusion as they?

It goes without saying that the greatest mutations in material and intellectual tools did not transform man's destiny all of a sudden. Earlier, I pointed out the importance of distinguishing between a discovery and its adaptation, in keeping with the cogent observations of André Leroi-Gourhan. We should avoid reasoning as if our era already has the entire range of processes and methods that will be available in the future. The technological society whose principles are described as if they were already hard-and-fast has barely begun its evolution — and is at nearly the same point as Renaissance society around 1580, before the discoveries by Galileo, Descartes, and Newton. Its possibilities and values are changing before our eyes at an enormous speed. However, it is pointless to compare a new, closed system with the aggregate of earlier ones; if we do so, we risk embarking on a process that will lead to a new state of immobility, a new blockage. Rather than attempt to explain a closed set of hypotheses, I aim to take

141

selective activities — be they technological, scientific, economic, or artistic — from among the current disorder to gain better insight into the present as it relates to other equally innovative and destructive periods in which the replacement of one technological environment by another and the adaptation to this new environment by certain men produced the key works that sparked this advancement.

I shall lay the groundwork for a renewed examination of the relationship between art and technology by showing that, in modern society, a development in art, simultaneous with the evolution of technology, has revealed a new way in which man can apprehend the world through his senses. I will also show that works of art involve not only individual perception and representation but the creation of objects — objects that concretely register the smallest motor reactions of the artist.

Modern art is not merely the whimsical interplay of provocative forms: it does not seek its validation in otherworldly experiences. Rather, it draws its ultimate inspiration from the totality of modern human activities. There is a good chance that most new practical applications will be derived from aspects of artists' bold figurative assemblages. Alongside Koyré's distinction between technological and scientific thought, it is necessary, then, to add what led to the recognition of plastic thought.

Artists do not act in isolation, independent of technologists and thinkers. And so the idea of a distinct history for each discipline and human activity should be replaced by the idea of an all-inclusive history that incorporates a society's various means of expression and unfolds as it shapes itself. Modern art is not a disinterested game of solitaire. When a man adopts a mode of expression he does not cut himself off from the community. Artists are also men who create objects. Their objects may be studied as representative of sensations and actions that do not necessarily

contradict the impressions and structures through which other categories of individuals, coming from the same technological and natural environment, express themselves and create objects. When examining the art object, we are indeed examining the forms and ideas that characterize contemporary man. Art is not a realm where values seek refuge and where men cower before destiny.

### The Nature of the Plastic Object

Through ruptures, leading to mutations, the primary function of human societies is to create objects. "Any society different from our own is an object; any group in our own society, other than the group to which we belong, is an object; and that group's practices are objects, even if we do not follow them." That is the sociological definition of the object as presented by Claude Lévi-Strauss in his remarkable preface to the posthumous collection of Marcel Mauss's works.

This is the most general definition of an object. Its principle merit is that it helps us to understand how the products of technological thought may be compared objectively, through the same frame of reference, with products derived from scientific or plastic thought. The artist who composes a painting or creates a sculpture produces a cultural object that, from one standpoint, has some of the same features of works issuing from society's most theoretical, experiential, or mechanical activities. In each case, something is produced that exists independently from the producer, that can be used by others, and that influences the judgment and actions of others.

Nevertheless, it would be dangerous to believe this idea could be applied to any and all products, regardless of the human activity from which they originate. Of course, all material or intellectual activities have led to the production of objects, around which human relationships are formed; but it does not follow that all of

the objects in circulation in a society are uniform. In this light, I shall focus more closely on the notion of the plastic object, which has fostered one of the most concrete relationships between the work of art and other products of human activity but which has not been the subject of any in-depth study.

### General Aspects of the Plastic Object: Specificity, Intentionality, Versatility

Viewing a work of art as an object has two facets. The work of art is, in fact, an object in the most tangible and concrete sense of the term. It is, as it were, a thing. In our usual surroundings, a painting is treated as a furnishing; it can be moved, rearranged, kept, changed, altered. It is as real, concrete and useful as any ordinary utensil. At the same time, some see the work of art only as a sign of education or wealth, whereas others see it as a set of symbols or elements laden with meaning, capable of inspiring meditation or evoking connotations that can either stimulate the pleasure of contemplation or give rise to thoughts that can be incorporated into daily behavior. As a consequence, the work of art is the product of an activity that is both tangible and imaginary for a given social group. Moreover, in both cases, it is sociological and individual, as is the personality of its producer.

As a result, the study of the plastic object must take into consideration the tangible and figurative aspects of the work of art — which is what I intend to do in the following pages. However, before examining contemporary works that point up the difficulties in the relationship between art and technology, it may prove helpful to focus on the greatly misunderstood notion of the plastic object, while emphasizing its practical and creative values. And so I shall begin by addressing the general mutations undergone by the object, materially and figuratively. I shall also consider, within the perspective of this analysis, those methods that best lend

144

themselves to the study of the changes since the mid-nineteenth century to the twofold nature of the form — or materiality — of objects whose value is primarily aesthetic. Simultaneously, I shall examine the form of other objects that are at least partly aesthetic. This examination of the notion of the plastic object will highlight three essential factors: specificity, intentionality, and versatility, which also characterize the mutations undergone by material objects and all other creative objects that contribute, along with the plastic object, to the immense network of figurative objects that make up man's surroundings.

An art object, wrote Mauss in his *Manuel d'ethnographie*, is an object recognized as such by a group. And so it is necessary to analyze the perceptions of the individual who uses the object as well as the reactions and intentions of its creator. In other passages from the same book, Mauss develops this idea but modifies it slightly. He notes that an aesthetic sensibility is exhibited in two types of works: those produced in isolation solely for aesthetic purposes, and those originally produced for religious or utilitarian purposes that possess, nonetheless, a *supplemental* aesthetic value. The views of Mauss and most sociologists — who contend that the work of art is a luxury item intended for sheer contemplation or who, when pressed, might admit the existence of a supplemental artistic value — coincide with the opinion of most historians and aestheticians, who generally insist that aesthetic sensibility be characterized as unbiased pleasure.

*Plastic Function and Efficacy: The Operative Character of the Work of Art*
The historians of primitive societies provided the first and most solid reasons for doubting the veracity of these interpretations. Merely because a work of art has a larger significance than is suggested by its outward appearance, or because the understanding

of aesthetic values entails direct intuition, or revelation, it does not necessarily follow that the work's artistic values are facultative or superfluous. Nor does it follow that aesthetic intuition excludes all rationality. Ethnographers have shown, for example, that in certain black cultures the idol was, objectively speaking, necessary to the life of the community. Every society has its myths. Contemporary myths are not any more logical or rational than ancient myths. To be sure, our generation possesses material means that far surpass those available to ancient societies. But ours, too, anticipates reality; it projects a utopian vision, founded on a dialectic between operative techniques and moral, social, and economic imperatives that cannot always be verified in reality.

It cannot be argued, then, that the power of art, like that of religion, is sui generis and that only techniques applied in the real world may produce a regular physical effect. For these techniques to be effective, they must use forces that link purely physical effects with social effects that result from the introduction of a new technology into a social body. Or, on the contrary: the arts and sciences, since they both produce social if not physical effects, have an equal capacity to generate a regular sequence of cause and effect.

Marcel Griaule's impressive studies on black African civilizations have shown us more precisely that figurative elements in these cultures played significant and well-defined roles. The plastic symbols were as vital as they were sacred. These symbols provided people with precise information on activities fundamental to the existence of the individual and of society. They served to record knowledge that was ultimately passed down as ancestral wisdom and had clearly practical implications, insofar as they governed the community's practical life as much as its technological know-how. At every stage of human development, drawing has served as a stable form of knowledge. There is as much

knowledge in Matisse's art as in the art of bridge building. And it is not at all certain that the engineer, who uses calculations to reproduce systems set down by his predecessors twenty or thirty years earlier, possesses a more modern turn of mind than does the artist, who, as we shall see, is often a forerunner, both in his perceptions and in his arrangement of forms — in which operative experiences and intuitions ultimately materialize.

Finally, we see why art cannot be considered a purely imaginative interplay of elements that can be added or removed at will from an organic whole once it has been constituted. More specifically, a society cannot be explained by first studying its laws or its architecture and then reconstituting, by analogy and comparison, the relationships that supposedly existed between one specialized area and another. The mechanic and the poet share the same environment. Of course, there is a difference in the way reality is interpreted or utilized, depending on the individual and his standpoint, but it is rare that an individual only participates in a single area of activity. The specificity of an activity, or even mode of expression, does preclude a shared body of knowledge or participants working in common. To speak only of the sui generis nature of art or religion is to strip it of its guiding inner force, to deny that there are numerous modes of human expression that correspond to numerous types of activities. It is to render unthinkable human societies whose very existence depends on man's power constantly to change not only the forms of his physical ascendancy over the world but also the intellectual systems that underlies new ways of rebuilding the materials and morals of the city.

No one would say that the ritual significance of a religious object is one supplemental usage among many others. Indeed, the ritual significance is the guiding principle behind the creation of the object. Mauss himself lucidly shows how aesthetics contributes to the power of rites. One could no more define Beauty as

147

an attribute separable from an object than one could isolate the mechanical, industrial, and efficiency-producing aspects of a machine. The object is always a totally human product. It is neither a fragment nor an accumulation but a synthesis. Thus it is absurd to deny that the aesthetic aspect contributes to the overall meaning of the object while according such a role without hesitation to other aspects. In primitive societies, the aesthetic aspect of objects was most frequently manifested in the decoration. However, decoration cannot be explained without taking into account the thing to which the decoration has been applied, that is, without considering the object's form and intended purpose. Decoration is not arbitrary. An activity is never entirely valid if it is devoid of meaning in the eyes of the community. The romantic theories of art for art's sake weigh heavily on our conceptions. Some view the materialization of aesthetic thought as being as important as the invention of a new motor or bomb. We understand ideologies as guiding forces behind human actions; but we have yet to understand the role and function of art in society. However, it, too, corresponds to an absolute human activity. Saying something is as important as doing it. Speech possesses a power that may incite action. Showing something is no less effective than saying it. But for society to grasp words or images, they must be incorporated into other activities.

Thus we return to the problem posed by the mechanists in the late nineteenth century, namely, the problem of functional art. Rejecting the idea of a harmonious union achieved by a trade-off between art and industry, the followers of the mechanistic doctrines of 1890 laid down principles identifying Beauty with new machine-based rules. Although they at first adopted different stances — endorsing the idea of a perfect coincidence between beauty and utility — they soon acknowledged that beauty was, in the end, only of minor importance in comparison with the ratio-

148

nality of machine production. Today, industrial beauty is deemed to be still in the process of evolution and will be fully developed by force of habit, until mass production has turned out enough forms to enable theorists of beauty finally to set down definitive formulas. In his impressive book *L'avenir de l'esthétique*, Etienne Souriau clearly demonstrated, however, that the meaning of beauty was not simply the sum of the public's reactions to machine-produced objects — at a stage of technological progress — but, to the contrary, art was an active and, above all, "formative" force. While examining the current state of industrial aesthetics, he also pointed out that views on aesthetic norms will undoubtedly have changed in another thirty or forty years. Regardless of whether machines continue to produce refrigerators, they will be influenced by other contemporary practical and theoretical activities. Like works of art, machine-produced objects — and technological objects in general — are influenced by all adjoining activities. Here, we touch on the general problem of the relationship between technology and art in contemporary society, which is the very subject that I shall address in this text, a subject that holds no predetermined answers.

## Intentionality of the Plastic Object

To set our bearings, I need to point out a final aspect of the plastic object. The art of an era cannot be characterized solely by those works that appeal to the imagination of a closed circle of initiates. This attitude is a leftover from romantic theories on art for art's sake, which is, unfortunately, alive and well. Moreover, we can no longer maintain that the taste of a period can be defined simply as the sum of technological conventions. This presents undeniable difficulties. On the one hand, some highly specialized works claim to be motivated solely by aesthetic intentions, and, on the other hand, there is a legitimate artistic value in

some extremely utilitarian products spawned by technology. However, a work of art does not assume an aesthetic quality simply because it presents itself as doing so. Quite often, there is a greater affinity between mundane objects and entirely dispassionate aesthetic works than there is between these works and all of the products that are held out as artistic but that are, in fact, mechanical reproductions of forms borrowed from a stock of artistic commonplaces. Art cannot be linked to an intended purpose alone. It is on this point that the fundamental problem of intentionality arises. Intention alone is not enough to create an organic link between a work and plastic thought. On the other hand, it is not necessarily excluded as a concern of technological production.

For most critics, a plastic object's intentionality was, unfortunately, confused with its specificity. The debate centered on determining the degree of aesthetic interest in any given object; and, as we have seen, art was associated, in the end, with the desire to produce a work exclusively, or primarily, out of concern for its aesthetic qualities — which were seen as flowing directly from a system of predetermined values external to the creative act.

This concept will be contrasted with another approach. The aim of this book is to demonstrate the dual speculative and operational character of art, in order to refute the ideas that there is an absolute scale of Beauty and that the artist merely transposes into his activity, or expresses through his behavior, the sum of certain intellectual attitudes. Intentionality is not extrinsic to the act of creation; art objects are subtle and intricate; they are not constructed in parts.

At the outset, several general observations will be presented that will enable me then to pose the problem in the context of historical developments in contemporary art.

The universally recognized complexity of a work of art (which is, as we have seen, both a material object and a plastic object)

rules out any assumption of absolute specificity. Furthermore, we must reject the idea that there is a dual reality whereby the work of art is originally a commonplace human creation to which aesthetic attributes are added. That amounts to assigning intentionality only to the tacked-on secondary aesthetic attributes.

To gain insight into the work of art as a whole, from both an engineering and a figurative perspective, we must resist viewing intentionality as the addition of secondary attributes to material originally produced according to other principles. Instead, we must see it as a process whose effects are both material and mental. To understand how intentionality can produce works that have mechanical or technological characteristics and speculative or contemplative characteristics, it is necessary, first of all, to prove that there are forces at work in an object distinct from those found in technology, which is merely an institution.

Art necessarily involves creative activity — that is, the creation of material systems — whether such creation is realized or remains a mental construct designed to promote understanding or to serve as the virtual representation of other activities. Figurative objects and activities enable man to convey his feelings concretely through a medium that is subject to constant change. Thus, to appreciate a plastic object's intentionality, we must first consider the mind's versatility, or plasticity.

### Variation in the Plastic Object

Without denying the plastic object's specificity, we must acknowledge that, in certain respects, it falls into the general category of objects of human civilization and even into the broader category of objects per se — that is, man-made or machine-made utilitarian products — and forms a part of the fabricated environment man has traditionally accepted as natural. Versatility and intentionality are common features of all objects. But the plastic object's status

as an object is twofold, since it is subject to the general laws governing all artifacts and, when viewed figuratively, it falls into the category of the object. Whether we are dealing with plastic objects, mathematical concepts, or purely imaginative constructs such as "rationally thinking beings" in literature, there are always affinities between the creator and the tangible or theoretical products he creates.

Although ethnographic methods cannot be applied directly to the study of contemporary art — given that society has become much more highly advanced and man's physical and intellectual capacities have evolved significantly — the fact remains that ethnographic research may yield precious clues as to how we might study, generally and specifically, the transformations undergone by the plastic object in the century of industrial mechanization.

Difficulties arise when a phenomenon that is entirely unstable, variable, and subject to the vagaries of the human mind — namely, art — is compared and contrasted with fixed values. The material object changes at least as fast as the figurative object, and the variability of shifting factors that interact within an ephemeral social system contributes to the ever-growing richness of history as human activity grows more efficient and generalizes. Hence the increasing difficulty of interpreting it with precision.

What should be kept in mind when conducting historical research into the general activities of primitive societies — that is, civilizations — is the need also to consider how each aspect fits into the social reality of a given human group. We must rid ourselves of the mistaken belief that the specificity and dignity of art are enhanced when art is detached from its human context. The specificity of artistic qualities cannot be conceived from the heights of lofty detachment. On the contrary; it finds its confirmation in practicality and utility.

To begin my analysis of the changes undergone by the figura-

tive object in contemporary society, I shall focus on the principles laid down by Mauss in his *Manuel*: "When analyzing a primitive society, an inventory must be made of all the materials it uses, as well as a checklist of the level of development of its sensibilities, emotions, and physiological mechanisms that allow it to appreciate and create works of art." This dual material and psychological checklist is difficult enough to prepare when one is dealing with relatively simple societies, which tend to be organized uniformly. But the task appears daunting when one is dealing with sophisticated societies that have numerous layers of superimposed traditions. Although such an objective seems utopian, it is worthwhile, nevertheless, to attempt to give a broad overview of the object's versatility, as measured materially and aesthetically, in nineteenth- and twentieth-century Western civilization.

## Transformation of the Technological Object

On both a material and an artistic level, we are still far from possessing a solid base of documented facts. All of the studies on the industrial arts within the past 150 years have been aimed at defending value judgments. Predetermined categories of mechanized activities have been set up, designating certain products as nonaesthetic — the locomotive, the Frigidaire — while ignoring the vast majority of everyday objects. Only Giedion saw a need to correct this oversight, which stands as one great merit of his book *Mechanization Takes Command*. His work contains remarkable studies on the transformation of everyday objects such as the lock, tools, chairs, and household furnishings. Unfortunately, he, too, succumbed to the temptation to explain the transformation of the object in aesthetic terms. For the most part, his examples were chosen to support his thesis that a lamentable functionalism had been surpassed by organicism-as-the-savior-of-humankind. Finally, he presents the dentist's chair and the artificial leg as typifying

objects of modern civilization — under the pretext that they are articulated, transformable, and organic! Once again, theoretical considerations dictated the orientation of inquiry and conclusions.

It would be preferable to use an altogether different method to prepare a checklist of objects in the nineteenth century that would give some indication of their fate. Before reaching a conclusion or making any comparisons between society's everyday objects and its art, one must thoroughly and objectively examine the fate of the object. This will entail an analysis of written and figurative documents, ranging from the most humble to the most sophisticated, in order to examine the disappearance, transformation, and appearance of new tools and utilitarian products in society. Giedion himself has indicated several possible sources of research. There are, on the one hand, the catalogs of industries and large department stores. Undoubtedly, there are also the not yet fully exploited archives of industrial firms. Then there are indirect sources, which are primarily literary. Until now, only texts descriptive of constituted interiors have been studied. A checklist needs to be made of the objects a particular author, without intentionally emphasizing the descriptive nature of his text, has singled out. But that is a task best left to language historians. Giedion also recognized the interest of books like those by the Beecher sisters, which formed the basis of his survey of the history of the mechanization of housekeeping. What Giedion has begun, with his focus on America and his particular philosophical stance, should be taken up more objectively and internationally and expanded to include other areas of human activity, although it is clear that the boundary between the utilitarian object, such as the vacuum cleaner, and the communal object, such as a public building, will remain ambiguous.

It would be futile to attempt to trace the history of every single object in a society. Obviously, each category varies in importance

or exhibits certain notable features. We will not be able to com-
pile a comprehensive catalog of modern objects and professions
that differentiates forms geographically and chronologically any-
time soon, but we will never be able to describe the progressive
development that gave rise to the transfer of physical and psycho-
logical reactions. In sum, that would involve amassing the archives
of modern society. One cannot but wonder if the time has come
to attempt an encyclopedia built on a new foundation, replacing
the guiding principle of human progress as measured against fixed
functions with the principle of a versatile hand that reflects a ver-
satile mind.

What are the roles played by tools, instruments, and machines
in today's society? According to what historically defined pace
were older objects gradually replaced by newer ones? On the
basis of which practices, which changes in manufacturing, or
which economic considerations was one commonplace object
replaced by another? What were, for example, the stages accord-
ing to which soldering, riveting, or brazing were replaced by
assembly methods? And what repercussions did this have on the
workforce and on tastes? How did the notion of the machine
evolve, it having at first been perceived as a composite of parts
and then as a kind of mechanical brain? What areas of activity,
depending on the social milieu, put up the most or least resis-
tance? What impact did these transformations have on fundamen-
tal human actions, ranging from daily life activities, such as walking
and traveling, habitation, practical pastimes, hunting, and fishing,
to diversions — games, sports, entertainment? Which technical
skills should be valued henceforth? The polish and regularity of
monolithic objects — as opposed to modeling, setting, mounting
— or the variety and diversity evident in objects made by earlier
generations? If advances in glass prompted major developments in
both community architecture and individual comfort between the

thirteenth and the nineteenth century, are not steel and concrete now opening up a third era in the industrial age? There is also the question of the wane or resistance of certain handicrafts, such as pottery and basket weaving, as well as the question of the order of certain activities, such as meals and rest. There is also the matter of the importance of basic industries: clothing, architecture, security, and comfort. These questions have been the focus of a broad series of studies, both morphological and functional, that have only recently begun and have been carried out rather haphazardly.

It is alarming to see how these problems tend to be glibly dismissed as secondary or already resolved. When otherwise eminent minds commit gross errors because they lack basic information, the urgency of the task becomes clear. It might come as a surprise to see a contemporary author state that, until the nineteenth century, a house was considered a shelter, a fortification, and a place of security but served no other useful purpose; but there is no functional study on the development of the private dwelling since the Middle Ages. Only a few lines later, the same author writes that the traditional palace consisted of a succession of rooms arranged in no logical order, each differentiated only by the decor and the furnishings, and that in a château like the one at Blois — which is considered typical of a traditional dwelling in France — no room afforded real privacy. Moreover, we read that there were no private hallways at Versailles, nor was there a central area for family life. Indeed, there was no notion of private life, and closets, it would seem, were a modern invention. We see the extent to which a nonspecialist can be ill informed, for none of these contentions stands up under analysis. And yet the author is a cogent thinker and very well-informed in other areas, particularly economics.

It is thus glaringly obvious that my conclusions in this examination of contemporary technology can only be relative and

partial. This rules out any possibility, at least at the outset, of modeling my approach on ethnographic methods, both because of this lack of adequate research and because of the complexity of the questions, which, as we have seen, prevents a mechanical interpretation of the facts.

## Transformation of the Plastic Object

Alongside an overview of the object's versatility in contemporary civilization, I shall consider its transformation. The plastic object may legitimately be considered closely related to other genuinely figurative objects in society. Its right to this distinction shall be borne out in light of the three predominant lines of thought in a civilization: technological, scientific, and plastic thought.

This will entail more than merely presenting a classical history of art, that is, a serial description of different intentional activities: painting, sculpture, architecture, and the decorative arts. In a departure from the traditional view that there is an autonomous aesthetic function, I shall not limit myself to tracing the history of each stylistic category of activity involved in creating works of art. Instead, I shall attempt to find the link that connects art-related activities at a given stage to other practical — and equally figurative — areas of specialized knowledge. As shall be shown, the versatility of human thought justifies such a theoretical approach.

Every behavior that is learned and transmitted by tradition is the product of a synergy between the muscular and nervous systems, which are complementary in a certain sociological context, such that the division of labor and tasks does not lead to a sudden disruption in the general order. Georges Friedmann has shown how transformations in large-scale industry — which eliminated former activities and shaped the reactions of workers who had been assimilated into the new system — destroyed certain earlier values. Some practical notions such as fatigue or precision have

changed both their meaning and form. The human mind was confronted by unprecedented situations, which meant that the type of mind that had, for example, created the smile of Mona Lisa had no chance of surviving. Other faculties, such as concentration, were no longer practiced as they had been in the past.

In their stead, new aptitudes have begun to surface in the world of the devouring machine. Although today's worker is incapable of manually producing the thousands of increasingly complex and intricate machine parts, certain latent faculties have begun to be revitalized. For instance, more and more often, man has again become attuned to the reality of rhythms that had long been confined to the realms of music and dance and deemed sacred. He is able to discern causes in ways that were not accessible to his ancestors, even his parents. The daily miracle of the wireless telephone — a purely mechanical device without a hint of artistry — enables him to understand the invisible forces behind nonmechanical transmission, however crude and unwieldy it may be in its current usage. Rapidity, quick decision making, and judgments made at a distance have developed in virtually every field in an era dominated by speed. The man of 1950 is not attuned to his body, nor does he perceive the outside world at the same pace and in the same way as the man of 1900. As a result, man's systems of representation, which depend on a mechanism interconnecting the images within his mind, have been transformed as well. The changes marking this century have affected not only the objects in our surrounding world but our inner world as well. We ourselves constitute these changes. Indeed, we might say that the true greatness of contemporary art resides in its ability to give expression to this rapid conquest of the new — to express the unexpected relationships that are sporadically formed between the exterior world and the mind.

By transforming nature, our era transforms the visible face of

the universe. On the day man must rely on materials of the past to make art, there will no longer be any art, simply the creation of pseudo-figurative objects that rapidly vanish in the face of the engineer's blueprints or the photoengraver's plates. Man cannot create by turning his back to present reality. To the extent that artists are able to create systems of relationships adapted to new means of human action, they will introduce art into our times and finally impress its form upon our era. Artists express and materialize basic mental laws. They take action. Their starting point is, necessarily, reality. They give concrete form to insights that scientists draw on to create dialectical systems and that technologists use to create instruments.

It should not be imagined that this perceptual and intellectual shift is happening for the first time in history. The faculties actuated by plastic creation and by the collective appreciation of its products are fluid, versatile. The ancient Greeks developed their sense of sight to the point that they could judge the slope of a column. Balancing a Gothic facade presumed the ability to square up a plan while drawing on surface and linear relationships that were completely different from proportions that prevailed during the Renaissance. Just as there are individuals who are more skilled or more talented in certain areas, there are societies whose faculties are more well developed than those of other societies.

To a large extent, these aptitudes were encouraged and developed to specific ends. In the age of polished stone, individuals who knew how to calculate how a piece of flint would shatter under a well-directed blow were held in high esteem: manual dexterity was highly regarded, as was the patience needed to obtain a good polish. The sensation of this polish was highly pleasurable, comparable to the feeling we get today when looking at a Brancusi sculpture or handling an abstract work that combines sensual, tactile sensations with those of sight.

Too little attention has been focused on the fluidity of sensual perceptions. In this area, the work by Lucien Febvre on the Rabelaisian era has recently laid the groundwork. All of the concepts that enable man to define his place and role in the world depend on how he becomes conscious of his body and how he puts it into action. Our most sophisticated notions on sensory experience are based on acquired and voluntary action. Modern man no longer knows how to harvest or polish by hand, but he easily comprehends the revolution of a moving geometric form. How could he produce an art founded on modes of action that are no longer attuned to his perceptions or to his conceptions of causality? Why should art be doomed to conform to bygone laws of physics?

There is a common background of sensations and activities that serves as the basis for all specific modes of human activity within a given historical period. In the Middle Ages, stone-carving techniques — which were the basis for the stereotomy of cathedrals — were linked to the development of the use of iron — which was essential to chivalry — and to the development of geometric reasoning. During the Renaissance, progress in the arts was conditioned on the rise of science — in which nature was seen as part of a uniform system of numeric proportions and relationships that were transferable to different mental operations. Even now, man's newly acquired powers are developed methodically each day, in order to gain insight into the forces behind the changing face of the universe, engendering a new art adapted to new sensations and new theories.

It is easy for the public to dismiss paintings and sculptures that it does not understand because they do not correspond to traditional figurative vision. The public fails to recognize the current form of a constructive activity characteristic of the artist throughout time. The Chaldean shepherds of old, the first to construct a

representation of the universe based on observation of the stars, used this representation to derive a system that was both mathematical and figurative, based on correspondences between the constellations and symbols from nature. In so doing, they laid down the precepts of an abstract order and a mythology, reflecting and unifying the intellectual concepts, beliefs, and value systems of their time. Renaissance artists overturned both the geometric and the figurative system of art. They replaced a system of signs based on abstract values with a representation that turned the image into a microcosm of human experience intended to provide a selective inventory of the world. As they gradually turned away from Christian legend, their works no longer ritually resurrected events that were part of a finite vision of history. They proposed another cycle of mythological legends as the basis of values. No longer representing the world as emanating from the thoughts of God, they searched history and poetry for elements that presented man not as totally resigned to his fate but as engaged in a struggle with the outside world. Must we not believe that the advent of printing led to a simultaneous upheaval in society's mental attitude and, in its wake, society then suddenly adapted to reading. Febvre has reminded us that, for a long time, texts were read aloud, even when the reader was alone. Should a society in which children learn through visual literacy conserve the representational system of the Middle Ages or of Modern Times?

Men do not execute or interpret the activities and gestures of their social milieu in the same way from one era to the next. Art is closely tied to forms of action. When one looks at silent-era films — which date back a mere thirty or forty years — it is difficult to interpret the actors' gestures. The text of the subtitles sometimes comes as a surprise. Neither the actors' rhythm and pace as they move in front of the camera nor the relationship between their feelings and stock gestures corresponds to our expectations.

How will the realism of François Rude's *Maréchal Ney* be understood tomorrow, when no one knows the meaning behind a cavalier with his saber drawn from its sheath? Can we expect that men who have performed their military service in tanks will be able properly to appreciate Delacroix's *Fantasia?* Versatility and figuration converge in a work of art. Modern artistic creations will not escape this law. It is through the works of Renoir, Toulouse-Lautrec, Seurat, and Degas that images of human action in the recent past were established; it is through the works of Matisse, Dufy, and Picasso that we see the man of yesterday and through Léon Gischia's *Jongleur*, Maurice Estève's *Hommes volants*, and Edouard Pignon's *Paysans* that, one day, the man of today will be visualized.

As I write these words, I have a magazine in front of me. There is a page showing a man in profile. This profile resembles a kind of ribbon man, which would have been totally illegible only thirty years ago. Shopwindows of large department stores are filled with figures that were revolutionary in 1925 and that now are the only ones able to arrest the attention, reflecting the attitudes held by the average man in the street, and are intended to create a need and appeal to consumer habits. Based on a common perception of reality, this culture of sensibilities, shared by artists in a given era, necessarily sets up a correlation between practical activity and figurative works.

Since, in every society, the plastic object, the utilitarian object, and the figurative object are each marked by a capacity for versatility, it cannot be claimed that modern art is the reflection — or the sum — of contemporary scientific and mechanical activities. The creation of art forms, as compared with industrial and scientific forms, is not merely a matter of transference: it is a different means of creating practical reality. A work of art is a man-made creation.

While returning to Paris on a highway one night three or four years ago, back when the tunnel was still lit by lamps arranged quincuncially atop the arched ceilings, I underwent a strange perceptual experience. When seen while driving at very high speed, the two interweaving systems of points of light and geometric forms seemed to spin as soon as I entered under the arch. A stream of images, made up of figures and volumes, appeared before my eyes. The next day, while visiting an exhibit on the works of Robert Delaunay — one of the genuine pioneers of art's immediate assimilation of modern civilization — it occurred to me that Delaunay's play with light would have been unthinkable only sixty years earlier. That is, these lights revealed an immediate contact with realities that had long existed but had only recently become of interest, because technology made them accessible for the first time.

The case of Delaunay is particularly remarkable when one considers that *Disques* dates from 1912. It expressed for the first time in plastic terms the immediate experience of color, by allowing color itself figuratively to represent the total order of phenomena — and of versatility — by means of a combinatory system of simultaneous contrasts. Although he was inspired by the pseudoscientific doctrines of Seurat, Delaunay was a great precursor and contemporary of the first modern technologists but was unaware of the contemporary forms of technological objects. He did not use borrowed ideas. He did not transpose an already formulated knowledge into his own spatio-compositional language. He gave a direct artistic rendering of a perceptual experience. Delaunay's universe is constructed, not represented. It is understandable, though quite remarkable — and emblematic of his great talent — that this construction of a figurative universe was intended to convey a perceptual experience analogous to that of the scientist.

163

It thus becomes clear how talents as different as those of the scientist, the engineer, and the artist can give rise, in each discipline, to works that convey the common human experience of an era. A new universe, created by the convergence of all the systems at work in a given social group, yields new sensations, which in turn generate new culturally specific faculties and inspire a new world of objects that are utilitarian, plastic, and figurative in the broadest sense of the term.

The artist gives concrete form to perceptions by relying on a system that parallels the scientist's theories and the technologist's activities. Every object is profoundly influenced by the actions and intentions that went into producing it. By examining a product, one can always find traces of the human action that created it, which is always both a process and a final purpose. If our era is to stand out in the history of the arts, it will be not on the basis of the values it preserved but on the basis of the values it created. It will not create these values by turning its back on today's reality — a reality that consists not of an unchanging human environment but of an evolving world interpenetrated by various human activities. For a given era, artists express, in their particular language, the shape of the world and the flexible laws of the mind.

Pseudo problems, such as the opposition between the arts and technology or between inspiration and intentionality, thus begin to fade away. No longer must art, which is seen as representative of unchanging values, be forced upon a society that is in constant movement. No longer must the aesthetic function be detached from the technology of production or from utilitarian or figurative objects.

When placing the work of art among the versatile signs of a universe that constantly challenges assumptions, we cannot expect the plastic object always to conform with all others. The versatility of the work of art sets up relationships with all other

categories of objects; that is, it becomes incorporated into general human activity. Its intentionality further determines its specific characteristics. But we may speak of specificity only in relation to a whole.

So far, I have emphasized the plastic object's status as an object. But it is now necessary to focus on its specificity. At the end of this text, I will suggest a possible aesthetic approach to art in contemporary society. First, I shall more closely examine the fate of the plastic object in the late nineteenth century and the early twentieth century. Rejecting specific categories in the realm of either art or mental functions, I shall attempt to gain a finer assessment of original artistic qualities by looking at the most complex and ambiguous works of our era. The aim is not to prepare a checklist or even to establish a general survey, which is difficult enough to do for utilitarian objects, but to examine the effective role played by modern style (as generally identified with areas of technology, painting, architecture and sculpture) in the evolution of plastic objects, which, as we have seen, have been affected by the versatility that has metamorphosed all objects.

By rejecting the ideas that beauty was sporadically added to products of human activity and that there was an immanent beauty in the rational production of utilitarian objects, I shall attempt to show that in the nineteenth century there was no contradiction between the creative forces underlying mechanization and the living arts. We shall see that the notion of style is no less efficacious than the notion of technology. Like industrial mechanization and science, art — through style — is, in Friedmann's words, one of the great tests of our era.

Having earlier introduced the remarkable idea that each mechanical age is linked to its predominant form of energy, Friedmann spoke of a first industrial revolution, brought about by the harnessing of steam, and of a second, brought about by the advent of

electricity. From there, he predicted the coming third age of atomic energy. However, one could just as well characterize the eras of civilization by the institutional systems that determine the machine-industrialization relationship or by the stages of painting.

The machine first attempted to replace man in his traditional activities. It sought to reproduce the same effects and, whenever possible, in the same way; it thus sought to produce the same objects. Little by little, as it was perfected, the machine gave rise to the idea and need for new objects, that is, new forms and uses. Then it operated according to new principles. It currently tends to follow its own logic to suit its means and needs. In the first age, then, the machine reproduced human movements. In the second, it produced new objects while guiding its own movements. In the third age, the movements and objects derived from its logic were imposed on man and in due course would be adapted to decrease human labor through advances in such procedures as electro-chemical soldering. In the new industrial era, both the machine and man would suffer less from fatigue, leading to a shift in the value and appearance of the object.

There is a clear parallel between the mechanical and aesthetic evolution that the modern world has undergone. For example, our eyes and minds are daily trained to record and interpret rapidly changing relationships. Thus montages and serial combinations have become fundamental for understanding contemporary painting, sculpture, and architecture. Cubism, for its part, attempted to point to a new conception of the plastic object, a conception that no longer reflected a limited attitude and point of view but took as its starting point — and not as its final purpose — the analysis of an entity's component elements. This decomposition into component parts and rearrangement of isolated elements to evoke a new realm of experience is the guiding force behind the development of mechanization and the figurative arts.

166

Sculpture in particular strove to highlight the object's interior lines of force so as to enhance the materialization of its structure. The motivations behind abstract art are founded on the intellectual conviction that the world is a system of forces in opposition.

Before examining the role played by figurative styles in the twentieth century, I shall attempt to show that artists, and particularly nineteenth-century painters, had already laid the groundwork for a "style" that constituted a guiding force behind a newly apparent order of the universe on the same level as technological industrialization and mechanization.

CHAPTER FOUR

# Mechanization and Figurative Style in

# the Nineteenth Century

In chapter 2, we saw that a turning point occurred around 1860–80 with respect to the advance of mechanization and the application of new technology to architecture. In this chapter, I shall examine a concurrent evolution that had a profound impact on the figurative arts, particularly painting.

## Courbet and Functionalism: The Conflict Between Style and Perception

The year 1860 was decisive in the struggle to define modern art. Courbet and Manet forcefully joined in the struggle; the impressionists reached full maturity; the heroes from preceding generations, Ingres and Delacroix, produced their last efforts. One might wonder if the evolution of painting ran counter to the development of technology and science.

It is freely admitted that there is a parallelism between the developments in twentieth-century art and technology. Cubism is commonly identified with mathematical discoveries leading to a new conception of physical space. And it is generally agreed that there are deep affinities between Degas's studies of movement and the development of photography and film. But there is great reluctance to think of the impressionists as influenced by scien-

tific research into the structure of light; and many shrug their shoulders if a connection is insinuated between the rise of contemporary painting and the extraordinary material transformation of the world in the wake of modern technological inventions.

The relationships between these events are, however, incontrovertible. The starting point can be situated even before impressionism. Courbet had already posed the two great problems that would transform the figurative arts and affect the evolution of society's technological activities. It is generally agreed that he first exposed the crux of this problem. There is less agreement that he also posed the problem of form. To some extent, this was his fault because he vehemently insisted on the former aspect of his work, which incited the greatest reaction from a public hostile to all modernist thought. In 1849, Courbet wrote of *After Dinner at Ornans*: "You cannot give a false color to something whose existence in reality escapes us." However, Jean Cassou has pointed out that, when Courbet was painting a pile of branches too far away for him to see clearly, he would suggest it visually through a few dabs of color and leave it to a friend to go off to identify the implied but not fully represented object. This anecdote is proof that the principle of the destruction of the object is already contained in Courbet's perception, if not his style, because he is intent on offering the viewer perfectly readable subjects. Insofar as that readability amounts to simply putting patches of color in certain parts of the canvas in order to bring the painting into balance, he intentionally forgoes explicit detail. However, no general aesthetic principle is derived from this. His vision is more modern than his theory.

The painting of reality, even its ugliness, is where these two starting points converge. The theory had already been affirmed in 1849 by *Funeral at Ornans* and *The Stone Breakers*. But the attack on the hierarchy of moral and social values was more intense than

that on the object, although the offensive against the object was the most boldly revolutionary.

Courbet, like Baudelaire, accepts the idea that the purpose of art is to represent nature and ourselves, with a view to expressing the physical and moral perfection of the human race. He does not envision the representation of man and objects outside their social milieu or familiar surroundings. His aesthetic sensibility is based in reality, not the imaginary. For him, reality does not pose a problem. There is nothing disturbing about the nature of the object or the human figure, despite the slightly odd signals picked up by the eye in specific cases, as with the pile of sticks. In the arts, Courbet serves as proof that a discovery does not necessarily lead to the construction of a system.

Furthermore, it is evident that throughout the ages artists who strove to record sensations experienced impressions that ran counter to their style. This was recently proved to be the case with Jean Fouquet, whose sense of curved space was like that of the ancient Greeks. In each case, the artist attempted to purge abnormal sensations so that his representational system would accord with an established belief in the mathematical and orthometric structure of the world.

Courbet's sensitivity to color contradicted his beliefs. For him, realism resided not in an analysis of the fundamental tenets of knowledge but in the unscientific, anecdotal choice of subjects according to social values. Ultimately, his style implied the preservation of form through traditional drawing. True revolutionaries are not those who critique society but those who propose another one.

Mauss offers a fascinating definition of drawing: "A drawing always comprises several elements, even when there is nothing more than a single line. Every drawing evokes an expression or an impression: an expression on the part of the drawer, an impres-

sion on the part of the spectator, who receives the shock.... A drawing comprises a number of lines that interact to present a motif. The unity of the motif is in fact the unity of the drawing. The difficulty arises from the fact that the drawing has the meaning that people wish to give to it, whether it is geometric or imitates the natural order." Mauss evidently has been influenced by the development of contemporary art. He owes his notion of motif to Cézanne and his notion of impression to Monet. "One can always extract a motif from any form," he adds. That was precisely the notion that Courbet did not have. Not unlike a chair or a piece of fabric, a fork or a table, the human form and a landscape seemed for him objective realities, subject to natural laws. And so, ordinarily, the goal of art was to emphasize one aspect or another of that exterior reality that for five centuries had been seen as lying within man's environment — an extra-natural environment, it cannot be overemphasized — and entirely determined by the creations and practices of a social group at a given time and place. A Roman or a Greek would not have understood what was going on in *The Stone Breakers*; and, for a Hindu, the rites in *Funeral at Ornans* are completely incomprehensible. We write the history of art and the history of technology according to an outdated form of the history of civilizations. That form is one foundation of the theory on the natural environment.

In short, Courbet is in a position somewhat analogous to that of Viollet-le-Duc or Ruskin. He stands out in stark contrast to them because he embraces progressive doctrines, but he is more audacious in his ideas than in his mode of interpreting reality. Like the architects and industrialists of 1850, he wishes to convey new values, but he sees these problems through the eyes of a reformer, not those of an innovator. From this perspective, Catholics and socialists who, around 1850, wanted to use art to serve propagandist ends and were in agreement on "utilitarian art" ultimately

adopted the same traditional intellectual outlook to comprehend the basic data and mechanisms of artistic expression as the defenders of art for art's sake.

At this moment, the great polemic over Content and Form began — a debate that was to undermine the proper assessment of the role of art in society. It was to painting and sculpture what the theory of functionalism was to architecture. For a long time, it impeded industry's efforts to manufacture objects similar to those produced by hand in preceding centuries. In no area was there a real awakening to the existence of a new universe. The Renaissance lived on.

*Impressionism: Sensorial Analysis*
Towards 1880, there were two groups of men — scientists and painters — for whom not only social reality but, even more, the so-called reality of nature no longer had its familiar aspect. As Marcelin Berthelot was overturning the fundamental concept of chemistry, replacing Lavoisier's quantum theory with the theory of organic chemistry, as Claude Bernard was challenging Linnaean-style classification systems and promoting an interpretation of life based on an unbiased empirical study of the facts of biology, and as Michel-Eugène Chevreul was analyzing light instead of measuring its speed, thereby yielding an entirely new understanding of color and setting down new possibilities and principles for some basic industries, such as that of colorants, a small group of artists was modifying the fundamental sensibilities of painting.

No longer would they espouse a social or political movement. Now all that mattered was painting itself. They adopted as their guiding principle their absolute faithfulness to their sensations. They also stated that, as part of their desire to convey their new values in plastic terms, they would embark on unprecedented modes of artistry. The impressionists played an important role

not only in the internal development of Western painting but also in their being one of the first groups to express themselves coherently, independent of centuries-old conventions. They did not believe that the form of phenomena was prescribed by nature or by the idealized formulas in museums. They did not believe that traditional perspectival relationships adequately reflected what emanated from nature. They did not believe that the world was illuminated like an artist's studio, with light falling at a 45-degree angle. Nor did they believe that one merely had to turn on a lamp or pull back a curtain to expose all of the world's mirages. They did not believe that a benevolent divinity had definitively endowed men with all of the colored powders needed to satisfy their need for plastic expression; nor did they feel that there was one method for mixing colors, or that there was a given number of formulas for blending them, or, finally, that the relationships between form and colors were fixed for all eternity.

As for the question concerning the order of precedence of Chevreul's and the impressionists' discoveries, I think it poorly put. It is a fact that Chevreul had laid down the principles of his discovery before the first impressionist paintings. On the other hand, the impressionists exhibited their paintings before learning of Chevreul's writings. It was, rather, succeeding generations of artists, from Seurat to Delaunay, who followed his works closely. It is absurd to suggest that a given form of art could have been or was derived from Chevreul's writings. But it is equally absurd to argue — as does John Rewald — that there is not an affinity between Chevreul's theory and the development of impressionist art. They are linked not so much by a cause-and-effect relationship as by correspondences on another level.

In both cases, we must keep an open mind when observing phenomena that have always existed in nature but that, until a certain moment, were not seen or, more exactly, were not con-

nected with other series of practical observations. It is not the physical fact of nature, as it were, that explains the development of Chevreul's theory and impressionism. Rather, it is the simultaneous recognition by artists and scientists of the importance of phenomena that were always perceptible but were to be discovered only by men who possessed certain similar needs and mental structures.

The impressionists' discovery is twofold: they replaced the former notion of the Object with a newer one; and they revived the analytic study of Light and Color. When Monet set up a canvas in a garden in Ville-d'Avray in order to paint in the open, he discovered that the flickers of light cast on the dresses of women seated under a tree created forms that overlapped the traditional outlines of the object. At the same time, he discovered that the surrounding shadows made the white fabric appear blue or green. The famous painting in the Louvre is no less a historical document of human thought than Bernard's treatise *Médicine expérimentale*. In 1867, Monet laid down principles of vision and representation that preceded Henri Bergson's *Données immédiates de la conscience* (translated as *Time and Free Will*) by twenty years and Jean Piaget's and Henri Wallon's treatises on the genetic psychology of the child and modern concepts of the progressive discovery of the notion of the object at the dawn of human existence by sixty years. He was more advanced than Herbert Spencer, who around the same period developed a Darwinian evolutionism, or William Le Baron Jenney, who constructed buildings in Chicago conceived as enlarged classical houses and adorned his architecture with decorative patterns. He preceded Ruskin by two generations. It was a mistake to associate the religion of Beauty with any and all traditional works. It was not Ruskin who heralded the art of the modern era, it was Monet. And Monet was, for his time, in accord with the boldest scientific discoveries.

This was not by mere chance. Artists and scientists saw new groupings of phenomena, and they alone expressed them in transmissible languages. There is no contradiction between scientific, artistic, and technological progress, as long as they are explained not in terms of parallelism or borrowing but by reference to the original vital sources of creation.

I am not saying that artists and scientists lead the world. They are far from realizing the dreams of Joseph-Ernest Renan, another great creative mind that sought radically to reinvent the relationships between phenomena. It is not they who develop the possibilities within perceptions — though they are often the first to define and to make apparent and communicable these perceptions. Scientists, technologists, and artists move in realms that never intersect. Yet no matter how radically different their mindsets, they create intellectual structures that are projected into works or activities. Finding themselves in a common social milieu and confronted with the same phenomena and possessing the same powers, is it any wonder that they render them, each in his own way, according to the same sensibility and logic? Their modes of action, be it working with concrete or abstract models or creating material or figurative objects, are unevenly distributed. Current developments in art prove that artists are not necessarily the adversaries of technologists and scientists.

In the last section of this book, I shall examine the specificity of aesthetic signs or symbols in light of the institutional impact. Around 1880, artistic creations were closely linked to scientific theories and to the manufacture of utilitarian machines and objects. I shall refer to the remarkable preliminary inventory of contemporary objects prepared by Giedion. It evidences an attempt to adapt the object directly to the pure gesture, which obviously parallels the impressionists' simultaneous attempt to rationalize optical sensations. It is clear that the rationalization of forms

depends on gestures that are facilitated by tools. It is also clear that each gesture is influenced by contemporaneous technological developments. The lever arm was not viewed in the same way in the century of the machine as it had been in the time of the pyramids. Seemingly simple creations, such as harnesses used for oxen or horses, are linked to an entire system of practical and theoretical knowledge. The form of a lever varied from one period to the next, depending on the understanding of force. It also varied according to the quality of materials used to forge the lever cap and the arm. This is all easy to see, but it is much more difficult to accept that a painting's meaning varies in the same way, depending on the mechanical and conceptual transformations that prevail at a given place or time.

However, the impact of technology on the work of art around 1860 is readily apparent. If Monet painted light, it was because his notion of color differed from that of his predecessors. Heretofore, the entire theory of color centered on the idea that a very small number of simple colors existed in nature. What is more, when reading Alberti or Leonardo, one notes that they had a very approximate and even confused idea of the relationship between color and light. Until the modern era, a painter's artistry was measured by his capacity to represent light cast on objects, that is, to present "real" colors as revealed optically and concretely in nature. By all evidence, this view stemmed from a belief in the reality of color, which was associated with pigments poured into an excipient as they were grounded. Following advances made in the nineteenth century, impressionist painters discovered that light is not simply reflected by surfaces covered with colored pigments but is one of the fundamental physical realities, one of the absolute forms for understanding the universe. It logically flowed from this idea that light not only reflected the color of phenomena but was intrinsic to appearance as a complex whole, a total

effect that was infinitely richer than had ever been suspected. Impressionism is based on a new conception of the correspondences between objects and the eye and on a new conception of the physical nature of light, henceforth included among the vital forces of nature.

Although the impressionists' discovery, which grew from an empirical analysis of the artists' sensitivity to color, parallels the discovery made by the scientist, which is based on another order of speculation, it does not follow that the impressionists were guided or initiated by the latter. In both cases, the trail of discoveries started with challenging traditional rules of judgment based in psychological and social fact. The discovery of wave theory is certainly not the culminating point of the optical and pictorial analysis of light, although it came half a century after impressionism. What was modern in 1880 was not technology, science, or painting per se but the efforts of men who adapted modes of activity to serve purposes that sometimes conformed to established social factors and at other times prompted a reexamination of the infinite array of appearances. It is natural that around the same time the object underwent a corresponding metamorphosis in plastic, technological, and scientific thought.

## The Unequal Development of Nineteenth-Century Techniques and Styles

Regardless of the thought or activities involved, a split and a mutation occur only when men create new systems that give rise to a new experience and lead to a reassessment of the mind's powers of understanding. The various activities converge in the social realm. However, these activities do not always advance at the same pace. Sometimes it is technology and at other times the arts or the sciences that is more or less slow to produce works that reflect an era's most revolutionary concepts. Moreover, mass

production is slow to align itself with figurative works that offer no practical solutions or are purely speculative and therefore not as readily accessible to the general public, although these works provide general solutions that lead to a more acute break with the established order. A society adopts the Frigidaire or the typewriter more readily than it does abstract art. And so there is no way to assign a specific date to the moment when a science or an art or a new technology is born. Earlier forms of art, technology, and science have produced works that will continue to be considered valid, even after new principles have been discovered that prepare the way for the slow, final conquest by different modes of perception. It is not entirely certain that the most representative works of an era are those that herald the future. Monet and Renoir, and not Bastien-Lepage or Fantin-Latour, were the painters of 1880. Similarly, the scientists who marked those years were Pasteur and Berthelot, and the technologists, Eiffel and Sullivan.

This is a matter not of belief in determinism or randomness but of historical fact. The civilization of 1860 produced numerous valid ideas, but it is clear that the use of optical displays instead of a system of weights and balances to measure masses marked a definite advance in the understanding of the structure of matter. However that may be, impressionism and its outgrowths constitute absolute progress in the handling of the nuances of light and color, which would thereafter be conceived as combinative aspects of the unique forces of matter.

Unfortunately, neither architecture nor the other figurative arts had their Monet or their Cézanne, their Berthelot or their Bernard. The greatest creations of the period were extensions of principles dating back to 1850. Contamin's 1889 Galerie des Machines and even the Eiffel Tower reveal a system of equilibrium that grew out of thinking from mid-century. It was only in the late nineteenth century or even the first years of the twen-

179

tieth century that architecture would finally create genuinely modern works. The 1903 Perret building on rue Franklin, Tony Garnier's 1905 projects for Lyons, Josef Hoffman's 1905–1911 building in Brussels (the Stoclet House), and Adolph Loos's campaign against ornamentation in architecture constitute, in my opinion, the first steps to align architecture with modern art, science, and technology.

It is easy to understand why architecture lagged behind painting and even technology, insofar as architects depended entirely on commissions to realize their projects and on individuals or consortia that were by definition conservative. Nonetheless, it was a matter of a lack of individuals of genius more than anything else. The trial-and-error process undertaken by even the most innovative architects is still evident today. The coordination of architecture's formal material-related problems takes more time than does the rendering of the purely figurative or conceptual project. Architecture suffers from its engagement with material and social factors. We shall see later how architecture progressed along the path of modernism, especially after 1910, but clearly, for a long time, this lag worked in favor of the purely figurative arts. That is what led to the difficulties and confusion that plague traditional explanations, such as those of Sigfried Giedion and Bruno Zevi. It is not appropriate to explain current architectural developments in light of the Arts and Crafts movement or the founding of the Union Centrale des Arts Décoratifs. The idea of a compromise or the dream of a marriage or at least a reconciliation between arts and industry is an ideal held by men of the mid-nineteenth century. Lacking the support of the figurative arts, technology of that period could not create living forms representative of contemporary civilization. Architecture did not enter the flow of the creative stream until it drew closer to figurative styles. This is a step that cannot be denied. That is why surveys of

modern architecture that do not take into account the impact of the discovery and use of reinforced concrete and do not examine its connection to the new painting of the Paris school fail to give a coherent historical picture. The reasons for this are all obviously nationalistic.

It is not possible to explain the factors underlying change by limiting an explanation to art, technology, architecture, or painting alone. To avoid protracting an already lengthy discussion, I shall not go into a detailed study of the work of painters from the end of the nineteenth and the beginning of the twentieth century. Rather than trace a history of taste that embraces all disciplines, I shall emphasize only the close relationship that has existed for three quarters of a century between architecture — the contemporary art most clearly linked to technology — and purely figurative styles.

# PART THREE

# Twentieth-Century Art Forms

# Introduction

I set out to examine the repercussions that the machine had on the development of contemporary art. To assess the present situation, it will be necessary to present the problem from a historical perspective, going back to art's original encounter with the new forces of industry.

Two difficulties become immediately apparent. First, it is not possible to make clear distinctions among the machine, technology, industrialization, and science. In current language, unfortunately, these phenomena are not easily distinguished, and intellectual faculties are confused with experimental processes or economic or social facts. As a result, analyses of the subject are wrought with confusion. Quite often, discussions are confined to traditional views that depict the Machine as an adversary of Art and, more generally, of forms of high culture. Thus there is a tendency to be contented with a simplistic chronology suggesting a natural opposition between Technology and the Arts.

However, in examining architecture's evolution in relation to the use of new technologies and materials that sprang from human creativity, it appears that the undeniable clash between technological proliferation and aesthetic traditions linked to the use of age-old materials and to the devotion to past symbolic and utilitarian

forms led to much more than merely a decline in art's particular values. Cross-fertilizations developed. Interactions took place between theorization and practical activities that guided the evolution of architecture — interactions that until now have been interpreted primarily through theories on the relationship between nineteenth- and twentieth-century art and technology.

Thus, rejecting the idea that human qualities are naturally in opposition to mechanical phenomena, which represent an evil power that fate has put in humankind's path, I shall objectively examine the rupture caused by the development over the past century and a half of man's power to use technology to exploit his universe. In spite of the debates as to whether there was a passage from a natural, immutable environment to an artificial environment, and as to whether past civilization was free of pressure for material necessities in an atmosphere of leisure, and as to whether there exists a Nature exterior to man that only needs to be deciphered, it is generally agreed that extraordinarily violent changes altered the way in which man and the artist confront the world. But there has been reluctance to make a sweeping contrast between the pure forces of art and the impure forces of the machine, the latter being a vague term encompassing diverse forms of activity. By viewing art as not just pure contemplation or irrational intuition but also as action and the creation of figurative objects, my approach will be based on fact, thereby enabling me to avoid the romanticized explanations in which the noble forces of art and the evil forces of the machine vie for the human soul.

A problem of methodology inevitably arises. It involves deciding how to approach the practical implications of art forms while adhering to a concept that defies categorization and acknowledges interactions between works produced by machines and those that are products of the mind.

It becomes apparent that the fundamental problem is that of

the plastic object. As soon as one rejects the notion that an art form can be identified with certain natural, or supernatural and immutable, values of a small group of societies, the work of art is no longer fixed. Between an absolute work, which disowns its links to the material world, and a humble work, which even in the most utilitarian or brutish creations retains some trace of figurativeness, there is an entire array of variations; and it is not easy to determine the degree to which they are truly autonomous works of art.

## From Rupture to Change

Leaving the realm of theorization, I would now like to show how this expanded concept of the plastic object makes it possible to review the history of artistic transformations in relation to key phases in the proliferation of the products of industrialized technology in the modern world.

Two observations still need to be made. In our era, man's separate activities appear to supplement each other. However, nothing could be more false than to conclude from this that the history of society is the sum of specialized activities carried out independently of each other. Save a few rare exceptions, there is no truth to the idea that works of art contain features that can be attributed to a given series of technological developments; nor is it true that certain types of people engage in their line of activity while keeping to a single form of intellectual inquiry. Technologists do not live in a closed world, cut off from scientists and artists; their points of view are different, but their works generally overlap — because their works, though involving different activities and modes of expression, reflect a reality exterior to man. More to the point, they reflect the fact that the real world is the product of collective human action, and the milieu in which man lives is a fabricated world.

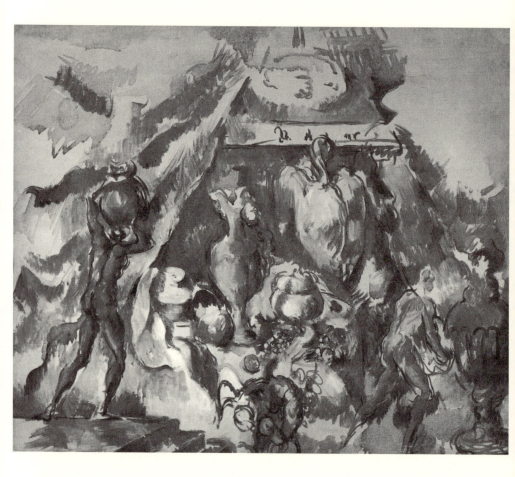

Figure 9. a. Paul Cézanne, *Les Préparatifs du festin*. b. Georges Braque, *L'Homme à la pipe*, 1912–13.

Modern painting challenges the stability of objective perception.Cézanne's romantic composition distorts the object by abandoning the human scale. Braque's cubist painting calls attention to the object and plays up the antinomy between form and tone. It isolates the object's spatiotemporal elements and projects them into a purely figurative order on the two-dimensional canvas. (a. Giraudon, Paris; b. Öffentliche Kunstsammlung Basel, Kupferstichkabinett. © 1999 Artists Rights Society [ARS], New York / ADAGP, Paris.)

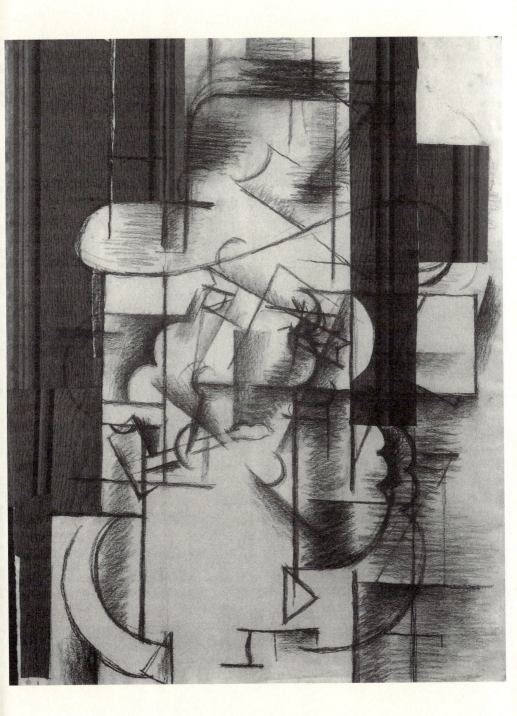

The point of reference that makes it possible to determine the value and expressive quality of an object is society, not an absolute. Like the human body, society has functions. The complementariness or correlation between human activities should therefore be seen as open-ended and not as rigidly fixed. The relationships between specialized activities do not reflect a model; they are attributes of an unfolding reality.

In our era — and throughout the ages — some activities have produced works that have proved conformist, while others proved progressive. A society capable of creating only innovative works is unthinkable. It would constantly have to leap into the unknown. Man cannot conceive a principle and then spontaneously carry it through to its fullest development. Indeed, principles do not necessarily have an absolutely final development, with definite consequences. Principles can be borne out only to the extent that they can be put into action. The reconstruction of a society on the basis of an ideal is precisely the realm of Utopia. That is not to say that Utopia does not serve as a model for the world: it is in the imagination that the most concrete forms of human activity — whether industrial, reflective, or intuitive — are first envisioned. It remains, nonetheless, in permanent struggle with reality — which is yesterday's Utopia, just as today's Utopia can become future reality.

Figure 10. Fernand Léger, *Femme tenant un vase*, (definitive state), 1927.

Modern painting created new objects that, when combined with previous objects, expressed a new sense of space. The object itself was preserved and even glorified, but it was projected into a space without operative coordinates, promoting it to the ranks of the absolute figurative. At the same time, the artist combined it with plastic elements on the level of the object. Reality was entirely figurative. (© Solomon R. Guggenheim Foundation, New York)

Starting from the idea that various human enterprises ultimately produced both activities and objects, I noted that human actions were carried out in a universe increasingly affected by figurative, not to mention scientific and technological, activities. Living amid unprecedented technological and mental activity, contemporary man experiences new sensations through a culture that touches on all forms of human action. Man does not live in a mechanized world, properly speaking. Mechanization is merely an economic and social aspect of an infinitely broader change. I intend to stress the contribution made by specific forms of modern art toward the elaboration of a new general system through which the world is perceived and represented.

# The Stages Of Architecture

# After 1900

In an earlier chapter I showed the circumstances that, throughout the nineteenth century, marked the confrontation between traditional architectural styles and new technologies. While at first leading only to an increase in the number and quality of assembled parts, technology developed through industrialization and seemed at one point on the verge of replacing the arts entirely, yielding not only new materials but indispensable and self-contained rules of invention. The relationships between art and technology were thus influenced by the widespread belief that technology would open the way to a new age, one perhaps lacking in beauty but nonetheless unprecedented; and the engineer stood on a par with the artist as the new driving force behind society's most significant activities, be they architectural, economic, or social. In the first era, the aim was, consequently, to bring aesthetics into harmony with mechanical possibilities. That period was followed by one in which mechanization took command, after having come to be associated with technology and even science — marking the engineer's ultimate triumph over the architect, not to mention the triumph of practical reality over the imaginary.

However, on closer examination, the superficiality of these earlier theses became apparent, as has that of recent historical

studies, which argue that the machine replaced activities that had determined aesthetic principles. We have seen that the machine influenced the orientation of architecture from 1860 to 1890 only through ideological theorization. It was also shown that the New World, which, by reason of its youth, was quicker to embrace technology, did not make real inroads at the expense of the Old World before the beginning of the twentieth century. Now that I have shed light on the complexity and ambiguity of the plastic object, I will more closely examine the actual relationship between technology and art in the development of modern architecture since 1900. I shall attempt to do so by assessing the current arguments that reduce this history to a conflict between rationalism and organicism, holding out the promise of a new golden age. While focusing on the highly complex object that is architecture, I shall also note elements that may be regarded as intrinsically artistic and may legitimately be associated with other modern figurative activities.

It is not easy to pinpoint the event that around 1890 definitively led to the rise of modern architecture. The widespread availability of reinforced concrete is not, in and of itself, a sufficient explanation, since the steel-skeleton framework, which had appeared by 1870, was just as efficient and yet had an equally indeterminate impact on inspiring a new style. It can hardly be said, either, that the application of new research toward private architectural projects was behind the rise of a new architecture. Americans had already passed beyond the stage in which a formative art was developed primarily through building projects commissioned by public authorities. What is more, the efforts of men such as Eiffel and Jenney evidenced a will to discover a new style based on avant-garde techniques.

Bruno Zevi has pointed out the impossibility of linking the development of modern architecture to a single sequence of

events. He states that four forces acted simultaneously to pro-
mote the gradual creation of a new attitude toward building
design: changes in taste, scientific and technological progress,
new theories on figurative vision, and a radical transformation
of society. But Zevi had set out to reveal the gospel of a new,
organic architecture — the architecture of tomorrow — rather than
to study, step-by-step, the history of the relationship between art
and technology in the creation of contemporary styles. And so,
when examining the role played by aesthetic theories — which he
groups under the headings of the various isms — in the creation of
new architecture, he points to cubism, expressionism, purism,
constructivism, futurism and of de Stijl, all of which, in reality, all
concern the development of twentieth century art and not the
all-important turning point that occurred in the last decade of the
nineteenth century. When he speaks, all too cursorily, of social
factors, Zevi states only that their impact was felt primarily
through the English Arts and Crafts movement, which dates back
to 1870, and through urbanism, which came thirty years later and
almost as a counterreaction to what had preceded it. While ana-
lyzing the masterworks of the first so-called modern age of archi-
tecture, Zevi likens Berlage to Perret, Horta and Loos to Antonio
Gaudí y Cornet, as he constructs a diffuse chronology of events
and, ultimately, underestimates the importance of the years be-
tween 1890 and 1900, which, in fact, were crucial and innovative.
Moreover, he extends the period in the other direction to 1920,
the year by which, in his view, the entire vocabulary of modern
art had been mastered and the rationalists had begun to reject the
academic and inhuman character of contemporary art. In his view,
the road to salvation was paved by the principles of the organic
style, which had already been incorporated into the vocabulary of
modern art and whose development had been fostered, in large
part, at the start of the century by his hero Frank Lloyd Wright,

whose revolutionary spirit had unquestionably dominated universal art for forty years.

Giedion, for his part, further emphasizes the scope of the crisis which he dates from 1893, the year of Sullivan's disappointing reception at the Chicago Exhibition, which, while signaling the end of the age in which his precursors had reigned, heralded the age of a sterile and destructive rationalism. It was the moment when, in Holland with Berlage, in Belgium with Victor Horta and van de Velde, in Germany with Peter Behrens, and in Vienna with Otto Wagner, an international modern style first appeared. Thus, for him, the period from 1890 to 1920, prior to the arrival of pictorial and sculptural avant-garde styles, is of capital importance in the development of a new architectural spirit. For Giedion, more so than for Zevi, this period is far removed from earlier movements, but it is also surpassed by and at variance with recent developments in organic art.

I shall thus try to determine, first of all, if a modern architectural style sprang from advancements in technology or, in the words of Giedion, from progress in mechanization. Then, I shall attempt to identify the mainspring that next led to the development of a rationalist form of this style before it was effectively eclipsed by active tendencies that had already been manifested in American-led projects between 1890 and 1905 and would later prevail through the messages of Wright and the Scandinavians.

### International Sources of Art Nouveau

In the available theoretical treatises, there is no mention of art nouveau per se. The belle epoque is ignored by modern architectural historians. There is only an account of the rationalist evolution, which, as we have seen, was contained in the doctrine of integrated art. No matter what reservations one might have regarding its quality, it seems necessary to devote some attention

to art nouveau, which was the first style to seem truly international and which, in certain regards, tightened the loosening ties between architecture and the other figurative arts. The last ten years of the nineteenth century not only stand as a testament to the temporary worldwide success of the floral style but also mark the prelude to rationalism and the organic style.

More specifically, two tendencies coexist within works like Horta's: the floral and the constructive, which came together without fully blending; and Loos's crusade is contemporaneous with the triumph of the Gallé style at the Exposition of 1900. This confluence, which characterized the ongoing conflict between structure and ornamentation, already existed in the works of Richardson and Jenney. The influence enjoyed by the overly elaborate style that came to be called the Studio style is linked to a pro-ornamentation movement that dated back to the middle of the nineteenth century and should not be confused with the encounter between the figurative style and architecture under cubism between 1910 and 1930.

Berlage is at the forefront of the men who made their mark in the years between 1890 and 1900. This Dutchman was among the first to take lessons from America. He wanted to find out firsthand the conditions under which industrialization was developing in the New World. Influenced by America, he constructed the Amsterdam Bourse between 1898 and 1903. Later, after returning from a trip to the United States in 1911, he introduced the Wright style in his country.

The Amsterdam Bourse is generally considered a landmark of the avant-garde spirit. I must admit that I find it difficult to share this opinion. The building is heavy, austere, and bulky. It was inspired, moreover, by the neo-Romanesque style, which, in 1880, was seen as having freed itself from the neo-Gothic or Renaissance manner but which, nevertheless, falls into the category of

a historical style. Americans in Chicago had followed that path. Richardson and Sullivan were caught up in the decadence of the historical styles toward 1893 because they did not counter their adversaries' formalist traditions with a taste clearly linked to recent constructive possibilities.

Through the neo-Romanesque style, however, Berlage discovered a focus of true plastic value: the wall. Without a doubt, that discovery would prove a crucially important element in the upcoming sequence of events. But the wall openings, the material, and the shape of the wall are not used to achieve a revolutionary effect. The contrast between structure and surfaces would not be expressed explicitly and cogently until Loos in 1897.

It is difficult to justify the view which holds that Berlage's ideas were a precursor to the open plan and the human interior space. His Bourse has more in common with the countless covered marketplaces built in the nineteenth century, ranging from those in Paris and London up to the Galerie des Machines (1889) and the Grand Palais (1900). It is more legitimate to characterize him as an innovator in the area of moral rigor — that is, of austerity. When looking at his work, one does not get the impression that he introduced a practical plastic expressiveness to the fundamental abstract idea. His building is as nude as *Namouna*, as naked as the wall of a church, and as didactic as an academician's lecture. An ingenious compromise between the Rhineland neo-Romanesque and the Doge's Palace, via Richardson.

After Berlage, the pioneers of modern architecture around 1900 are the Belgians Horta and van de Velde. When the Tassel house built by Horta in Brussels in 1893 at 12, rue de Turin is praised, it is described as the first example of the open or free plan, the brightest star in the firmament of the future rationalist style as well as the organic style. But no one ever mentions that the Horta house first appeared as a very precocious example of

the spinach style. Everything about it is curve and counter-curve; the architecture is covered with floral ornamentation. The work announces the style of the Paris Métro and is closely related to Gallé and the Nancy school, which neither Zevi nor Giedion seems to suspect as having been influences.

Also, a crucial point is overlooked. Local customs govern the entire plan of the Horta house. In Brussels, all houses are on plots of land whose narrowest side faces the street. The layout of the property continued to be determined by medieval tradition, which situated houses at the most desirable location on a street. This preference arose from Belgium's having preserved its customs of family life. As a result, virtually all of the houses in Brussels retained the remarkable feature of having three rooms arranged in a line. To accommodate common areas — living room, dining room, bedrooms — architects had until that time followed the convention that had led to the creation of an indirectly lit room at the center of the house.

The genuine problem resolved by Horta resides in the importance he ascribed to the stairwell in the overall plan. The house on rue de Turin differs from ordinary houses in Brussels because, between the room facing the street and the two interconnected rooms overlooking the garden — one room being dark — there is a monumental staircase illuminated by a skylight. From the blueprint, it is clear that the architect was engrossed by the problem posed by the stairwell — or rather, two stairwells, for there is a service stair in the standard blueprint. In a large number of houses in Brussels, the problem of the staircase was resolved by enlarging the proportions of the standard house and sometimes by breaking the rule of three rooms arranged in a line. The novelty and boldness result, ultimately, from the superficial ornamentation and especially from the strict unity achieved between the floral curves of the decor and the iron column that supports the flight of stairs.

Here, we are in full Gallé style, as well as within the mainstream of the English style, as embodied in the cover of *Studio* magazine or in the staircase entrance to the Métro.

The other typical Horta work is the Maison du Peuple in Brussels. Built in 1896–99, it totally lacks the unity that typified the organic style then in vogue. The meeting hall is reminiscent of wrought-iron marketplaces. The service areas are outside the main structure but not linked to it organically. As for the style of the facade, the less said about it the better. It shows no progression beyond the St. Louis wharves.

In 1927, Baron Horta finally revealed himself to be more preoccupied with honorary titles and ribbons than with lasting glory. He played a decisive role in the rejection of Le Corbusier's project submitted for the League of Nations Palace in Geneva. This act of complicity with the opponents of the man who is now regarded as his adversary does not help to enhance Horta's image as an innovator.

With van de Velde, the situation is quite different. Van de Velde is above all a theorist. However, he built several important works: his house in Brussels, in 1892, and the Werkbund Theater at the Cologne Exposition, in 1914. But neither is enough to justify his reputation. In avant-garde architecture, he played a role similar to that played by André Lhote thirty years later in spreading cubism. Like most builders, he expressed himself better in practice than in words. Van de Velde's creative importance is highly debatable. He lacked as much in character as in real talent. In a first period, he became the exponent of English style in his country. At that time, pro-English sentiment had become the fashion. Thus in a series of conferences he gave in Brussels between 1894 and 1900, he was seen as the exemplar of ideas dating from 1850. He was then the defender of art in the face of industry; on this point, he remained true to his ideas, for although

he took up the themes of Paul Souriau and the Nancy school, around 1895, announcing the eventual marriage of beauty and machine-made products, at the Deutscher Werkbund Congress in 1914, he clashed violently with Hermann Muthesius, who called for the production of strictly mass-produced materials and claimed that standardization would dictate the rules of beauty best suited to the machine age. He then proclaimed that the artist is a passionate individualist and a spontaneous creator of pure beauty. Hence the period in which he defended the idea of marrying the arts and industry, under the aegis of industry itself, seems no more than an interlude between the two idealist phases of his doctrine. An ardent admirer of Germany, after having been the promulgator of English ideas, van de Velde is treated with great respect by figures like Zevi who are more aptly seen as European propagandists for foreign influences than historians of modern architecture.

It is a gross exaggeration to present van de Velde, who settled in Germany around 1900, as the initiator of the European art-nouveau movement. However, some would have us believe that he preceded both Charles Plumet and Pierre Selmersheim in France and Otto Wagner and Joseph Olbrich in Germany and the Vienna Sezession. This fits in with the idea that true artistic movements are born from the artistic theories of their popularizers. It also reflects an extraordinary misunderstanding of the great European cultural movements in 1890 and 1914.

In Zevi's book, there is a fascinating chart mapping out the great movements that shaped modern art. It is astonishing that none of the routes leads to Paris and that Brussels is placed at the center of universal culture. Granted, Brussels played an important role. It was an active and liberal city and was receptive to controversial forms of art, thanks to the spirit of a group of international figures. Brussels had welcomed Wagner before Paris, and it was a hub for artists and poets. The Artistic Circle of

Brussels and the Movement des Vingt were major forces behind Old Europe's initiation into the modern arts. Van de Velde played a role in this movement by introducing first English then German styles. At the same time, it is absurd to single out Brussels as the originating point for new ideas — simply in order to eliminate Paris from the history of contemporary taste and art. Anglo-Saxon culture deserves better disciples than Bruno Zevi. This is not intended to deny England's place in the genesis of modern architecture. It is a protest against the systematic minimization of Germany's and France's contributions to the innovative movement.

In reality, around 1890, there was a great movement that traversed all borders. Van de Velde's art nouveau took the form of Art Moderne in France, Jugendstil in Germany, Sezession in Austria, Modernismo in Spain, and the Liberty style in Italy. In England, the Arts and Crafts movement seemed to have lost steam by then and no longer showed the same vitality. It was an extension of ideas from the 1850s whose Franco-British origin I have already shown. It is undeniable that in France itself a pro-English sentiment had often associated the modern style with Morris and Ruskin. This association would culminate not only in the Paris Exposition of 1900 and the Gaudí style in Barcelona a little later but in the painting of Pierre Bonnard, Edouard Vuillard and other Nabis painters until around 1920.

In the face of this linear and literary movement, there developed a French tradition that sprang from Viollet-le-Duc and was associated with functionally inspired works. It is possible to see it as a fresh contribution to the years stretching from 1890 to 1900, toward either Charles Mackintosh's School of Applied Art in Glasgow (1894–1909) or Otto Wagner's Postal Savings Bank in Vienna (1905). We approach the Chicago style in 1885, linked, as we have seen, with the rational use of the steel framework.

Everywhere there was an oscillation between the austere style of Mackintosh and the floral style of Horta. The interrelatedness of structure and decor is the most salient feature of this period. In Paris, even as late as 1903, the house built by Auguste Perret on rue Franklin has one of the boldest plans imaginable; however, when viewed from the exterior, it belongs, like Horta's Maison du Peuple, to turn-of-the-century style.

And so toward 1900, there were two major international movements. They both arose from the working of iron and steel to enhance and preserve classical forms. This led to the superimposition of identical parts, the piling up of cubes, and the freeing of forms but was intended to serve technological ends, as was the case with the Maison du Peuple or the house on rue Franklin. At the same time, two major decorative principles entered into direct opposition: one based on the straight line, under the influence of Mackintosh's school, the other based on a floral curved line, as was the case with the house on rue de Turin and the Gaudí house in Barcelona. All these ideas dated back to mid-century. Both of these opposing principles — one seeking to integrate structures through the unity of surface ornamentation and the other seeking to maintain a strictly structural harmony — sprang from experiments carried out before 1880 throughout the world.

That said, the debate over the rank of one creator or another, or the dominant role played by a given group, seems pointless. The disputed originality of the men of 1890 and the ascent of an earlier organic style, which timidly appeared around 1890 and was slowed down temporarily by the offensive launched by "Cartesian rationality," are no more than questions debated between studios. These ideas merely fed a version of history based on the quarrels engaged in by various artistic clans.

## The Twentieth-Century Resurgence

Leafing through an anthology of buildings constructed between 1890 and 1930, one is likely to be struck more by a new element than by a modification in the proportions of earlier elements. This new element is linked neither to a freeing up of the building plan — which had been accomplished several decades earlier — nor to new concepts relating to equilibrium, size, or construction materials but to stylistic factors.

The genuine innovation between 1890 and 1905 consisted in the use of concrete not to render structures more massive or to make superficial changes in exterior treatments but to create a new relationship between figurative structures and the building as a plastic object. This would seem to support the doctrine embraced by those who claim that the road to modern art had already been paved by an "organic" style, that associated interior volumes with structural freedom. However, as we shall see, there are two essential points of divergence.

Let us first look at examples that will enable us to place this style in a proper light. The movement developed in two phases. The first was theoretical. Its proponent was the Viennese architect Loos. By 1897, in a series of articles published in particular in *Wiener Zeitung*, Loos took a stand against the then all-powerful ornamental movement. He did so in the name of reason, taste, and morality. In the face of the flowery embellishments of art nouveau, Loos proclaimed the rights of the artist as a human and the rights of technology, which require a faithful use of materials. He saw excessive ornamentation as a kind of tattoo that disfigured modern man and put him on the same level as the primitive or child. It goes without saying that Loos's concepts are not entirely modern and that a good part of his theories springs from outdated attitudes. He was basically inspired by a quasi-mystical ideal of purity, much as was Saint Bernard, who was shocked by the idola-

try of his contemporaries. Underlying Loos's ideas is the notion of a periodic return to iconoclasm, which owes more to a psychological mind-set than to aesthetic or technological concerns.

However, there is another important feature in Loos's constructions. Zevi speaks of his spatial conception — which, in his opinion, Horta had already demonstrated in the house on rue de Turin — to unify interior spaces horizontally or by integrating spaces on different floors into a single volume. Then there is the exterior treatment of Loos's buildings, as evidenced in his most characteristic houses: the Steiner House in Vienna (1910), the palace on Lake Geneva (1904), the Tzara House in Paris (1926), the Kuhner House in Payerbach (1929), and the Müller House in Prague (1930). It would appear that the rigid, cubic style of these buildings, which were devoid of ornamentation and even cornices — considered scandalous at the time — does not conform with the doctrine which suggests that Loos was a precursor of the Wright open style. Indeed, Loos went to the United States after 1893 and, as a result, is automatically viewed as a pioneer of the style of the future.

However, looking at his works, one cannot help being struck by their rigidly cubic austerity as well as by the overall effect of their large, nude surfaces. This linear and stylistic severity is not due to chance but is linked to the themes of the anti-ornamentation crusade, which, as Zevi points out, had already gained momentum. Moreover, it is hard to see how one might characterize a European architect from the early twentieth century as an innovator by citing as his distinctive quality either his architecture's horizontality, which eliminates dividing walls on a floor, or its verticality, which brings aspects of various floors into a unified whole. The latter idea does not represent an absolute theoretical break from the familiar magisterial strain in classical architecture, while the former idea grew from the application to private houses

of new possibilities for increasing the bearing load thanks to the use of iron and the general development of marketplaces and other buildings with vast interior spaces, dating back to the beginning of the nineteenth century.

The true note of originality was heralded by two stylistic features: the first consisted in replacing the traditional methods used to enlarge areas and volumes — addition and juxtaposition — with interlocking interior volumes. The second relates to Loos's theories on the building's exterior treatment. Other than Arab dwellings, no house without a cornice and stripped down to such austerely nude surfaces had been seen before. It is not likely that Loos had been consciously influenced by this type of house, although the vogue for Africana had begun to spread by that time. It is also unlikely that he brought back from Yankee America the image of New Mexican–style Spanish houses. But it is highly probable that Loos had become familiar with cubic houses, which fit in so well with the basic tenets of his doctrine. The simultaneously articulated and austere rendering of space most likely came to Vienna from the Orient rather than from the United States, which was caught up in the fervor for industrialization and where the vestiges of the past were a colonial style imported from Europe.

Furthermore, Loos's houses — which are absolutely different from those conceived by Berlage, who sought to simplify wall surfaces without showing particular sensitivity to volumes and remained rooted in Western historical styles — were not the only turn-of-the-century houses based on this new concept of engaged volumes. The Stoclet House was built in Brussels between 1905 and 1911 by another Viennese, Josef Hoffmann. There are also Tony Garnier's projects, which date from 1905, but few of them, unfortunately, were ever completed. I could also cite the Darmstadt artists' house built between 1901 and 1908 by Josef Olbrich and the Berlage Home built by Hendrik Berlage in 1913–14, as

well as van de Velde's Werkbund Theater of 1914. A second era is marked by the series of projects by Theo van Doesburg (1920), the compositions by Kazimir Malevich (1920), the sketches by van Doesburg and Cornelis van Eesteren (1922), the building on rue Mallet-Stevens in Paris (1925), the Rietveld House in Utrecht (1924), the common housing designed by Jacobus Oud in Amsterdam (1924–27), Gropius's Bauhaus (1925–26), Behrens's Lowke House in Northhampton (1926), Mies van der Rohe's Wolf House and Tugendhat House in Brno (1926–30) and, finally, Le Corbusier's Villa Savoye built in Poissy in 1929–30, following the Stuttgart Exhibition (1927), and the Laroche House in Paris (1923). These are the major creations that, over approximately thirty years, defined a style. As can be seen, all of the great architects of the period contributed to it at one point or another. It would be wrong to interpret this as meaning that one might formulate a strict doctrine that sets the free treatment of interior space in diametric opposition to a consciously austere exterior.

Some were more timid than others. The artists' house in Darmstadt alternates cornices and roofing; its boldness is limited to the use of smooth walls in only certain parts of the edifice. The plastic aesthetic generally emphasizes interlocking volumes. The Stoclet House is much bolder, although it has elements that unintentionally hark back to the tower, and, on the roof of a cubic wing, there is a neo-Renaissance loggia. Berlage's Home, as well as van de Velde's Werkbund Theater, reveals the extreme difficulty, even for consciously innovative architects, of adopting a new vision of the plastic. Only rarely were engaged volumes successfully fused with nude walls and sparse wall openings. Too often the aesthetic of the blind wall is reminiscent of historical styles, such as that used in the Doge's Palace and curiously, in the Stockholm City Hall built by Ragner Östberg between 1911 and 1923.

Figure 11. Robert Delaunay, *Circular Forms*, 1930.

The twentieth-century plastic arts were born from the convergence of technology, theory and the rational. In the color wheel, extreme colors that are spread out by the spectrum are brought together and given a luminous unity that is at once stable and vibrant. By 1912, Delaunay had discovered that the juxtaposition of colors in a given order could express the full array of optical sensations and generate movement. (Solomon R. Guggenheim Museum, New York.)

Figure 12. Pablo Picasso, *Man with a Pipe*, 1911.

Twentieth-century painting associates the object and the sign. The link between perception and mental processes—a link that had been established at the turn of the century—set painting off in various directions. Cubism pursued two paths simultaneously: one that sought to retain the object's perceptual elements and another, again inspired by Cézanne, that strove for elision. (Kimbell Art Museum, Fort Worth, Texas. ©1999 Estate of Pablo Picasso / Artists Rights Society [ARS], New York.)

As for wall openings, the Steiner House in Vienna paved the way for horizontal bay windows, but it was still faithful to cube-like design, whereas later architecture would evolve toward plans with freer interplay of space.

I shall also distinguish between the design of the Rietveld House, which is based on the interplay of staggered levels attached by mortise-and-tenon joints on a simple cubic volume, and the system that led to flowing inner spaces and interlocking surfaces marking the boundary of outer volumes, through which European research caught up, as we shall see, with Wright's earlier research in North America.

Le Corbusier's Villa Savoye stands apart from the rest. It is, unarguably, the most innovative and most perfect creation in the whole series. It is absolutely scandalous that this villa — a land-mark in the history of architecture and modern art — was long deserted, converted into a vegetable warehouse, neglected, and destined for destruction. Fortunately, public authorities recently took their mission to heart and promised to safeguard this national treasure by classifying it as a historic monument. Indeed, the Villa Savoye introduced a primordial aspect into the buildings being considered here: movement. Spaced out and interlocking volumes truly flow into one another. Inside, there are suspended spaces, an "architectural promenade" that develops, on its own, from inside the volume of the building as a whole. The work is treated as a sculpture. In spite of one or two flaws, such as the lower entrance to the staircase, nothing more audacious or more complete has been attempted in the past fifty years. In the Villa Savoye there are at least three buildings contained within the space.

This rudimentary survey does not begin to give a full chronol-ogy of twentieth-century avant-garde architecture. My aim was to emphasize the complexity of the problems that are treated so perfunctorily in current studies. Enough has been said about the

relationships between technology and architecture around 1890–
1930 to suggest basic guiding principles.

It was not concrete that inspired Loos on his crusade against
ornamentation. Concrete was well known much earlier and had
not furnished, any more than did steel, the dialectics that would
found a doctrine. Concrete was used by Loos and his contempo-
raries because it provided the means to achieve figurative ends. It
was not merely Loos's Calvinist mentality, marked by a hostility
towards any decorative embellishment, that determined the ori-
entation of his first creations. To express his rejection of surface
ornamentation, he drew on things he had seen. As mentioned
earlier, it will be necessary to examine the affinities between his
starting principles and traces of Oriental, Arabic, and ancient
architecture. But, above all, I need to address the influence of
contemporary developments in the figurative arts.

### Cubism and Architecture
It may be said unequivocally that cubism determined the orien-
tation of the lively arts in the twentieth century. This idea has
already been proposed by Giedion and was rejected with great hue
and cry by the defenders of Anglo-Saxon culture. What was not
pointed out, as I mentioned earlier, was that this new attitude
toward the plastic arts and architecture had been defined not by
the work of one or two isolated precursors but by the joint efforts
of numerous innovators — none of whom clearly and definitively
embraced methods that sharply contravened outmoded conven-
tions. Moreover, the definition of cubism and its relationship to
architecture have remained highly problematic.

For Giedion, cubism entailed the introduction of a new di-
mension, time, into the fine arts. To be sure, this was also the aim
of the proponents of the movement, or more exactly, this was one
of the first statements made by critics in defense of a movement

211

that is fundamentally pictorial and cannot be applied to a concept. Certain points need to be covered before I enter the crux of my subject, namely, the examination of the plastic object in its various constructive and figurative forms at one period in the history of human thought.

*Links Between Architecture and Painting*
The notion that cubism arose from the introduction of Time into painting results from a confusion between the concepts of time and movement. The idea was introduced by the first friends of cubist painters. Giedion refers to a book by Hermann Minkowski that appeared in 1902. Other, less theoretical sources should be mentioned as well. Movement had been a central focus of artistic circles for some time. It had obsessed Degas and Toulouse-Lautrec. At the same time, films had begun to attract artists to the question of movement. It was generally thought that the then recent discovery had been based on setting an image in motion. Moreover, the research underlying the first films, such as Etienne-Jules Marey's studies on the plasticity of sensations, had begun to filter to the general public. Finally, other factors, such as the success enjoyed by the philosophies of human experience by William James and Bergson, had popularized the notion of the flux and dissipation of reality — an idea made highly accessible to artists by the impressionism that had begun to appear in literature. It is also probable that conventions used in the artist's studio were following the same tendency. An indication of this is found in Rodin's famous remarks collected by Paul Gsell and, in particular, in his brilliant analysis of *Pilgrimage to Cythera* — which became the mainstay of the so-called aesthetic interpretation of modern art.

The cubists' contribution consisted in combining the notion of movement with that of dislocation. By departing from classical

form, by "breaking up the fruit dish," as Delaunay would put it when speaking of Cézanne, and by juxtaposing and superimposing the fragments of a shattered reality onto the flat surface of a canvas, the cubists felt they had introduced a new factor, which they baptized as a dimension. Their error, and the error of the numerous individuals who have obstinately held to such an opinion, arises from their not understanding that, in modifying the traditional ways of perception on canvas, they had not, in fact, added a new dimension to painting. They sidestepped a crucial point: to add a new dimension, that is, a new set of assumptions, into a system entails more than merely adding another aspect to preexisting ones; rather, it entails accepting an entirely new system in which the former attributes of reality — all its dimensions — change. A four-dimensional figurative system cannot be viewed as a three-dimensional system with an additional dimension. It is a totally different mode of perception.

That is precisely what distinguishes the theories that had inspired Le Corbusier's Villa Savoye — an inspiration that unfortunately remains partly theoretical because he did not pursue this most promising path — from the overly didactic efforts by Loos and van de Velde. But it must be understood that between the two extremes there were the very impassioned and fecund experiments that had prepared the way for Le Corbusier, namely, the work of the Dutch Stijl group, which had been inspired by Parisian cubism of 1910.

Obviously, it would be a grave error to suggest that modern architecture, with its emphasis on open volumes and distinct spaces, grew directly from pictorial cubism. On the other hand, it is altogether legitimate to disclaim the idea that, in architecture as in painting, modern creative forces were manifested primarily on a stylistic and not a technological level.

Before expanding this idea by showing how architecture devel-

oped in relation to technology since the beginning of the twenti-
eth century, it is necessary to justify the stance that associates
architecture with other forms of contemporary figurative art while
also placing them in the general context of the century, in light of
the doctrine set down in the preceding chapter. It is argued that
style, not technology, determined the direction of modern archi-
tecture under the influence of events not between 1890 and 1900
but from the late nineteenth century — with the advent of the
machine-as-the-source-of-beauty doctrine and the theory of util-
itarian art — until around the 1930s, a span which covered the first
two phases of modern architectural style. This style is linked to
cubism, it being generally agreed that this term does not reflect a
pictorial and sculptural style related to the introduction into a
series of traditional forms of a fourth dimension, Time, which is
confused with movement.

*The Stages of Cubism and Twentieth-Century Architecture*
The first sign in the early twentieth century of a new style was
cubism. But the term is open to debate. We have seen that the
definition offered by Giedion cannot be accepted without strong
reservations. Cubism cannot be limited to the introduction of a
fourth dimension, Time, into the figurative arts. This opinion,
drawn from writings of the period, accentuates aspects of con-
temporary art but minimizes the scope and nature of the most
important source of this recrudescence.

The ambiguity arises from the rash judgment associating an
extremely broad movement with a fad. More specifically, the
ambiguity arises from the connotation of the term itself. Cubism
is rightly considered the one movement that has determined the
course of modern art in the last half century. But one tends to for-
get that these developments were progressive, sometimes contra-
dictory. In short, underlying principles are confused with effects,

geneses, and structures. The problem is identical to the one in-
volved in impressionism and cannot be resolved unless a hasty
judgment is set aside in favor of a step-by-step description.

Cubism appears to have been linked originally to the use of
cubes. As simple as it seems, the discovery that lent its name to
the movement was made around 1905–1920 and gave rise to mod-
ern art, while also affecting the development of contemporary
technology and society.

It was Cézanne who initiated the movement. Or, rather, it be-
gan with an aspect of Cézanne's work and the strong impact
of some of his works on the young artists who discovered them.
Although cubism is incontestably centered on Cézanne, there
were many factors that linked him to both the past and the pre-
sent. Cézanne himself once stated that his desire was to express
all forms in their simplest geometric shapes: the cone and the
sphere. However, he did not always limit himself to that, and his
aesthetic largely surpassed this starting principle.

There is perhaps no better way to explain how Cézanne influ-
enced cubism between 1907 and 1910 than by showing his place
within the evolution of the artists who participated in the move-
ment. Georges Braque was then experimenting with a kind of
fauvism, which had grown from impressionism, and he would
soon veer toward expressionism. However, overnight, he began
to render the object by setting if off from its distant background
and outlining it with rectilinear proportions. Picasso abandoned a
form of expressionism inspired by Degas and Tolouse-Lautrec,
closely related to the expressionism of Isidro Nonell y Monturiol
and Edvard Munch, and began to highlight the angularity of ob-
jects. The contemporary work of Fernand Léger exemplifies this
dual attraction to the rectangle and the sphere. It is the Cézan-
nesque canvases from the Jas de Bouffan period that are at the
origin of this split — or, one might say, bias. At the same time, the

painters and sculptors Henri Laurens, Aleksandr Archipenko, Jacques Lipschitz and Picasso executed works using fragile materials, such as match boxes, which were extended through to the collages of Picasso and Braque. In a second stage, pictorial cubism took off in another direction, focusing less on the object and more on theorization of lines. But the first works of modern architecture from the beginning of the twentieth century, until Loos's Steiner House of 1910, are direct offshoots of the first phase of cubism. Architecture then turned in other directions, enriching and transforming its original sources of inspiration. But there can be no doubt that the earliest distinctively twentieth-century style was derived from a limited interpretation of Cézanne that touched all the arts.

In a second phase, various twentieth-century artistic techniques developed in parallel. As the Steiner House and Stoclet House were succeeded by the Rietveld House, painters moved from a cubism intent on dislocating the everyday object to a linear period, then to a period involving new conceptions of building plans. Interlocking and interposed plans suggesting transparency mark the second step and would be common features in all of the arts. In sculpture, they would be represented by the second period of Laurens and Archipenko.

The third step, in which a style finally emerged, is marked by the incorporation of elements other than angularity and cubism per se into a system. In architecture, it was the period when Le Corbusier executed the Villa Savoye (1929–30), creating, as we have seen, interlocking engaged volumes. In sculpture, Brancusi's style marked the triumph of rounded, polished forms synthesized in ambient space. In painting, there was a compromise between the works of Matisse and Dufy, on the one hand, who were inspired by their attachment to color, and the works of Delaunay, on the other, who revealed himself to be an analyst of light.

Several clarifications need to be made in this schematic over-view of the parallel evolution in various fields of art, giving shape to the relationship that would unite the arts with certain forms of contemporary technology. I do not propose to begin by defining cubism or describing how it is linked, on the one hand, to archi-tectural theories and, on the other, to more generalized trends of ideas and sensibilities. Cubism cannot be defined by abstraction, by simply replacing an earlier formula with a newer one. Rather, I shall begin, once again, by drawing on facts in their historical con-text and, whenever possible, in relation to the full range of phe-nomena of contemporary civilization.

The building style of the 1910s did not arise from doctrine any more than pictorial cubism arose from the application of a new art conceived abstractly. While pointing up the parallelism be-tween different modes of expression, I have not set out to rank them or mix them. To the contrary: I intend to highlight the qual-ities that can be identified with each mode of human expression. Cubism is, properly speaking, a pictorial mode used by artists in a period when human attitudes were influenced by life conditions affected directly by technology and indirectly by the scientific, aesthetic, philosophical and literary theories of preceding genera-tions. Undoubtedly, progress flows from a continuous transfer of related activities and discoveries; yet there are periods when unprecedented events dramatically highlight how far a society has moved beyond earlier lifestyles and means of expression. In the early twentieth century, the human environment underwent such an upheaval. Naturally, all languages and systems of human com-munication underwent change, to a greater or lesser degree. As a result of these changes, which were conditioned on earlier tech-nologies and the expressive requirements dictated by the nature of each human activity, comparable intellectual and perceptual upheavals occurred as well.

In this light, I can legitimately attempt to determine which aesthetic principles were common to architecture and other forms of figurative expression in this period and also decide if they are related to the remarkable evolution in other modes of expression. This approach is predicated on principles formulated in chapter 3: the object underwent a general metamorphosis.

### Human Foundations of Twentieth-Century Representational Language

Rejecting the idea that the modern concept of beauty stemmed from machine-inspired principles, while admitting that various contemporary styles have a common inspiration, I shall suggest that diverse modern human activities draw on a common repertoire. Taking painting as our point of departure, while emphasizing its affinities with architecture and noting that it has developed coherently over the past fifty years, despite passing through different phases, we shall see that three main ideas have prevailed in the development of the modern figurative order as well as in the rise of technology and science: a new perception of space, speed, and the internal structure of material objects.

The notion of Space is so general that, ultimately, it encompasses all the others. There is no perception or representation of the world that is not spatial. It is important to understand that experience is not stable but perpetually evolving. The confrontation between mobile spatial forms familiar to Western societies since the Renaissance and forms from ancient or primitive societies has barely begun. Only now is it being realized that this is more than a matter of sense perception — the common misconception at the end of the nineteenth century — but is also a matter of a "construction" involving social values as well as sensations. In China, for example, space is linked to time, the seasons, and the social hierarchy. Space is periodically rethought according to the

stable relationships between the sky and the earth, in keeping with religious precepts. The representation of space therefore cannot be determined simply according to the manner in which artists project pictorial images onto a two-dimensional fixed surface, based on conventional rules of perspective. It involves assigning values to locations or to a series of privileged acts. In the nineteenth century, the traditional notion of space was transformed, mainly through impressionism, in two ways: there was a change in themes or, if you will, subjects and a change in the conventional systems that made it possible to form a correspondence, within a figurative composition, between details that were artificially isolated from lived experience.

First of all, the impressionists offered the public subjects that differed from those proposed by their predecessors. They found interesting forms of life outside the traditional major themes, which had centered on the representation of fixed accessory details, locations, or activities. Christian parables, along with mythology as it was being taught in schools, had ceased to provide "subjects" for most painting. It was modern man's pictorial attitude itself that served as the "themes" for new painting. Moreover, this attitude drew on the charms of the outlying regions of Paris and the banks of the Seine or its tributaries instead of the consecrated locations that until then had served as the settings for events recounted by Religion and Fable. Entering into closer contact with concrete reality, late-nineteenth-century painters also elaborated new relationships, which were less optical than figurative, between the details they chose as characteristic of new social values. All artists have relied on the same organ of vision. Each time they have broken an established figurative order, their work retained affinities with their first studies. The new figurative language of nineteenth-century painting did not consist in discovering eternal man's power to analyze and fix sensations automat-

ically. Rather, it consisted in renewing the capacity to create a conventional, defining order of arrangement. Those who believe that art is the faithful transcription of reality ignore the fact that, in each human system, there is always a surplus of signification. It might be said that the artist who represents phenomena exactly as he sees them would not be understandable. He would create an unknown masterpiece. A work of art is not an imitation of reality: it cannot take the place of reality; a work of art does not excite the same sensations as nature. Whether it be a canvas, a sculpture, or a building, the work of art contains both more and less than the given reality.

What we perceive are structures, that is, arbitrary relationships between elements that the artist borrows from reality. These structures enable us to discern his emotion or his thought. Thus the work of art is, in truth, a special kind of object, a figurative object, that is, a kind of relay signal that is neither the model nor the image that appeared in the artist's mind, nor the image that he ultimately renders, nor the different image that appears in the mind's eye of each beholder. That is because it has a tinge of indeterminateness. It presents concrete but necessarily fragmentary reference points; moreover, it conveys communicable reactions. Here, we perceive one of the fundamental characteristics of a work of art and one of the potential points of convergence between forms as seemingly divergent as a painting and a building. Just as a canvas or a sculpture is not the duplicate of an immutable object in Nature, a building is not the concrete materialization of a natural process. Both are a montage, an association of figurative values, needs, and activities esteemed by the men of a period.

The transformation of plastic space was a reflection of the interest in new activities carried out in new settings. Nonetheless, this transformation is far from absolute. The effects of perspective, for example, continue to be seen as signifying new values.

When Tony Garnier built the stadium in Lyons, at the beginning of the twentieth century, he used perspective to determine the bending effect of a band of concrete that surrounds the bleachers, giving the impression of monumentality. When Gerrit Rietveld used spaced out panels at Utrecht in 1924 to enhance the walls plastically, breaking with the simplistic form of Loos's Steiner House, he relied on perspective.

If we try to pinpoint the essential characteristics that define the modern world's new conception of space and perspective, which has inspired different architectural, pictorial, and speculative exploits, we might be tempted to think that the fundamental step was the use of split-view perspective — with multiple points of view — to replace the linear perspective of the Renaissance. However, this presents difficulties. First of all, it is not at all evident that Renaissance perspective was relied on uniformly. I showed elsewhere that the adoption of linear perspective was neither general nor sudden, as is commonly believed. Furthermore, the opinion expressed by Giedion — who wrote, echoing the academicians, that in linear perspective objects are represented on a flat surface without reference to their forms or to their absolute positions and that as soon as linear perspective was invented, around 1420–30, modern individualism embraced it without reservations — is entirely false. Linear perspective is not a means by which man's individual vision can be faithfully projected on a two-dimensional surface (which would have led to the total marriage between Renaissance art and science). Nor is it true that for generations men were satisfied with a single approach, which they regarded as objective. Linear perspective's realism was proclaimed only in academies, toward the end of the nineteenth century — precisely when the system no longer fully corresponded to artists' aims or to visual phenomena as experienced over generations. Renaissance artists themselves had long been reluctant to adopt

it. They did not always interpret the method in the same way; and neither they nor their disciples ever practiced only one system of representation. In particular, they had always used bird's-eye view to represent architecture. Vast collections of architectural drawings did not follow the strict rules of linear perspective. It should not be believed that the modern era's use of bird's-eye view was totally unprecedented. However, it is undeniable that numerous innovations in later nineteenth-century art were due to the systematic use of plunging views, for example in Degas's work. Until then, bird's-eye view had generally been used for documentary purposes — in architectural surveys, battle charts, and panoramic renderings — but now it became properly aesthetic. Before, it was regarded as a means of providing data that could not be gained by direct visual observation; henceforth, it was also considered a normal expression of reality. Degas also introduced further innovation into spatial composition. He was followed by Toulouse-Lautrec, who frequented circuses, just as Degas had frequented theaters.

However, these explorations had more to do with the approach to cubic vision than with an entirely new presentation of reality. With the artists of 1905-1908, that threshold was crossed. For the cubists, the viewpoint was not only from above but from an angle. Two-dimensional space was juxtaposed with forms or lines that dislocated not only the point of view but the object itself. Delaunay's *Eiffel Tower*, for example, presents a montage in which the subject itself and not merely the observer's perspective is fragmented. Artists had always juxtaposed sensations; henceforth it was not merely the figurative object but the concrete objects of analysis that they began to fragment and subject to differential montage. This led to experiments by men such as Estève, who, in *Hommes volants*, for example, attempted to convey the sensation experienced from midair as one views the countryside

unfold below. Clearly such an evolution is impossible except in the life of a man immersed in a mechanized civilization and, more specifically, in the current mechanized civilization. Only men living in the age of the airplane could make the transition from the conventions of Degas to those of Estève. I seriously doubt that Estève, Gustave Singier, or Alfred Manessier were aficionados of aviation, and perhaps they never even got on a plane. But what is even more revealing is that they imagined the optical impressions of contemporary fliers, just as fifteenth-century artists had imagined the marvels — without seeing them — that travelers recounted in the journals they kept during their far-off voyages. Modern Orientalism has been an art based on imaginary vision. Should we not admit that artists today strive to represent not so much the reality of a mechanized world filled with dazzling machines as the concepts that inspired the creation of machines and were derived from their use? Certain technological forms are thus apparent in works of art, which always were, and always will be, products of the imagination. Entire generations imagined distant points of the globe through the imaginative renderings of art, and this will continue to happen, even though academicians might try to make our great-grandchildren believe that our era represented the world as it was.

Speed has also played an important role in art as well as in man's daily behavior. Everyone uses some form of rapid transit, and the speed of transportation has transformed all of modern man's perceptual experiences. It is a question not merely of the direct experience of speed or the bird's eye view but of understanding the relationship between things differently. Farness and nearness, in space or time, are no longer gauged in the same way. Not only are our bodies accustomed to judging a car moving at 100 kilometers per hour, but our mind juggles facts and events in ways that were unthinkable in the past. Nor is it a question of the

improvement of relationships that remain subject to earlier frames of reference. The assessment of speed as well as its impact on time frames has modified our concept of causality. If we consider the rate at which news circulated in the past, compared with the speed at which it travels now, we see that modern man's system of perception and his system of setting up relationships between phenomena defy comparison with what was valid forty years ago.

Not too long ago, artists attempted to represent this new psychosomatic experience of speed. Turner created a famous painting: *Speed. Wind. Smoke.* By 1875, Monet had set down the poetry of the locomotive. Poets sought to translate into verse the drunkenness caused by speed. Everyone now thinks in terms of the relationships between isolated facts, which is a direct outgrowth of this new experience, intellectually as well as experientially. In addition, there is the vast array of concrete images provided by modern instruments and apparatuses. Every day, the photograph presents us with images of objects in movement. Film depends entirely on the automatic recognition of a succession of images.

Modern man's recently acquired familiarity with the consequences of speed has affected every realm of art. The capacity to manufacture standard materials and transport them rapidly in large quantities has altered the very way modern architecture is understood. Henceforth, architects would prefer one of two systems: prefabricated materials permitting rapid on-site assembly of modular constructions or on-site factories in which raw materials are brought in and mixed by machines at the location where they will be used. Material is conceived no longer as being made up of natural elements to be squared or worked but as a concrete mass available in varied dosages; and so construction material has ceased being raw and has become a product. Since Egypt and Chaldea, the fundamental systems of the composite and the monolithic block have always been the main alternatives for technological invention

in architecture. But the most original contribution made in the field of construction during our times is a particular conception of montage which is dependent less on the possibility of transport or rapid manufacture of raw materials, than on the general comprehension of the mechanical processes involved in the production of the object. The progression from the detached house or two-story rental property to the skyscraper or modern housing unit did not result only from a quantitative increase in the means of production; it also grew from a recognition of man's new power to create materials as well as from his desire to group related activities together through an unprecedented understanding of space and time. The great modern buildings are not simply a conglomeration or piling up of old-style dwellings; they reflect new combinative principles. Undoubtedly, the misunderstanding of this idea led projects such as the one in Marseilles to bear the indelible stamp of the past.

The third factor that attests to technology and the arts having come to a crossroads in our era is the discovery of the infinitesimal. There is no need to prepare a checklist of modern works of art that correspond to the categories of thought influenced by the possibilities opened by technologies in the mechanized world. It cannot be overemphasized that transference never occurs by mere exposure. The artist's discovery of the world of the infinitesimal resulted from purely pictorial research carried out in parallel — but not in direct association — with scientists. If the era of the microscope is also the era of pointillism, it is because each grew independently from a similar need to analyze sensorial perceptions. Scientific thinkers attempted to find material means to enhance their powers of discrimination in order to provide tangible evidence of their intuitions about the mystery of the infinitesimal, whereas artists developed means of sensorial analysis in order to free themselves from conventions governing the transposition of lines and complex wholes. Then the former devised calculations

or hypothetical chains of causality, while the latter developed new orders of figurative composition, giving rise to Seurat's pointillism, on the basis of Monet's luminism, Delauney's Orphism, and the practice of pure tones in contemporary art. The discovery of molecular structure was thus prepared by artists who directly recorded the world — a world that no longer coincided with well-established images and was based more on the subtleties of perception than on empirical observation. Photography and film were the next to confirm the distortions inherent in perception, that is, the artificiality of classic images. This made it easier to think that recognition and meaning were linked no longer to wholes, volumes, and themes but to nuances, which would be used to examine not artificially selected and arranged objects but the mental image and, above all, the image grasped on the most basic level of optical perception.

It is pointless to dwell on the strangeness of contemporary figurative art compared with art from the recent past. Systematically, it is characterized by the rejection of stock images, familiar contours, and consecrated objects and themes in favor of a sometimes exaggerated focus on details to achieve a hallucinatory effect. It relies on a new set of distinctions in pure perception. Sometimes a detail subsumes the whole; sometimes the aim is to bring into focus inconsistent details in a paradoxical way. In all cases, the specific is emphasized over the general. The spatial disposition of objects in relation to one another is played down in favor of arranging selected elements on the canvas. It becomes possible to imagine arrangements that reject any evocation of a background. The pursuit of unity gave way to the desire to place individual components in stark relief; each component was conceived no longer in relation to an overall design but in relation to the intimate, constituent nature of each entity or object.

Some characteristics of contemporary painting and architec-

ture may be summarized as follows: new values are attributed to settings and objects that had formerly been ignored; the static image — an immediately recognizable phenomenon presented from a given angle or in a given setting — is replaced; meaningful fragments are combined according to different points of view to provide an intimate, qualitative understanding of figurative objects taken from reality, which now reflects mental frameworks and not action; speed is viewed as a value that determines the attributes of signs and makes it possible to identify them; complex combinations reflect the spatial and temporal ambiguity of phenomena; a single sign may belong to a grouping formed actively or mentally. Each characteristic corresponds to aspects of contemporary technology and science.

Now that I have shown that it is possible to find values common to various arts — and to other human activities — I shall discuss how the transitional styles of the late nineteenth century grew into the forms that predominate today.

### The Builders' Contribution

Let me resume my chronological survey of modern architecture where I left off, keeping in mind that this historical development is as closely linked to technology as it is to other arts and even to other, seemingly unrelated forms of contemporary theory. To summarize, we can say that, following the figurative rigor and austerity that culminated in Loos's theoretical stance around 1897 and the first attempts to apply these principles through the geometric stylization derived from Cézanne, modern architecture broke definitively with the earlier tradition. Curiously, the imaginative framework was supplanted before the social framework was reformed. By 1910, a twentieth-century style existed, linked to general advances in contemporary activities, although to this

227

day we are still struggling to decipher the basic motivations under-
pinning a society that was groping to create itself and its art. This
comes as a surprise only if we forget that societies, too, are human
creations.

Giedion and Zevi signaled this break of 1904–1905, which
now seems obvious to every observer. But I cannot agree with
them as to the significance or the exact value of these events. No
grammar of modern style was given definitive form by a system-
atic and rational effort of a generation of forerunners applying the
lessons learned during America's glorious years. It is an insult to
the great achievements of creators from 1910 to 1940 to consider
them rationalist epigones, that is, mere disciples of the natural
geniuses of the 1880s, who supposedly sprang wholly formed from
the great virgin earth of the New World. Although they followed
the tone set by painters, who were the greatest figurative talents
of that time, their contribution was to have a lasting influence.
They created modern architecture and art, in a close and fluid
relationship with other contemporary activities.

It might be said that Loos's austerity and Cézanne's figurative-
ness represented the two major trends that were in continuous
conflict. The first of these trends led to what may be called the
cellular style. The second culminated in a free, open style and in
the virtual elimination of the wall.

There is no point in addressing the criticisms leveled against
the ideas and works of Le Corbusier — except as regards the gen-
uine aesthetic explorations that led up to the Villa Savoye and
the superstructures of the *unité d'habitation* in Marseilles. Instead,
I shall highlight the universal conflict that, in the work of all
builders, pitted monumental against small-scale works. As we
have seen, in the beginning, the typical works of contemporary
architecture were small-sized buildings. Earlier, I mentioned only
works by forerunners from France and central Europe. But the

228

same may be said of the works of Wright or Aalto. An extraordi-
nary dilemma arose from the promotion by contemporary tech-
nology, economy, and society of man-made industrial products.
For obvious reasons, it is more advantageous to build large blocks,
which relieve foundations and loads, leading to greater efficiency
in construction. This is an outgrowth of the importance that
twentieth-century society has placed on grouping people to-
gether, which is reflected in improvements in transportation and
in the increasing popularity of group activities, ranging from
sporting events to movie theaters. However, architects have not
asked whether the same style can cater to all the material and
plastic needs of their era. In a manner of speaking, they have been
contented to take the same basic idea and double or triple it each
time when applied to a larger number of users. More specifically,
they took the same plastic elements used on a private home and
applied them to large-scale constructions. Once again, style and
the plastic were secondary to the project itself. It was as if plastic
creativity had once again run up against an obstacle.

In some periods, specific parts of buildings systematically
became the central focus of the structure. In the sixteenth cen-
tury, for example, the staircase was the focal point of all major
buildings. Nowadays, there is a tendency to view the "basic living
unit" as the center of interest, which may seem paradoxical in this
century of communal living. The living space has become the fun-
damental architectural principle, along with the other absolute
imperative — the necessity of illuminating a room as much as
possible by removing the constraints imposed by walls. It is as if
modern architecture were torn between two temptations: either
to focus on surface treatments or to free up space by doing away
with partitions. This dual-faceted imaginative enterprise was
linked, as we have seen, to the development of cubist representa-
tion, which was both geometric and liberating. Hence, the two

229

architectural styles of the period, the cellular and the so-called organic or free-volume, also emerged from the aesthetic, pictorial, and sculptural theories of the Paris school. Whether it was the glass-paneled houses built for Florida millionaires or the blocks of rental units that sprang up from Marseilles to Chicago to Rio de Janeiro — inspired by the likes of Le Corbusier, Mies van der Rohe, and Oscar Niemeyer — in every case, a style developed in which technology provided almost limitless means but they were subordinated to the desire for plastic expression.

It is astonishing that so few architectural forms have been inspired by the nearly boundless possibilities that have opened up, while figurative systems have been revitalized. Granted, in every era, there will be only a limited number of creators, but it is also true that stylistic foundations are rapidly being laid, and, in the purely figurative arts of sculpture and painting, there has been an almost unprecedented explosion in individual styles. It is perhaps unfair to view contemporary architecture in the same terms. We are no doubt too close to events to observe them with proper detachment. Even so, it is hard not to wonder if modern builders have suffered some aesthetic failure as a result of falling under the spell of the engineer. This debate opens up a gray area where reservations, if not fear — the fear that the rapid proliferation of technology has jeopardized the fate of the arts — seem justified.

While I do not wish to embark on a history of twentieth-century architecture, I should point out that men like Gropius and Mies van der Rohe cannot be seen as the rationalist disciples of Berlage and van de Velde. Giulio Carlo Argan has stressed Gropius's importance, suggesting that, through him more than anyone else, it is possible to see the true extent of the ever-closer association between art and industry.

Gropius, who founded the Bauhaus in 1919, personifies two tendencies prevalent at the time. The conflict between art and

industry and the democratization of art dominated his life. It would be a dishonest oversimplification to suggest — as is often done — that it was Gropius who, around 1920, sought to combine Behrens's open plan with Wright's articulated volumes. Behrens's open plan simply reflected the freedom afforded by nineteenth-century materials to lighten bearing points in order to open up spaces. The articulation not of surfaces but of volumes did not appear until afterward, in the theories advanced by Wright and Le Corbusier. Moreover, the Bauhaus style is quite varied. It takes on different aspects depending on whether one is speaking of the buildings Gropius constructed in Dessau in 1925, which were derived from the first cubist aesthetic, dating from 1907, or of the theories that sprang from Bauhaus workshops, which in 1922–23 had called on the services of van Doesburg, who merged the first and second phases of cubism; the latter of which involved an inter-play of mobile planes in space — an evolution that is best illustrated by Fernand Léger's achievements in painting and is an example of figurative architecture at its most creative.

Gropius's truly individual contribution lies elsewhere. In addition to his merits as an arbiter of modern taste, he played a role at the leading edge of technology and the plastic arts. Gropius conceived of architecture as a methodology. He shares Wright's faith in a certain illuminism. However, Wright believes his calling is to offer men a revealed truth to which they should docilely submit to ensure their salvation, whereas Gropius's doctrine is firmly rooted in action.

While Wright remains the representative of a Victorian individual aesthetic, Gropius had understood by 1920 that the major problem faced by man and the artist was that of creativity in communal action. He did not believe that the social structure of the future would depend solely on the predictions of a few individuals. He felt, on the contrary, that it could not come about except

through a large-scale social collaboration. And so he viewed new architecture not as a theoretical formula but as a technique to be put into action. As he saw it, contemporary architecture was democratic, not aristocratic. In the end, he was on the side of labor, not patronage.

For Gropius, architecture is one of the functions of every society. It reflects man's constructive and regulative "faculty," which opposes the violent impulses of the irrational. It is part of a process of human action, which the artist must oversee and command without violating the natural laws of his environment. Thus the architect is, first and foremost, an essential force in social life. Like Wright, Gropius believes that once a class-based hierarchy has been shattered good architecture serves as the basis for a new harmony.

Architecture, in Gropius's view, is pedagogical and social. Neither the figurative nor the technological creates the social context; each merely allows it to be expressed. Also, Gropius gives a very open-ended meaning to this notion of expression, refusing to be tied to a hard-and-fast formula. He was quick to disagree with van Doesburg and the Bauhaus neo-plasticians on this point, who argued that the individual should not be educated beyond what suited the community's immediate interests. Once the movement had been born, at Bauhaus, an ideological rift soon developed between Gropius and his artistic collaborators on the subject of Mondrian's and van Doesburg's expressionist neo-plasticism and Kandinsky's sentimental art. Many things came from Bauhaus, but Gropius himself departed, for reasons that were perhaps as much aesthetic as political.

Gropius — who helped promote neo-plasticism and a certain abstract-art movement and who created noteworthy works for both currents (the first Bauhaus and the Weimar monument to the war dead) — made his individual contribution precisely at the point where art and technology converge. Art, being a social act,

allows man to integrate himself into the world, not dominate it. The true aim of contemporary architecture is therefore not to determine a priori forms intended to evoke moral and emotional virtues but to define the norms of industrialized production. Thus it was Gropius who by 1925 had clearly set out the problem of integrating the arts and technology into architecture.

How can a qualitative principle be introduced into mass production? Gropius categorically rejects the idea that standards of taste can be decided by a pragmatically oriented style determined outside mass production. He links the creation of the multifarious Beauty of our era to the harmonious development of a fraternal society. This implies that it is possible to educate large sections of society through art, but it also opens the possibility of separate art forms that depend on the available technologies or needs of different social groups. In short, Gropius links art to the technological activity of its users. He refuses to separate art from the individual's other social activities. He does not relegate it to the realm of leisure pursuits. He identifies it with the totality of human experience, and, since that experience is now principally influenced by technology, he links art to the laws of industrial production and the standards of the working class. Setting art apart from pure perception, he attaches it to the specialized activities of each individual. In short, he puts it in action by considering it a superior quality apparent in each work when the highest level of contemporary technology and human capacities is attained. He is thereby, in fact, the greatest original theorist of functional art.

Chased from Germany after 1933, Gropius founded a kind of new Bauhaus in America. His direct and indirect influence there was immense. He was responsible for all of the efforts to set down architectural norms on the basis of contemporary machine- and behavior-based guidelines. George Nelson, the champion of a new architecture whose calculations and ratios flowed from the

233

dimensions of prefabricated materials while complying with the most demanding individual requirements to ensure comfort in the workplace — as may be seen in the Saint-Lô Hospital and the suspended-house project — saw his work as an outgrowth of Gropius's. Together they represent the highest ideal of an architecture that is not entirely subject to technology but liberally borrows from its underlying human and material premises. Both were seeking, above all, to break free from the earlier stylized architectural conventions that, in various forms, had sprung from cubist figuration. It is remarkable that, on the whole, their works remain linear, and their general appearance is inspired by cubist figuration or, rather, by cubist representations from 1910 to 1930. Although the spirit of the Saint-Lô Hospital was diametrically opposed to that of the Marseilles house — insofar as the *modulor* was an arbitrarily numerically based model that achieved flexible unity by using light slabs of concrete width-wise or in half width and incorporated calculations made on the basis of the human body to determine the length and width of a cot, optimum lighting conditions, and so forth — the contours of the two buildings are strikingly similar. Plastically, they both draw on a common figurative concept, focusing on the use of volumes and the sculptural treatment of surfaces.

Gropius's lofty principles and liberalism were of little use to him in America and Germany. After teaching at Harvard for twenty years and being persecuted by intolerance, he resigned his post. It is totally unfair to claim, as have Giedion and Zevi, that 1930s functionalism grew from an abstract geometric spirit. It is related, on the one hand, to a living art form, cubism, and, on the other, as in Gropius's case, to a preoccupation with social life more than with aesthetics. The main complaint that might be lodged against Gropius is that he minimized the importance of figurative theory.

Any aspect of twentieth-century functionalism based on the subordination of human activities to the dictates of the machine hinders, as we have seen, progress beyond the mind-set of late-nineteenth-century theorists who advocated the total union of art and technology — that is, a union of art and the technological activities of man living in society. Gropius's concept errs not on the side of abstraction but on the side of an excessive "sociology," in the narrowest sense of the word. In this regard, Nelson's attitude is infinitely more human. Rejecting the idea, shared by Gropius and Le Corbusier, that man's needs are determined by his means, Nelson believes that the means must be made to suit man's needs, as defined in today's world. Gropius dreamed of training a class of technologists capable of materializing the values inherent in mechanized and industrialized work. Starting from the idea that tools determine the nature of work and objects, he thought that the work of art was a reality produced by technology and that taste merely helped one learn how to accept it. Despite his independence of thought, Gropius found himself, as the theorist of technocracy, arguing essentially that in the future the scale of Beauty would be determined by the degree of mass efficiency and by how mass activities were organized, without reference to any strictly theoretical or aesthetic values. Ultimately, Gropius's creations reveal a restraint, which can be traced to an ideology; and they point up a common aesthetic shortcoming in his style and in that of many of his disciples, which is symptomatic of the immobility mentioned earlier.

Clearly, it is absurd to assess modern architecture according to classical standards. But it must not be forgotten that, in the beginning, in another civilization, these standards reflected man's intellectual attitude toward the world and had a direct bearing on the lived experience and technical practices of marble cutters and stonecutters. And so the formula sought by Nelson is different

from both Gropius's structural realism and Le Corbusier's *modulor* (which is no more than a new human-scale model based on Renaissance plastic arts and proportions). It tries to establish a relationship between earlier models and modern practical activities. In the final analysis, Nelson's vision is not an attempt to reconcile Vitruvius's and Dürer's models with modern materials, nor is it an abstract vision of man in the absolute. His architecture comes much closer to reaching an accord with the general activities of our times, especially since it possesses artistic qualities that are closely linked to contemporary plasticism — above all when he does not use painters to give a superficial aesthetic character to his buildings but himself gives the buildings intentionally and structurally plastic qualities.

Between Gropius, one of the first advocates of the aesthetics of functional Beauty, and Nelson, who harks back to the aesthetic developments of 1930 cubism, there are numerous architects who contributed to this search for a middle way between the need to cater to technological imperatives and the need to create a link with new forms of figurative art. Since my aim is not to trace the history of modern architecture but simply to lay the groundwork for a more in-depth study, I cannot examine the work of all of those individuals who contributed to the development of modern art over the past thirty years. For all their merits as artists and contractors, most current leading architects have merely borrowed from the great creators who helped forge a new plastic sensibility at the beginning of the twentieth century and have adapted their ideas to fit the machine. For example, Mies van der Rohe, who emerged from Gropius's entourage, merely accentuated the building's structure in relation to the material — preferably, steel. Oud, on the other hand, exploited the plastic qualities of concrete, in works that are rich in aesthetic value. Richard Neutra created elegant works in California, pushing the open

plan to its limit. Yet despite the undisputed merits of several creations, it is striking that so few works make a new statement in their own right. There is no break from the two movements, represented by Gropius and Nelson, emphasizing either the absolute primacy of technology or the reworking of existing technical forms. And so if we wish to consider the case that best exemplifies the impact of rationalism on contemporary architecture, the relationship between architecture and twentieth-century figurative arts, and, above all, the shift caused by the emergence of a style distinct from the cubist movements, we arrive at the question of the originality and genius of Wright's contribution to architecture.

To discuss Wright, it is necessary first to define the true degree of originality in his work and then to examine the validity of the argument that, since 1930, has credited him with causing an upheaval in world architectural values, subordinating technology and reason to a new ideal of spontaneous art.

Wright's work can be divided into two very pronounced chronological periods. The first extends from 1887 to 1924. Wright was then a young American architect, trained at the Chicago school, and a disciple of Richardson and especially Sullivan. He worked in Japan from 1916 to 1922. Before that, he had apparently studied prints of Japanese houses, which had experienced a cultural efflorescence that had spread throughout Europe and is represented in the style of 1880. Wright was building mainly for a middle-class clientele. One result of the Chicago Exhibition of 1893 had been a veneration of historical styles among the leisure classes, while technological advances had led to the development of skyscrapers in the 1880-1900 international functionalist style. The six criteria of organic architecture, as set down around 1908 — simplicity, individual style, organic composition, colors in harmony with the surroundings, authentic materials, and a plan expressing a specific

ART & TECHNOLOGY

aspect of the composition, such as height — do not seem to con-
tradict contemporary European theories. This is how Zevi himself
summarizes Le Corbusier's approach: columns, roof gardens, open
plan, horizontal strip windows, a free facade — all emphasizing the
principles of volume, surface area, and geometry — and above all
a guiding plan whose parts were inseparable from the whole.
Wright's architecture seemed innovative especially because it was
picturesque and colorful — which is not intended to detract from
its original merit. Wright is undoubtedly a true "artist" and the
most gifted builder of his era.

Wright's greatest success was his one-man exhibition in Berlin
in 1910, which brought him exceptional attention from young
artists in central Europe and determined the general orientation
of later Germanic architecture. However, as often happens, what
was retained from his models were common elements rather than
individual characteristics. It is worthwhile examining to what
extent his works influenced the direction later taken by Rietveld
and Robert Mallet-Stevens, in parallel with cubism.

From 1924 to 1934, Wright plunged into virtually total si-
lence and did not return to the spotlight until around 1935. It
was then that he apparently formulated the theories and practices
of organic architecture, which would save humanity. It is not pos-
sible to contend that this architecture developed slowly, gradually
gaining universal acceptance, and simultaneously credit Wright
with discovering it. Giving all the credit to Wright minimizes,
in particular, the role played by Scandinavians like Asplund and
Aalto. By 1930, the former had put into words and action the
basic precepts that would later be taken up by Wright — precepts
that make much more sense in the ideological and mystical set-
tings of the northern countries than in the rugged America of
boundless industrial expansion.

It was Asplund who considered the house a refuge from the

Universe, a denial of nature's hostility in the world of an Ibsenian morality tale in which man confronts society and the machine. It was from Asplund and Aalto that Zevi borrowed, via Wright, the theory of interior space built on the image of man lost in reverie. It is to the Scandinavians that we owe the concept of flowing spaces that communicate with each other according to the whim of the occupant's imagination. Until his most successful and most recent creations, Wright remained faithful to an entirely different system of combinations, which was derived directly from colonial American architecture. Works by American historians have shown, in effect, how the principle behind the development of the house in the New World has always involved adding on space around a core, in contrast with the principle that prevailed in the Old World, which emphasized fusion. In short, we are presented with three possible systems of integration: joining together, coupling and combining articulated space. Furthermore, it is impossible to deny that the system of combining articulated space merely applies principles that spring directly from cubism, as is evidenced by the Rietveld House and especially Le Corbusier's Villa Savoye.

The opposition that sets newly imagined space against the figurative and static space of cubism is a total fallacy. Moreover, the architecture of every era has had a sense of a well-thought-out interior space, and it is laughable to suggest, as is often done in the theories advanced by Wright's disciples, that the baroque lacked a true sense of interior spaces! In fact, the recent propaganda championing Wright's revolutionary architecture asks us to disregard that the Gothic style had its own theories on the value of illuminated space, not to mention other equally brilliant values of the past. Let me state, then: Wright may legitimately be seen as holding a high place among the best modern artists. He should rightfully be counted among the pioneers, especially for his principles that led to a new vision in which civil architecture was

applied to private projects. It is no slight to his works to refuse to consider them inspired by a superhuman vision of the future and to see them, rather, as the most extraordinary products of our times. Wright, who had the double and rare privilege of living to a ripe old age and of reinventing himself, at least once in his life, deserves the title as the pioneer of contemporary architecture, much more so than Horta or van de Velde. Without question, he surpassed Gropius and Le Corbusier on several points. However, his art does not challenge the great movements that inspired technological and scientific progress as well as the evolution of architecture. Certainly, Wright is, along with Loos, the first great figure of modern architecture – an architecture that, by abandoning the dream of drawing on aesthetics and technology in equal share and by rejecting the subordination of aesthetics to the imperatives of the machine, introduced a technique whose values were closer both to new technologies and to new figurative forms.

I have thus challenged two generally accepted points of view. There was not, from 1890 to 1910, a generation of pioneers (principally outside France, either in America with Wright or in Belgium and Austria) who formulated a new grammar of architecture based solely on technology. Nor can it be contended that this period was followed by an era of rationalists, which was then succeeded by a new generation of creators following in Wright's footsteps who pushed on toward new frontiers of free inspiration.

It cannot be denied, however, that the situation of architecture after 1930 is much more problematic. If we refuse to accept, for reasons to be developed later, that poetry can be equated with creative power or that genius can be equated with the irrational, we cannot conclude that a culminating point had been reached in the 1920s and that modern architecture, then defined in terms of its new relationship with technology, could only advance by breaking free from technology.

Today there are artists who believe that the era of research and absolute discovery is over, just as there are scientists who believe that we are lagging behind and that, although the ultimate principles of nature have not been discovered, it will be several decades before new, unprecedented realms are opened to researchers. For those artists who took part in technological progress, certain theories of the plastic arts over the last decades have already enabled us to enter a new era — one in which humanity will discover the keys to universal harmony. Simple geometric forms or dazzling spatial patterns revealed by the chemical and physical analysis of matter have helped to forge the principles behind a new geometry and, by extension, behind a new aesthetic. Simple forms — solids, parabolas — which science helps us to discover in reality, will serve as a framework for the imagination. In abstract Nature, as in biological Nature, there are ideal forms for every situation. It is merely a matter of recognizing them or inventing them. Functionalism, which fortunately has reached its limit, is tinged with an abstract purity that is reminiscent of the doctrines of Johann Winckelmann. The number of possibilities open to man seems limited. All the extremes meet. Down the ages, functionalism and formalism have negated individual human effort. But that is beside the point.

On the other hand, one fact stands out from the brief historical overview presented here: since 1930, a new movement has taken shape, emerging perhaps from earlier theories while exhibiting unique qualities. Asplund, Aalto, Wright in his last style, and Neutra no longer produce works comparable to those from preceding years. Whatever the true source of inspiration — which I shall examine below, since that is the key to the relationship between style and technology — it is undeniable that a new sense of taste underlay the achievements of this period. The conventions that emanated more or less directly from cubism continued

241

to produce notable buildings, but there were other buildings that reflected vitally new orientations. In other words, the absolute originality of Wright is debatable. Without a doubt, the problem of transition arises.

True to my original objective, I shall determine if the works that force us to recognize the decline of cubist forms reveal technological imperatives or stylistic intentions. In other words, the true problem of 1930–50 involves not the as-yet-undemonstrated revelation of an inspired, supra-material architecture but, rather, the possible transcendence of cubism by a new principle of inspiration.

CHAPTER SIX

# The Problem of Abstract Art

There is supposedly a third, namely, organic, era of twentieth-century architecture — an era assimilating the revolutionary principles of the 1880 style while bypassing the intermediate step of sterile rationalism — which takes the form of abstract art. This is a problem that encompasses architecture and the other arts, but its practical aspects cannot easily be set in a historical context, as was the case with cubism, since it is intertwined with present experience.

First, an observation: in the beginning, there was no consensus on the nature of abstract art, and, even today, there is hardly any agreement as to which contemporary works warrant this name. Certain reservations notwithstanding, it can be argued that there are two very different explanations, which correspond to two radically opposed types of works. In their texts, current disciples of Abstract Art defend a doctrine that places art in the realm of the incommunicable and intuition. Yet over the past half century, there have been very important works of art linked to the Abstract Art movement, formally or not, that aim to create new forms. It is true that the former works also claim to lead to the creation of forms — and that is where the problem arises. Are art forms essentially in the mind, or do they emerge from a contact with the real?

243

## Two Movements of Abstract Art

### The Incommunicable: Wagnerism and Intuition

On close examination, the arguments surrounding Abstract Art are hardly convincing. Despite certain disagreements, which seem personal, critics all concur that Abstract Art's main characteristic is its rejection of any reliance on the visible world. According to Léon Degand, we may consider abstract "any painting in which neither the ends nor the means evoke the world's visible appearance." Hence abstract painting seemingly has freed itself from any concern for imitating familiar appearances in nature. This supposedly constitutes a total innovation, placing our era at the forefront of history. Until around 1860, it would seem, phenomena were presented "as they were." Under impressionism, they were presented "as they were seen"; and afterward the artist freely "invented" new and original forms as circumstances allowed, according to the dictates of creative expression. Instead of expressing subtle observations of the exterior world, in the manner of Cézanne, the artist captured his perceptions in their pure state, and they materialized immediately on canvas or physically, much in the way imaginary figures are born in the mind solely from sensory impressions.

Along the same lines, Michel Seuphor explains that in new painting and sculpture, there was no longer any reference to observed reality. Introspective man was henceforth free to reproduce perceived reality — that is, the substance of his imagination — directly, without mediation. The true artist invents nothing and refers to nothing; he conveys an "incommunicable" world within. The logic of abstract art, which sets its own laws, is different from the logic that governs the arrangement of objects in the exterior world. As a result, the artist conveys his interior world. It is the art of the "self-world" in the artist's mind, the art

244

of a privileged genius whose every work re-creates the universe, without reference to the laws of lowly nature.

In this new perspective, the abstract artist is no longer tied to the object. Degand argues as a given that only the object can evoke the third dimension. He also asserts that color — in the oldest sense of the term, as a function of the object or the model — has until now contributed mainly toward the depiction of the conventional, everyday object and toward the transfer of the physical laws of a reality outside man to painting. In contrast, he sees abstract art as having the capacity freely to situate planes in space at distances and on levels no longer dependent on the imitation of forces foreign to the human mind. Thus the artist advances into the realm of the unexplored by "invention of the self."

The third general theme preached by the prophets of this new Gospel of future art proclaims that art would now rely on elements specific to this art and its primary feature would be its anti-descriptiveness. Even when using colors or lines, they use elements that at first glance seem to belong to earlier art but in fact are not entirely similar. There would no longer be stylization, careful elaboration, and compromise, in a slow process of decantation intended to extract noble elements from base reality. Media and forms now depend on the artist's creative impulses and are transfigured into "new realities." They share nothing in common with earlier instruments of art except in name. Art is transformed, in both its means and its ends.

All of this phraseology has a common source. It is paraphrased from Kandinsky's *Concerning the Spiritual in Art*, a small text published in 1912. Maurice Raynal gives a marvelous overview of his ideas. The fundamental experience for Kandinsky was color, which was the source of sparks and flames. Because of his Slavic temperament, which drew him to chaos and the infinite, plastic forms were somewhat alien to him. And it was no accident that

later he protected himself from the dangers of anarchy by adopt-
ing rigid geometric forms. He attached little importance to the
Western conception of Beauty, in which volumes and proportions
were inevitably derived "by contemplating and measuring natural
forms."

It is all there. Slavic charm and the attack on the outmoded
ideas of the Mediterranean peoples, who were slow in all fields,
including the arts, to adopt the great works of genius offered by
the new races, liberated from the prejudices of the intellect.
Moreover, the crux of the debate is immediately apparent. In its
common form, abstract art is a type of existentialism, which grew
out of the idealism that flourished at the height of Parisian sym-
bolism within the *Revue blanche* circle, alongside Wagnerism and
the discovery of the Slavic soul. The final word on abstract art, as
it was understood by Kandinsky and his followers on the banks
of Lakes Zürich, Spree, and Schelde, was set forth in an 1885 text
in which Teodor de Wyzewa commented on his new discovery,
Novalis.

Invited by Dujardin to translate Wagner's aesthetics and make
it accessible to the French public, Wyzewa described Wagner's
doctrine — not without putting much of himself into it. He
started with the notion of the ideal theater, a dreamlike work des-
tined for an ideal public, which would be capable of putting it on
without using electrical or musical effects but simply by strength
of conviction and the act of reading. Then, taking up texts by
Wagner, Wyzewa showed that the Wagnerian aesthetic was based
on an interpretation of Beethoven through the lens of Schopen-
hauer's philosophy. "Will, which is nature, can be perceived even
in spite of flaws in the performance. Will attains its highest
degree of perfection in musical interpretation when individual
will is silenced and universal will is awakened in us, this being an
expression of the supreme unity that is at the root of all things."

There is no need to stress the impact of such an attitude, which linked the theories leading up to abstract art to a paraphrase of musical creation. Today the propagandists of Abstract Art are not mistaken when they speak of this art's poetic quality, rightly emphasizing its lyricism and its affinities with music. "The master's (Beethoven's) genius, thanks to his deafness, is delivered from all *non-ego*. It now lives in itself and for itself." These are the very words used by avant-garde critics. The master's genius, Wyzewa adds, takes into account his creative power, "this power to give form to the imperceptible," and from this power gives immense joy.

Contemporary critics have not gone so far as to present the typical artist as a blind man, but, consciously or not (which is most likely), they have assimilated theories put forth in 1885 in Paris in *Revue wagnérienne* — theories that have had an enormous impact on the universal aesthetic sensibility. Clearly, this theory is closely related to Mallarmé's art, with which Wyzewa was familiar around 1885. It is also obvious that these aesthetic ideas played an important part in Proust's writings. In 1885, Wyzewa called for a novelistic form that would, like Wagner's theater, revive the aesthetic; and, prefiguring Proust's novel, he even envisioned a single-character psychological novel, which he traced out in *Valbert*. "The Ego alone lives, and it has one never-ending task: to create." What we call reality is merely a projection of the image of our intimate essence "into the external void." "Out of deep belief in it, we continue to create it in the same way; and we suffer from its incongruities even though they provide us with pleasure."

Wyzewa's aesthetic assessment goes even further. The Wagnerian philosophy — or more precisely, Parisian commentary on it — is a deliverance for the prisoner of the Platonic cave. "As soon as he realizes that he himself is the cause, he is free, and the prisoner of the cave becomes the divine Seer, the Seer-creator...." Two

paths lie before him. By rejecting egoism as a cruel constraint, he can "bring Unity to his works.... He can combine his soul with this non-ego that is nonetheless his soul, ... and by showing compassion for the World and for himself, he will give his work the full harmony that will put an end to self-imposed suffering. This Seer is in fact Parsifal.... Moving freely in the World of Creation, that is, of art, he will change his means of creation and will build a new universe beyond the present world." He will sing, in Mallarmé's words, "about where life should be lived." The sage is in fact Beethoven, da Vinci, Racine, Tolstoy, and Wagner, "all smiling in the face of the illusion they have created, using it to take on all the suffering of existence." Today we might add to this list all of the masters revered by Romain Rolland, both Mallarmé and Proust and, gladly, Kandinsky.

The point is not to deny the merits of the doctrine nor, above all, to deny its enormous historical importance. We stand before one of the major movements of our times. It touches not only art, music, and literature but thought in general. All of the existentialisms of 1950 grew out of this movement, which was inspired by Paris-based theories of the 1880s, the years of impressionism, the turning point of modern thought, comparable to periods like romanticism, or what Paul Hazard called the crisis of European consciousness. The scope of the movement explains why it spread so slowly around the world. Today critics and philosophers from the provinces — even if they exercise their profession in Paris — have finally caught up with the inhabitants of Toul, who were introduced to Wagnerism some twenty years after its brief surge in Paris.

This is not meant to suggest that such a profound movement was born from texts buried in *Revue wagnérienne*. These texts did not inspire artists. They were merely the first aesthetic awakening to the problems encountered by the artist in light of modern

materials. They attest to man's anxiety, apprehension, and inner upheaval, which Giedion observed without pinpointing the exact origin.

This thinking was transmitted through thousands of movements, reflecting the decisive role played by Parisian circles at the end of the century. It is not possible to study all the ramifications of this question, as was attempted in a small book by Isabelle de Wyzewa devoted to *Revue wagnérienne*. But she was more interested in seeking out the ties between this movement and Wagnerism than in its eventual impact. What is more, my aim is merely to show that it is impossible to consider a certain form of so-called abstract art emanating from the works of Klee and Kandinsky around 1910; we must trace it to a whole idealist movement dating back much earlier, and we must consider whether there are other forms of abstract creation linked to the movements arising from the triumph of technology and science.

When Kandinsky met Klee and van Doesburg at the Weimar Bauhaus in 1924, they personified certain values but values that often were generations old. Despite the insistence by a few unimaginative and misguided disciples who saw their contributions as a fresh creative infusion by a few original geniuses, the fact remains, until it can be proved otherwise, that their contributions were a watered-down form of mysticism borrowed from great romantic theories or the Dutch strain of the cubist tradition — which was plastically and intellectually superior to the Kandinsky tradition.

Moreover, the true source of inspiration for Kandinsky is, in addition to the 1880s illuminist philosophy — in its French variant, it is worth repeating — the reminiscences of a youth spent in Russia. It is art nouveau in its Muscovite form and can be seen in engraved illustrations from Russian books of the pre-1914 period; I am also convinced that the symbolic patterns on his canvases

arose from his early experience in woodcutting. His form of abstract art irrefutably exemplifies an immense and lively movement, but it was also traditional and not at all new. It sprang from Novalis's philosophy, via Amiel and Kierkegaard. And, in the realm of the arts, it is a modern answer to romanticism, immanentism, and centuries-old flights of idealism. It is but one facet of the struggle between intuition and reason. How can we believe that it is a genuinely new perspective? It is not possible to be both a traditionalist and a pioneer, nor for new art both to reflect the incommunicable world of individual thought and to be the natural outgrowth of the modern machine-dominated world. It cannot be simultaneously argued that contemporary art gives concrete form to an immanent reality and that there is no reality other than the incommunicable one of the mind. Faith in the artist's vocation cannot be built on a belief that his art cuts him off from the visible world toward an inner truth — where suffering and joy are experienced so intensely they surpass all else. Indeed, the final word on the matter was stated sometime ago: "all the rest is silence."

In truth, this ultimately becomes an apology for automatic art, in which Beauty is generated by mere chance. It harks back to the divinity, held suspect by the much shrewder ancients, which was endowed with all the principles that informed values and the concepts of duration. This is also a denial of art itself, insofar as it denies man's capacity to create, that is, to alter his field of perception at will. To be sure, purely oneiric art had its adherents, and it was readily believed that children and fools could reveal the secrets of genius. We may wonder, then, exactly what emerged from all the literature whose principal feature was, in the end, to promote what had been revealed in the past? Nothing more than commonplaces. The worst sort of academicism is behind so-called abstract art. I say "so-called" because there are

other movements that are sometimes identified with those I have just described and that, in fact, center on a genuinely plastic art embodying the artistic spirit of our time.

I have already said that the truly original effort in our era consisted in creating new forms, and I believe I have demonstrated that the true problem is one of knowing whether these forms are the intellectualized expression of the real world or of an incorporeal universe of mental images. It is irrefutable that contemporary art has given birth to new Forms in the past thirty years or so. Our era has had its great artists — painters and sculptors in particular. What we need to determine is if the various forms shaped by Matisse and Dufy, Braque and Picasso, Laurens and Brancusi point to the arrival of a style that differed from cubism and its offshoots. In spite of the diversity in the artists' personalities, can one legitimately speak of the existence of an Abstract Art, the way one speaks of impressionism and cubism? If so, are the new forms of Abstract Art detached from the object's reference to the outside world? Indeed, how does the relationship between this art and machine-inspired forms present itself?

There is something of a consensus — reached more or less in a spirit of goodwill — as to the creative value of the modern era. The resistance offered by staunch holdouts — who grudgingly witness the world changing before their very eyes — stems, ultimately, from a desire to show that if Matisse and Laurens are great artists, it is to the extent that they sustain the art of the past. To the contrary: the true interest of contemporary art resides its having introduced unprecedented elements into the world of forms. I will now turn to the nature and value of this contribution.

As mentioned earlier, contemporary artists and critics of Abstract Art have conflicting viewpoints. The thesis I discussed that attributed the creation of modern art forms to mental processes and the absolute denial of experience — viewing abstract

art as the intellectualized expression of the immaterial world and not of concrete reality — does not reflect the attitude of all artists. In automatic art and conceptual art circles, many divergent views manage to coexist.

André Bloc states that the goal of art is to invent Forms and that imagination remains the essential feature of new art. He warns against confusing skill with pure drawing. He states that the goal of innovative art will be, above all, to replace the systematic deformation of figurative art with the creation of forms per se. Inherent in this position is a rejection of the artist-as-intent-on-deforming-reality idea, prevalent since Maurice Denis. It does not necessarily entail the rejection of all experience. To accept that the goal of art is to create forms in the imagination is not necessarily the same as postulating that these forms can only correspond to an internal illuminist vision, without reference to reality.

Alexander Calder states that, while looking at Mondrian's geometric works on the walls of his studio, he came up with the idea of allowing floating forms to oscillate in space, suggesting the movement of space itself. The basic reference to the object is formal. It is understood that a specific kind of object is involved, one that does not correspond to traditional definitions and that itself constitutes a creation. There is nonetheless a reference to the outside world and not merely to the closed world of thought.

Furthermore, an entire movement of avant-garde criticism always speaks of "new realities," and one of the liveliest studios is called the Salon des Réalités Nouvelles. To be sure, it is possible to argue that these realities are created in the mind. However, they are materialized and conveyed to the viewer in a reality experienced through the senses. It is difficult to see how living works could exist in the confines of the creator's mind. The theory of the anti-sensorial quality of modern art — whereby Abstract Art supposedly marks a definitive split from impression-

ism and cubism — does not jibe with this attempt to intellectualize painting. Even if it were true that current art is based on purely imaginative representation, the intellectualization of the intangible world implies, by definition, a reference to ongoing operative experience. The theory that attributes to each individual his own incommunicable universe is, as I have noted, incompatible with the notion of art.

One of the most talented and lucid artists of our time, Jean Dewasne, states that abstract art is endowed with its own techniques — which is true of all art. He adds that the idea of a third dimension determined by a hierarchy of plastic qualities is a fallacy because a canvas, by definition, has only two dimensions. It is legitimate to see some truth in this only when speaking about color, because it can occupy the foreground or the background of the canvas, as if of its own accord. Here, we come face-to-face with the uncertainties and sophisms of Platonism and, curiously, a kind of realism limited to the treatment of materials and a physicality that beg the question of the relationship between art and science. This is a rather naive concept, in which color takes on the absolute quality of a reality and the concrete in painting is placed in an industrialized reality.

The sculptor Naum Gabo is all too familiar with this idea. In his view, we did not discover electricity, X rays, and the atom; we invented them. These are of our own doing. We make our discoveries precisely where we direct our sights. The scientist has the right to change the face of the world, why not the artist? Art is a constructed reality. The human mind is both creator and creation. The outside world and the inner world obey similar laws. That is the secret of art and the key to understanding it.

I could add still other statements. There are, for example, those by the sculptors Nikolaus Pevsner and Robert Jacobsen regarding the discovery of space — not only the space surrounding

the work of art but the completed work's interior space. It should be recalled that by 1911 Robert Delaunay had brilliantly posited that an artist's deformation of objects results not only from a diagrammatic and linear treatment of an abstract idea borrowed from the outside world but also from a dissection of the physical laws of light. The definition and the plastic experience of abstract art cannot simply be viewed in terms of the outmoded precepts of symbolism from around 1885. Abstract art must be seen in terms of an act intended to create artistic forms. And although it is certain that the earlier notion of the Object will no longer suffice for determining the meaning of contemporary works, it does not necessarily follow that one must eliminate all relationships between the work of art and the physical, mental and figurative realities in which we evolve.

Reality only exists in relation to the potential for action. The artist engages in an act of figurative representation — whether in its broadest sense, by attempting to alter the operative field of our vision, or in a more limited sense, by creating figures from a repertory of earlier representational forms. It cannot be denied that the first characteristic of a work of art is precisely that it be a work and not a symbol or a whimsical conceit. The primary feature of art is that it take on material form; otherwise, there is not art, only intentions. By definition, the work of art is executed, enacted, and is not virtual. Works not subject to the laws of physics involve, in fact, literary or philosophical processes, which, in spite of appearances, belong as much to the exterior world as plastic processes do. It cannot be said, properly speaking, that there was a discovery of figurative art; rather, there was a transfer of intentionality and, in the final analysis, a denial of the conditions underlying aesthetic creation.

Ultimately, recent speculations on abstract art have revealed that a belief in the existence of a reality that poses itself before the

artist like a model has become unacceptable in the modern world. Today we sense that man's contacts with the world are diverse, tied to ever-changing modes of activity. We also sense that a man who appears capable of readily modifying his way of seeing in one domain, owing to his thorough knowledge of it, may be fiercely attached to static concepts in other domains.

Since impressionism, the rough sketch has been much praised. There was a mystery attached to the incomplete. This movement merged with another. It was believed that the main reason why the exotic arts were held in such high regard was because of their rough-hewn, unfinished appearance — betraying an inability to see that, in fact, they were executed with extreme precision and simply responded to dictates that differed from those of classical art. There was a tendency to compare the consummate works by the great masters with spontaneous sketches by children or fools, leading to statements that made no real distinction between the relatively widespread talent for imitative drawing and the true ability to create. There is art only when there is repetition — governable, willful repetition. Art is situated between the instant when the individual takes a sketch and transforms it into a complete work of art, carrying it, as we have seen, to the limit of experience. This brings us back to abstract art. Are the Forms recently created by artists related to a new experience of the world? Is there a style that is now taking up where the distortions wrought by impressionism and cubism left off? That is, does it mark a move away from the recording of the object's mobility under light and the ability to show an object in space not subject to the Renaissance rules of scenographic vision? Is such a style linked to the experience of a new age of human action in every field, whether mathematical, technological, literary, or economic?

In short, the question is one of determining whether figurative expression over the past thirty years has provided tangible evi-

255

dence of specific values that differ from the modes of intellectual or technological activity. As I did when examining the impact of turn-of-the-century experiences on the cubist style, I shall attempt to identify the new scale of experiential qualities that underlies the new scale of plastic qualities and that transposes, as it were, the general values of human effort into the domain of art.

## The Creation of New Forms and Painting Qualities

Spatial composition, speed, and inner structure were, as I have said, the primary features of the object stressed under cubism. Thereafter, it was possible to say that the characteristics of new human activities were color, rhythm, and material. Naturally, these were not absolute discoveries. It would be easy to show that art is always defined in terms of a tangible and symbolic use of color, an evocation of movement, or the use of certain materials. I wish to stress merely that there were innovations in these three areas and that they were also the guiding principles behind other technological and intellectual activities of the time.

### COLOR

It is often stated that the impressionists liberated color. Without them, of course, art as we know it would not have been executed in the same way. However, it is debatable whether they in fact set down our modern concept of color and, moreover, whether other innovations have not occurred within the past twenty years.

The impressionists overturned the traditional notion of color by rejecting naturalistic color ground. In spite of superficial differences in coloration between the great poets of color, such as masters of the flat shades like Piero or masters of composite shades like Tintoretto, they always used color to render a so-called natural form to achieve a perspective effect or the symbolic manipulation of space. Yet the impressionists retained a basic suggestion

256

of forms identical to those used in the Renaissance. They blurred outlines; they studied the variation of light on surfaces; but their research merely prepared the groundwork for a transformation that would be carried out progressively after them.

At the start of the twentieth century, with Cézanne, van Gogh, and Gauguin, a new and more radically novel concept of color appeared. Cézanne introduced the notion of the reality of the motif by enhancing the sense of emptiness in the spaces between objects. With him appeared the overall unity of the components of the figurative image. He set the stage for the next step, which would develop by the start of the twentieth century, cubism. At the turn of the nineteenth century, Delacroix, who had remained faithful to the traditional handling of color, used small amounts of red to give a suggestion of light to the whole. In his works, the entire canvas has a general tonality in which dabs of color heighten the spectator's attention. Color was rarely used in large planes. Monet sought selectively to refine his eye for color. What is more, he juxtaposed pure shades, but in small amounts, through slight strokes, creating an optical glaze intended to elicit a general impression of color, and evoking the sensation normally experienced. He was scrupulously faithful to a pictorial practice developed over centuries. Van Gogh simplified and further expanded impressionism's sense of discrimination; and he learned to exploit the emotive value in pure tones — in the intrinsic quality of color. But it was Gauguin who showed that it was possible to create a new order of color using large flat surfaces in which a pure shade spreads out without conveying the object's naturalistic color ground. He discovered the full metaphorical value of color, which could be used to suggest reality without reproducing it.

Painting at the beginning of the twentieth century is entirely dominated by this discovery. Instead of trying to reproduce retinal images on canvas, there is an attempt to construct an order known

to be different from the order of phenomena recorded by the human eye: an analogous order suggested by experience.

A painting thus became a system with its own laws in which the spectacle of nature is recognizable not because the artist imitates the order of things as best he can or faithfully records perceived experiences but because he creates a composition that evokes mental sensations similar to those experienced in the world. This all-important shift has served as the guiding force behind all contemporary painting over the past half century. It helps us to understand how the problem of Abstract Art was first presented and points up the close links between the evolution of modern art and radical technological innovation.

At first glance, it is tempting to imagine that the spectacular development of modern painting was due to the appearance of new coloring products on the market, which replaced earlier pigments that had been ground more or less empirically. It is also tempting to suppose that psychophysiological experiments determined new forms of art. However, the case of Seurat stands out as clear evidence that the transference of scientific precepts to art did not necessarily yield a new vision of the plastic arts. We also have evidence that a greater understanding of art's visual world is not enough to save a form of visual perception no longer attuned to the century: at the very moment Charles Lapicque was providing the scientific explanation behind the use of blue casting to render far-off distances, which had been so passionately elucidated by Leonardo da Vinci, the figurative order, based precisely on this illusion of distance, ceased to satisfy the demands of modern plasticism. Since no single form of painting is valid for all generations, it is a question not of finding a scientific explanation for instinctive actions nor of disclosing the secrets of a system by dismantling it. Man's true strength resides not in his analytic faculty but in his capacity to create systems in which specific forms of

activity come together. Analysis merely supports and explains an artistic method inductively; it does not generate it.

The characteristic feature of modern painting is the interconnection of plane surfaces and the spatial arrangement of volumes in ways that do not follow Alberti's laws of perspective. When Matisse uses large colored planes, with reds serving as the background to blues in the foreground, in defiance of all earlier laws, he underscores the virtues of a new figurative system that is less intellectual than sensorial. Just as cubism had detached planes from reality in order to arrange them freely, combining them on various levels and superimposing them through transparency, it also used color to serve theoretical ends: figurative themes began to replace the object as it was usually understood. Elements that could not be detected by the fixed eye — plastic surface dynamics, mobility of colors instead of values — sparked a veritable revolution that has continued over the last half century.

It is now understood that color itself can evoke distance and depth without shadowing or the strategic placement of objects under a focused light. An important experiment, which scientific analysis would later confirm, had already been carried out. It meant that there was no turning back; and, as during the Renaissance, theory followed experimentation by artists. The experiment, which justified theorization without generating it, had demonstrated that if a given modern painting was embraced by the public, it was because it was perceived as a contemporary curiosity. It would be wrong to suggest that science possesses laws that art appropriates. It is not science but the exterior world that possesses these laws. Art, like science, interprets them, in keeping with the times.

The question that arises belongs to another order altogether. Insofar as flat color is inarguably the great discovery of this half century — at least on a par with the Paris school's break from tra-

ditional forms of drawing — we must wonder what impact this change had on the development of abstract painting.

By 1910, Matisse had sensed the dimensions of color (a shade possesses qualities related to its absolutely irreducible dimension on the canvas, and to its intensity). By the same date, Delaunay had perceived that, in addition to the active role played by the eye as it sweeps across the canvas and generates movement through its mobility, the figurative construct has an absolute value, as it were. If we take *abstract* to mean an art that borrows its methods from the techniques of painting, without attempting to transpose systems from other activities or forms of knowledge, cubism and the pure painting of 1910–14 already bore the seeds of all Abstract Art. Here, we come up against the oft-mentioned ambiguity of true and false abstraction. True abstract art is the logical outcome of figurative experiments conducted at the beginning of the century rather than the result in the plastic arts of the literary and philosophical theories of the 1880s. Moreover, the question of the degree of independence, originality, and cross-influence between the men who reached the peak of their art around 1910 and their successors of the 1930s is perhaps linked to the representation of rhythm rather than movement.

RHYTHM

Since the Renaissance, the basic principle underlying all arrangement in spatial composition was the juxtaposition of parts to obtain a more or less perfect symmetry. In painting and music, as well as architecture, it was a matter of holding forces in balance: equilibrium, the equivalent of Lassalle's iron law of wages ultimately expressed in scientific terms by Carnot's principle. In short, the whole was superior to the individual parts. It was felt that a beautiful composition achieved a balance between fullness and emptiness, light and dark strokes, straight lines and broken

lines or curves. A sonata or a symphony was seen as a system of rapid or slow movements. Everything was based on a strict balance between different affective values that could be broken down into measurable units. The principle of assembling parts also governed the work of the technologist: in mixing chemical substances, the scale served as the basic instrument; in the same way, the assembly of wooden furniture sought to achieve a solid, relaxed effect by balancing lines. "I hate movement that disrupts lines," a poet would state at the end of this era.

In the last fifty years, this concept has disappeared from human consciousness. The passage from classical verse to free verse did not occur simply to add rhythm to the movement of mental images; Debussy's music today seems to take licenses with classical music when we listen to works by Schoenberg or Alban Berg. A man who watches a film does not experience the sequence of images in the same way as someone who looks at a drawing. A man who is used to looking at photographs, which reveal infinitesimal details of nature, or who is used to an image of forms in movement — such as a turning generator — cannot evoke the same notion of movement or of form as in times past, since he has been exposed to new and unexpected relationships between conscious experiences.

Until this time, a form had always been evoked as stationary. Henceforth, it was *also* in movement. And so equilibrium was no longer necessarily seen as the organizing principle behind natural composition or behind artistic or technological creation. Dynamism has become the golden rule of our times. Everything moves, flows, and changes. This is as true for societies as for objects and forms. Equilibrium is no longer immobile but mobile. We experience movement directly, intimately, while traveling, while watching a film, or while watching machines that produce or destroy materials. It was inevitable that, once art found the appropriate

261

means, it would express man's new experience of the world. As a result, other civilizations' modes of understanding, which were starkly different from those governing our systems of representation down the centuries, have proved viable.

For centuries, the concept of drawing in the Western world has been governed by the meanings assigned to a gesture. Western man believed in the efficacy of his acting on the exterior world — in contrast, for example, with Eastern civilizations in which ritualized gestures in dance express transcendental and immutable qualities. The contrast between dance in India and in the West is, in this regard, crucial. It reveals the relationships that a society imagines to exist between its potential to act on the universe and its manner of dancing or painting. The gesture made by Michelangelo's God on the ceiling of the Sistine Chapel is inconceivable in a culture that believes in an eternity of essences.

Nowadays, it is not belief in a gesture's efficacy that has been shaken but the nature of its effect on matter. The Renaissance received its faith in objects from the Middle Ages; it viewed the human body — as well as architecture — as part of a giant construction on a demiurgical scale. In this way, it conceived of movement in terms of human locomotion. Space is determined by man's point of view; and so, to experience Renaissance space, it is necessary always to imagine an individual looking at the world, otherwise that space will have no form. Drawing is thus the science of arranging the concrete components of the world; it fixes actions whose effects are established and regular. A conventional, closed world is expressed through contemporary drawing and perspective. But this concept of movement is no longer acceptable in today's world. Now nature is viewed as a changing system in which man is no longer the center nor the microcosm; he is but a transitory and secondary point where forces in movement converge. The impact of a gesture is also seen as being incomparably

greater than that of a simple movement of a limb or an object, and its consequences are not always visible. In these times of the wireless, we no longer place much store in the vocabulary prescribed by the Academies or literary expressions. Today it is possible to imagine acts that affect the molecular and wave structure of the world. In mathematics, this concept, born of technological progress, is expressed in systems whose geometric bases are more far-reaching than what was suggested in Euclid's postulates. In painting, it inspired Delaunay's attempts to found a new painting based entirely on the direct notation of the relationships between colors. It also inspired the deformations in Picasso's work and the rise of a style such as Matisse's, which is founded on the juxtaposition of dabs of color. In a civilization where the permanence of an object or a man was a given, drawing quite logically sought to define the distinction between colors and attitudes. The belief in stability implied a belief in the clearness of a line. Thus, for five centuries, traditional drawing was founded on lines intended to reconstruct component elements according to the laws of symmetry. In his *Saint John the Baptist*, Rodin admirably showed how the viewer follows the artist who suggests *actual* movement through a combination of *truly* fragmentary gestures. Classical drawing thus consisted of figurative lines that broke down gestures while integrating them into a "motif" that helped the viewer to reconstruct the unfolding action, thereby incorporating time into a stationary spatial vision.

However, studies of other civilizations show indisputably that this method of reconstituting objects, meanings, and values through motifs integrated into the framework of unimagined spatial perspectives does not correspond to a single model of the senses and human mind. The differences can be explained, quite simply, in terms of civilization. The concept of the universe and methods of representation in frescoes in India, for example, are completely

263

different from those of the West. In Ajanta (sixth to seventh centuries), the viewer's eye is drawn, spiral-like, across geometric forms leading from one figure to the next independently of anecdotal groupings symbolizing the unfolding of life. In China, space and time are conceived in a universe that differs entirely from the Western concept of the universe. Marcel Granet's admirable works on Chinese thought inform us that, in China, space and time were conceived as being one and the same. Although they are discontinuous and separate, they produce effects jointly. Also, man is seen as having the capacity to act on space and time and to represent them through symbols, through writing. Space is precisely localized according to four cardinal points. Time can be broken down into eras, seasons, epochs, just as space is divided into fields, climates, east, and west. Geography and the calendar are the bases of the dual knowledge that regulates writing, societal behavior, and art. To know the name of something, to say it and represent it, is to appropriate it. Furthermore, in a series of signs, rhythm plays the role of syntax. The life of forms and phenomena, the life of nature and of the mind thus share certain rules. Here, we touch on the essence of life in primitive societies where the relationships between things, between man and things, are conceived entirely differently than in the West. Far be it from me to suggest that this points to Western society's absolute superiority. Nevertheless, the comparison with Eastern thinking enables us to conceive of systems that satisfy the needs of very different human groups.

The Greeks' discovery of logic was the great step in human history. But systems different from our own could have been founded on logic and reason. The principle of equality and the established value of words and figures could have taken other forms. No form of art, be it painting or any other, can survive if it is associated with signs that are considered permanent substitutes for thought.

It follows that, in today's world — where movement is playing a new, intimate role in man's daily experience, where speed has changed in its practical impact, and where technology has achieved new levels in its capacity to break down or synthesize materials — an art linked to the ancient concept of movement is outmoded. Georges Friedmann has insightfully analyzed the fundamental role played by rhythm in the development of our mechanized society, showing that it has been both a source of power and one of the most dangerous threats to humankind. Rhythm is behind the organization of output and the discipline of gestures. On the other hand, society's accelerated pace, which has sparked the race to standardization, jeopardizes man's mind and his fundamental reflexes. Similarly, rhythm has stimulated the development of all of contemporary art. By 1912, Delaunay had made it an overarching principle in his writings and paintings. Since then, abstract art has, for the most part, abandoned the pursuit of rhythm. All of Laurens's and Brancusi's sculpture is based on the experience of visual and tactile combinatory rhythms — one suggesting the other. Music, from jazz to avant-garde, has striven to evoke pure rhythm. Architecture, too, rejected symmetrical compositions in favor of open plans, thereby sparking opposed movements. Le Corbusier's Savoye House in Poissy is an example of the absolute rhythm of cubes and curved volumes. Cubism flattens the object on the plane and distorts volumes. But it attempts to depict rhythms to evoke recognition and values. From cubism — indispensable and outmoded — emerged an art that for all intents and purposes, is nothing more than an attempt to organize rhythms, in particular that of color. All variation in the recording or notation of sensorial impressions is a source of rhythm, whether expressed in dance, a system of strokes, or improvised lines on pottery or on any plastic surface. As our era knows only too well, rhythm is not necessarily symmetrical. There is an affinity between man's different repre-

sentational systems: musical notes and dance gestures, the disciplined exploitation of the human voice or of color. We have grown accustomed to more and more sophisticated exercises in deciphering or reconstitution — ranging from signs juxtaposed in space or represented in sequence — based on the notion of rhythm. Between radar and abstract paintings, there is, as with film, an essential oneness.

## MATERIAL

The new focus on material involved not only the specific method used within a technical tradition but a twofold resurgence. First, there was an "active" concept of material, as it were. Second, it was recognized that man, the artist, created his materials as much as he appropriated them.

Sculpture in particular helps us to understand this transition from a so-called passive conception to an active conception of material. With cubism, artists began to use elements derived from an analytic decomposition of earlier figurative reality and created montages of recognizable objects. With bits of cardboard, matchboxes, and pieces of metal, they devised humorous constructions. This type of style relied on a sense of recognition and, ultimately, on traditional forms of vision.

Somewhat later, a crucial discovery led to the emphasis on inner volumes. As we have seen, the essential feature of cubism was its elaboration of geometrically defined form. The three-dimensionalism of cubism led to parallel developments in sculpture and architecture up to the 1930s. Just as Le Corbusier's house at Poissy integrates interior volumes into the space, Laurens's sculpture — then Moore's — rendered interior volumes active and independent. Sculpture had long made use of masses and volumes; but it considered them strictly delimited by surfaces and possessing a unity. During the Renaissance, Donatello's principal

Figure 13. Raymond Duchamp-Villon, *The Large Horse*, 1914.

The cohesive unity of twentith-century style arose from the explorations of the Paris School. The plastic object as a figurative object underwent transformation at the start of the twentieth century. In sculpture, as in painting, the first experiments primarily involved a stylization that formed a montage of deformed reality-based elements. (Collection Walker Art Center, Minneapolis. Gift of the T.B. Walker Foundation, 1957.)

aim was to make light penetrate the mass of sculpture; to do so, he strove to have light from the illuminated contours penetrate and splinter the bronze or marble block. Until Rodin, this concept inspired all of sculpture. In the first part of the twentieth century, sculptors who were escaping the influence of Rodin refocused on the block of the sculpture and sought to model volumes and surfaces after a characteristic archaism. Not until after 1930 was a new formula discovered, one that no longer viewed the mass as an envelope but saw the interior volume as an active, autonomous form. The transition occurred naturally, moving toward a concept that viewed the block's interior as containing a dual force: one that materialized both the surface and the core. It was an idea taken from the principle of balancing solids and blank spaces in a drawing and, starting from an Ingres drawing, led to Matisse's remarkable pencil drawings that generate volumes to offset a form's interior space. A certain tension is deemed to exist between the inside, the enclosed space, and the outside, the space subject to the laws of light and the environment.

In a third phase of this development, there was an emphasis on the active void at the core of the mass. And, finally, in some countries, a parallel series of forms developed that broke up the continuity of the surface. This resulted in a style in which the void was no longer balanced and represented except by slight lines of force; it evoked a void instead of enclosing it within a solid shell of material. This was exemplified by Nino Franchina's and Robert Jacobsen's wiry style, which stands in contrast with Moore's predilection for hollowing out.

Now that I have demonstrated the parallels between this development and trends in architecture and drawing, it remains to be shown that these parallels were also influenced by prevalent ideas in science, whose secrets were increasingly appropriated and incorporated in the structures of materials. There is also a

parallel between the figurative representation of molecules and the creation of sculpture and architecture that sought to render visible the dynamic components of materials.

The transition from one style to another was clearly marked by a two-part movement. Artists were exploring the forces hidden in a slab of stone or metal, then using light to generate dynamic forms that still suggested the bulkiness of blocks. At the same time, architects were freeing themselves from blind servitude to a wall with simple openings, so as to create buildings in which the flow of light set up a passage between the exterior space and the contoured interior space.

With the move away from Cubism, another figurative system was embarked on, one that could stir the painter's imagination about spatial composition and that was attuned to contemporary scientific theory. The most delicate issue involved deciding whether this new style could be rightly called abstract. The identical problem was encountered in impressionism and cubism, the baroque and mannerism. It is both insolvable and very simple, if words are taken at face value — that is, as terms that helped artists to convey their theories — and not as narrow ideological categories.

*Technology and Technique*
At the same time, another crucial factor began to take shape. The movement's starting point was neither industrial technology nor artistic technique. The virtually unlimited conveniences that the artist owed to contemporary industry did not inspire the specific forms of his creations. He could easily create heavier or bulkier slabs of metal or artificial stone; or he could just as easily use technology to extrude extremely thin steel wires, in spite of their resistance. The ability to produce materials was not, in and of itself, a source of creative inspiration, although, hypothetically, it had led to the tangible and, eventually, active characteristics of all

269

parts of the material. The impetus behind contemporary plastic arts was the abandonment of the principle of inertia. The artist creates the material that he feels best suits his mode of expression. Like art, science is figurative. Technology, however, is not. We are dealing with two distinct questions.

Whereas during the entire nineteenth century, technological progress and the discovery of iron, steel, and concrete enhanced the means available to artists without forcing a break with traditional figurative representations, the beginning of the twentieth century witnessed the appearance of two distinct styles: cubism and Abstract Art. Functionalism had failed, as always, to subjugate art to materials. Ultimately, an aesthetic aspiration rapidly set the course for the great figurative transformations of the modern world. Obviously, the rapid development in modern plastic arts did not come about through abstract self-contemplation. Rather, it stemmed from man's awakening to a potentially new way of acting in the world. The artist expressed himself not secretly but through his power to order the broadest range of his experiences.

The artist's newly discovered ability to create material himself was an extraordinary novelty. Until then, the influence of materials on art manifested itself in methods that made it possible to make superficial changes in surfaces. Thereafter, the artist assigned attributes to materials instead of simply exploiting them. When speaking of the relationship between Art and Technology, an ambiguity arises because no distinction is made between general techniques of a period and isolated or individual techniques. There is also a problem of technique specific to art. One may speak of Matisse's or Picasso's technique, but doing so creates problems different from those in industrial techniques. The word *technique* is used today to connote all of man's mechanical activities. The proliferation of such activities in the space of

one century obscures the lack of a distinct factor that can be isolated from other human activities. Each type of activity corresponds to a technique. Art, in particular, is always technical. The word *technique* evokes not a specific form of activity but a particular aspect of all of our activities. There is a technique to the violin, just as there is a technique to painting, to physics, and to accounting. A technique is not an autonomous function. In certain respects, science as well as art or philosophy is a technique in the broadest sense of the term, if it is viewed as a regulated body of thought. From this perspective, there still cannot be a natural opposition between Art and Technology, since art always has techniques that apply to figuration and to execution.

And so the terms to be used in the final part of this study have been set out. I shall attempt to determine art's place in society or, more specifically, in modern relations. I shall also attempt to determine art's place among the techniques of expression, that is, within the order of languages.

PART FOUR

# The Function of Art in
# Mechanized Society

# The Success and Value of

# Contemporary Art

At a conference in Geneva in 1949, a number of writers and art critics held talks on the problem of Art in Contemporary Society. Over the course of a few days, everyone spoke as if the issues they raised were beyond dispute. No one questioned whether, under different political, social, economic, or technological circumstances, the relationships between artistic activity and other forms of contemporary activities would have been altered. However, Man, Nature, and History can only be understood and examined not as essences but as realities within a network of constantly changing relationships. The tendency to consider Art, Nature, Technology, or Man as simple data stems from creation metaphysics, or Bossuetian or Enlightenment philosophy. Yet all critiques collapse when they attempt to situate the problem of art in contemporary society within the framework of a dual assumption: society's homogeneity and the permanence of forms.

It is now common to deplore the gulf that separates art from the public. It is seen as proof of a schism that goes to the core of the human soul, as if that soul — much like the Platonic soul — were a permanent reality among the constant transmutations of creation. For those who think that art is, and always will be, nothing but art, it comes down to discovering whether art has main-

tained its place in a society whose principles are starkly at odds with its long-standing imperatives — as can be inferred from an examination of its most recent historical forms.

I hope I have proved in the preceding chapters that there is no contradiction between the development of contemporary art and the scientific and technological practices of modern society, for they are all based on the intellectual attitudes regulating the human environment created by contemporary man. By recognizing the technological nature of art and examining it in relation to contemporary theory — philosophical, mathematical, or physical — I have subverted the widely held belief in a natural opposition between art and other practical or speculative human activities. However, I also demonstrated that, although its development indeed drew on progress in technology and in general human knowledge, contemporary art also traced an utterly stylistic evolution, linked to aesthetic values that were not dictated by the imperatives of other specialized activities. Consequently, it would be as mistaken to think that art was perfectly integrated into other distinct societal activities as it would be to reject the idea that a relationship exists and to set up a complete antinomy, either of principles or of objectives.

We must envision a relationship between the creative activities in society other than one based simply on cause and effect. Artistic creation, which is technological in certain respects, can also be economic or political, while retaining characteristics that cannot be reduced to any one activity. Art can be seen as both autonomous and directly linked to other activities. Consequently, the point is not to survey our era to trace the appearance of an unprecedented function, be it technological or artistic. In every era, as in every human activity, technology has played a part, either in the most abstract mathematical theories or in the boldest aesthetic creations. What distinguishes the modern world is

not the role played by technologies nor their rapid proliferation. It is, rather, the economic and social ends toward which technologies of every kind, including artistic, have been applied.

It is not possible to assess art's place in contemporary society by making a general comparison between the societal and the technological sphere. While art bears distinctive and essential features, it can never be entirely separated from any one sphere, either in terms of reality or in terms of essences. Moreover, there are no fixed forms of art any more than there are fixed technological or societal forms. We are faced with a problem whose attributes constantly shift and crystallize only in the real world. In other words, to assess the importance and nature of aesthetics in contemporary society, we must consider two issues: public acceptance or the success of contemporary art; and the appropriate means of approach, that is, art's understandability and the valid means for determining its intrinsic and social value.

## The Institutional Character of Contemporary Art

There is no need to go to great lengths to demonstrate that contemporary art has pervaded life in society. Everyone is aware of this fact, to the point that the history of the arts has shifted from the domain of science and taste to that of popular culture. Nevertheless, it is necessary to point out several ways in which it has penetrated society: art has affected the general transformation of everyday objects and influenced recent developments in art theory.

## The Universality of Contemporary Art

If we compare a modern city or even a village with an urban center from the nineteenth century, the transformation appears even greater than what occurred over the preceding 150 years. A type of house, which first appeared during the seventeenth and eighteenth centuries, no longer suited the needs of man, whose tastes

and lifestyles had changed radically. Moreover, a transformation in the materials used in everyday objects followed, as we have seen, the development of means of production based on new industrial techniques. Familiar objects such as the cauldron, the skewer, the wash basin, and the candelabra disappeared to make room for new tools indispensable for daily life. The electric iron and the Frigidaire have become daily conveniences sought by countless housewives who had dreamed of copper ware and dripping pans only sixty years earlier. Rarely has there been such a rapid shift in materials used in daily life. I have already indicated the pressing need to take stock of how this total transformation affected the object, man's familiar but changing companion throughout history.

I have been careful to stress, as well, that this great transformation in the materials used in creating objects was due not only to new means of production but also to the spread of civilization and to growing uniformity. That is, objects used to perform human activities spread uniformly around the world; and their ever-increasing availability reduced former class distinctions. As a result, insofar as art participated in the material transformation of the world, it increased its power of penetration while abandoning one of the most salient features of its former activity. Art no longer stressed forms reserved to fixed categories of people — potentates or a private circle of the initiated. Instead, it exalted the generality of perceptions and messages. In short, this phenomenon overturned the situation of art not only socially but also geographically. Henceforth, and for the first time since the prehistoric period, there was a form of universal art.

This point is of crucial importance. In spite of the vogue among certain groups for folk art or popular art, a persistent trend led contemporary society to use similar types of objects, whether figurative or utilitarian. Today people build or dress the

same way in Paris, Warsaw, Rio de Janeiro, and Pakistan. Painting exhibitions from Sydney to Oslo share remarkable similarities. Even in places where there is some reluctance to embrace the modern plastic arts, such as in Soviet Russia, Western art of yesterday continues to be promoted, without creating a form or material. In 1850, Victor Hugo said: "The world travels by train and speaks French." In 1950, one could say that the world travels by plane and designs and sculpts the way they do in Paris. The vocabulary of the plastic arts is becoming uniform across the planet, ahead of general language conventions. Therefore, studies based on the analysis of forms are crucial for understanding the social and mental structures of the world.

To be sure, in many respects, modern art serves the imagination. It projects imagined human actions into fictional or abstract times and places — the reason for its far-reaching repercussions. But at the same time, modern art crystallizes values that affect daily life, through either purely figurative signs or manufactured objects.

No one can deny the major role that advertising plays in modern life. Today advertising springs directly from artistic techniques perfected by a small group of Parisian artists at the beginning of the twentieth century. It was Toulouse-Lautrec, in particular, who helped bring about the transition from advertising based on catchwords to a purely visual format. Around 1840, Balzac described the window display that César Birotteau installed in central Paris when he wanted to reach the widest possible audience. It is a printed-word advertisement. Letters emblazoned across the window extol the virtues of the *Reine des Crèmes* in a scene taken right out of the famous La Mésangère collection, echoing the Directoire or Restoration style. Honoré Daumier's style, as well as Paul Gavarni's and Eugène Devéria's, makes use of captions. During the nineteenth century, images illustrated or conveyed a

message. From then on, the caption waned, then disappeared. The image spoke for itself; it owed its impact no longer to captions but to color. In this way, advertising participated in the most esoteric artistic development of that time. Undeniably, in this century of cinema, our contemporaries are more impressed by an image than by a caption. Drawing ceased to be a commentary on speech; it became autonomous, signaling an enormous upheaval in the destiny of the most refined art.

*Legitimacy and Influence of the Avant-Garde*
In all likelihood, the art of tomorrow will spring from ideas born on the banks of the Seine. This is not meant as a prophecy that the world will be overtaken by artistic conventions destined to endure. However, by all evidence, the language of the plastic arts is common to much of the contemporary world. No individual or event will turn modern social expansion toward academicism and architecture inspired by Antiquity. It is cubism, abstraction, and the avant-garde forms that best express the prevalent language of the last half century. Avant-garde art is not only at the center of today's aesthetic debates but also the impetus behind the most legitimate efforts by new societies to cater to the economic and technological demands of Western science.

If the current debate centers on the fate of art in Paris, it is because this art has continuously offered original and innovative figurative and concrete forms to suit the technological possibilities of the times. Indeed, advertising offers a striking example of the progressive impact of yesterday's art on the today's world; and its daily influence is still plainly visible. Not only is today's public presented with figurative signs inspired directly by abstract art, its imagination is not truly stirred except by the avant-garde. We need only compare the advertising approaches used twenty years apart by a major wine merchant to note the great strides that have

been made. The wine merchant follows the principles of the live-ly arts. It is not true that art has confined itself to esotericism. Aestheticism blossoms among the doctrinaires of academicism.

Austere, open interiors evoking spaciousness and luminosity mark the triumph of the principles of cubism and Abstract Art in today's world. The predilection for smooth surfaces and inter-connected volumes attests to the role played by sculptors in the development of the modern dwelling. Color, light, volume, rhy-thm — these themes reoccur, more often than forms, in all adver-tising and commercial approaches.

To be sure, the world burgeoning before us is not perfect and will not be filled with marvelous plastic creations of the first order destined to live on forever. Airplanes crash and architects and interior decorators create monstrosities. But in this cruel and ever-changing world, the lines of force indicate a close alignment between the arts and practical activities of society. In every era, art has been linked to the loftiest figurative theories and to the mass production of items for daily use, because art itself is always both a system of representation and a technology.

As Maurice Halbwachs's works on collective memory have shown, art attests to phenomena that overlap an era's socially determined activities. It creates an interface between individuals who are not aware of each other or who are at odds. Like lan-guage, art enables men who have nothing in common to build a collective society. It is one of the many links that enable men who live in different eras or places to agree on ideas, through the set meaning of certain signs.

On this point, I need to make a fundamental distinction be-tween fashion and style. The latter is not the sum of a society's passing fads. It is based on other values and is determined in response to other functions. Whereas fashion reflects a continual desire to change, style, according to R. Bonnot, is about a soci-

ety's desire to be, and to believe itself to be, eternal. New material systems or certainties lead to the collective adjustment and adaptation of actions as well as ideas. All that will be retained by future societies are those artistic and technological conventions that respond to means of action and to general and relatively durable systems of understanding.

That is why I am justified in considering valid only those forms of art today that affect the most boldly original works as well as the most pragmatic social activities. Why Le Corbusier and Gropius rather than the Paris Ecole des Beaux-Arts? Why Laurens and Brancusi and not Paul Landowski? Why Estève, Gischia, and Pignon rather than Maurice Brianchon, Roland Oudot, and Christian Bérard? It is not merely because critics have the absolute right to follow their taste but because, as shall be shown, certain forms of art simply prolong a value system derived from activities no longer adapted to contemporary lifestyles.

It is natural and legitimate that social groups, tied to established values, reject the generally imperfect theories of avant-garde art. There is no way they can foretell with precision how the art of tomorrow will look. Yet there is no doubt that it is on the basis of these speculations on the general development of contemporary practical and theoretical endeavors — and on the basis of them alone — that the next representative style will take shape.

This attitude poses two difficulties. One is easily resolved because its solution is found in history: for a long time to come, several art forms will follow parallel paths and share the public's favor. The other is more complex because it can come about only through the development of a new human experience: How will today's strictly aesthetic values be transferred to mass production?

Rarely is a style an immediate triumph. For a society to break its links to figurative traditions, it must overturn all of its social relationships. As we have seen, that was the case with backward

societies that suddenly came into contact with societies equipped with more resources. There are many such examples — from the New World, Africa, and Australia — in which the impact is the same: the subversion of art goes hand and hand with the destruction of social links and the loss of creative force. A cult object is both the product of a technique and the figurative focus of human values. It is institutional while also conveying a power to inform material. For certain black cultures, the sculptor is a blacksmith, partaking in the secret of fire. In all primitive societies, the artist transforms whatever he touches through a magic power that gives him access to the mystery of creation. He institutes; he informs material. The same is true not only among primitive peoples whose way of life has long been infused with magic but also in societies like our own. The discovery of the physical and phenomenal character of Color is rather recent. Its principles do not date back further than the seventeenth century. Until then, the technical aspects of color were limited to the realm of alchemy. The painter, like the dyer, materially transformed what he colored. Color is a constituent element of the nature of things. Leonardo was the first to have a vague prescience of the relationship between light and color, but he did not pursue the issue beyond changes in appearances. He did not associate color with the separate but similar phenomenon of light. Not until Newton and the discovery of the spectrum was it realized that colors blend to make up white light. However, before a truly revolutionary insight into color could take place, it would be necessary to await Lavoisier and his discovery of the principles behind the minute analysis of the components of natural compounds, then Turner and the impressionists, who undertook further explorations of the fundamental data of sense perception on the basis of the new understanding of high-wavelength light in the color spectrum. Until then, it was necessary to possess the color in order to repre-

283

sent the reality of the object; but this possession meant an ability to materialize it.

Not only is it natural that contemporary societies resist the passage from a representative concept of color to a figurative concept that runs counter to age-old practices; this resistance is necessary for the advancement of civilization. Indeed, when a society rejects all of its technical certitudes and traditional representations, it abandons, simultaneously, all of its values. It literally yields to the human group that imposes its techniques and new representations. Destroying the images of deities has always been one of the most efficient ways of subjugating. The natural process of human progress requires that new systems of understanding and representation be seen as integrating earlier ones without entirely destroying them. It entails an enlargement, an enrichment, not an outright replacement. True progress requires an attachment to the past. Only the most active and alert members of society are able to grasp avant-garde conventions rapidly, although these conventions alone are destined to spread and can provide the means of expression suited to the production of new objects or signs.

It is outside the scope of this book to treat the countless details that evidence the influence of avant-garde forms in modern society. But that is not my objective. I am not trying to determine whether modern art is on the ascendancy despite the inevitable obstacles intended to hinder its total triumph. Instead, I shall attempt to point up the enduring relationship between contemporary progressive technologies and this era's strictly figurative style. Whether or not the public has accepted modern art forms is not the issue at hand. To demonstrate such acceptance, it would be necessary to provide supporting documentation as to its universality and its impact on objects that, at first glance, seem to lie outside the domain of art. Instead, I shall focus primarily on doc-

trines that have a direct bearing on the principal subject of this study: issues debated within the highly important Industrial Aesthetic movement and, at the other end of the spectrum, the existence of purely figurative objects, which seem devoid of social utility.

## The Industrial Aesthetic

### Origins of the Problem

The Industrial Aesthetic movement emerged from nineteenth-century aesthetic theories. Its progenitors were Ruskin and William Morris. It is no accident that it is currently most firmly implanted in Anglo-Saxon countries. In France, however, it has undergone a resurgence in the past few years, thanks to Jacques Viénot, who drew much attention to these issues within industrial circles. In Germany, the movement, which coalesced in Gropius's Bauhaus after the First World War, regained momentum and paved the way to a large international congress in Darmstadt held in 1953. In Italy, industrial art exhibitions multiplied in Milan and Venice, and the movement was supported by the remarkable sponsorship of Olivetti. *Civiltà delle machine* is the best magazine of its kind. In the United States, it not only stimulated research; it was a teaching doctrine — although that does not necessarily explain America's lead!

Movements are complex. Some are theoretical, others practical. Certain followers strove to introduce more taste and art into industrial production; others merely wanted to improve the advertising for their products. Moreover, a whole part of this movement grew from theoretical speculations; but current disciples include practically oriented men, cultivated engineers who earnestly undertake endeavors that are as representative as possible of all contemporary processes.

285

In the beginning, there were two trends. One focused on art and the other on practical convenience. According to another hypothesis, the two overlap. Artists and manufacturers both draw on their experience of the world, although in very different ways. There is no reason why their work might not overlap and why, as a result, they cannot jointly create works that reflect contemporary life as a whole. The entire movement is thus based on a strong belief in the necessity and efficacy of the aesthetic function. As I have mentioned, for some, it was merely a matter of acclimatization, to the extent that the eye had grown accustomed to certain commonplace forms — an argument that fails to take into account the active engagement of mental processes, even in manual or automated labor. In contrast, among industrialists and businessmen, there was a desire to make a practical assessment of the artistic function in society. Rare are the unenlightened circles — unenlightened about theory above all — in which quality is professed to be a by-product of quantity. To be sure, in the long run, such serious intellectual shortsightedness would have disastrous economic effects in a world open to competition.

## The French Doctrine: The Stylists

There are several attitudes that differ in principle from one country to the next. In France, it was Viénot who set down a coherent doctrine: taste can be learned. Certainly, it is also a form of intellectual activity distributed innately among some people. This applies not only to taste but also to music. It can be developed by a culture, at least to the point that it is possible to measure practical factors according to a given order. Artists cannot be created, but their public can be prepared.

Here, we encounter a problem. Accustomed to a mechanized world where the qualities of a product can be determined, specified, and monitored, technologists are tempted to set down mea-

surable norms of taste, much like the standards applied to the components used to produce all other objects. They are surprised and shocked if not contemptuous of values that cannot be measured according to a fixed scale of relative magnitudes comparable to other manipulable scales. They readily concede that only scientific aesthetics is of interest to them. They are of the same mind as another large category of technologists from the human sciences who also dream of eventually scientizing their discipline or, more specifically, of transferring scientific forms into their field. Viénot lucidly pointed up the major difficulty of their enterprise, which consisted in making a clear distinction between a teaching method and a strictly aesthetic doctrine, on the one hand, and applying a pseudo yardstick based on artistic values borrowed from another order, on the other hand.

It does not naturally fall to industrial aesthetic circles to set down the modern rules of aesthetics. It is already remarkable that these circles are aware that the inclusion of aesthetics and art in their spheres of activity depends on the historical and psychological development of human sciences. Their story is crucial evidence of the error committed by those who think they can adapt all types of knowledge to fit a few conventions from a single order of intellectual activity. Unfortunately, this happens all too often. Most societies let themselves be dominated by a single line of thought, which reveals more about obstacles than about social progress.

The second point of Viénot's doctrine centers on the impossibility of public education, strictly speaking. In his view, the adult population is too large and its practices too ingrained for its tastes to be educated, let alone reeducated. As a result, the goal of an effective reform movement must be to educate the tastes of manufacturers, who are fewer in number and, in theory at least, more easily influenced by demonstration.

To support his case, Viénot relies on principled arguments and historical examples. He states that if men of the past used everyday objects whose quality and aesthetic features are still admired today, it is not because the peasant from Lower Brittany had taste but because the artisans who produced limited types of everyday objects faithfully followed age-old manufacturing principles set down by men of taste. In short, he traces the aesthetic quality of utilitarian materials to a permanence of styles and to a general indifference of the masses.

The facts are clear. Artisans of the past did indeed follow principles that had been laid out, to a large degree, by artists. The use of sketchbooks was absolutely indispensable. Models were passed down from hand to hand. At times, in Antiquity, the production of works was limited to several specialized workshops, as was the case with Athenian pottery and, in late Antiquity, with the Gaelic sarcophagi in Arles and Toulouse. In the Middle Ages, the mutation and transmission of styles accelerated. The number of workshops increased, without altering the way in which the "secrets" of manufacturing objects or constructing cathedrals were transmitted. On the one hand, there were preparatory procedures applied to materials, and, on the other hand, there were models of long standing used to determine the decorative or architectural forms to be used in all areas of human activity. With the discovery of printing, there was a rapid increase in the number and availability of models. Soon, compilations of models began to appear, broadening the spread of styles, which, at the same time, forced local workshops to comply with the tastes of the dominant spheres of society. The interplay of styles intensified as styles spread more rapidly and widely. Still, local and manual labor remained faithful to techniques and principles of taste imposed by small teams of innovators. In this particular regard, not much has really changed in our times. Even now, and on a virtually world-

wide scale, the production of objects and forms is determined by a few small groups. As in the past, we note the dual influence of technologists, who, depending on man's capacity to transform materials, determine which objects are most practical to make and the quickest way to produce them, and artists, who determine the form and the decorative setting of these same objects, in keeping with prevailing tastes. That is why there is a consistency of style within a period, bringing together the most sophisticated forms of art and the most utilitarian objects.

And so it is true that in the past the artistic quality of utilitarian objects was linked to the tastes of a few individuals and, despite the relative difficulty of exchanges, was under the direct influence of artists. Nevertheless, it would be hasty to conclude that the role played by users was entirely passive. Using the same objects, two neighbors might arrange their interiors in completely different ways. From the same sketchbook, two designers might decorate a piece of furniture or paneling with either delicate or bold arabesques. It is a matter not of knowledge but of taste. The distinguishing feature of a society is not the objects it has at its disposal but how it uses them. Primitive peoples who are given Western tools use them awkwardly. Throughout history, there have always been people who have rebelled against the prevailing taste. A society arbitrarily given the resources to achieve aesthetic or technological progress does not necessarily have the means to put them to practical use. It is not true that a civilization passively accepts its artistic environment, whether or not it is perceived as beautiful. To understand the role played by each artisan and each user in the shaping of a form, we need only observe the permutations undergone by medieval or Renaissance styles as they circulated around the world. It was not the object or the form that was intrinsically a thing of absolute beauty. As is true for all objects, the work of art is intended for a particular usage. It

is not created for pure contemplation; it is intended to serve a purpose. Its meaning, which is never a part of the object's essential nature, is grasped only in the eye of the beholder. Art is a phenomenon that always involves an exchange in which the creator and the public are not on equal footing insofar as the creator stands alone before the mass of users and seeks to impose his point of view. Still, it is an exchange in which nothing is entirely gratuitous.

As a result, although educating manufacturers can transform taste, it is not enough to elevate or transform artistic sensibility in a given historical context. Such a transformation cannot occur without a simultaneous education of public taste. Moreover, today, as in the past, the general public is not indifferent to the values of the plastic arts. The belief that it is results from an overly intellectualized idea of the nature of art, which leads to a failure to recognize that artistic sensibility is not linked merely to the development of other discursive or analytic faculties but solicits an individual capacity that is not evenly distributed. It is a mistake to think that there are special classes or closed groups that alone can grasp an artist's message in its entirety. To the contrary: art is a network of overlapping intellectual relationships and requires the active participation of the creator and the public.

Viénot's idea, which represents what might be called the French school, is founded mainly on training specialists to transpose the most refined artistic conventions into practical use. Without a doubt, the Industrial Aesthetic movement is dedicated to taking up the work of men who, down the ages, have drawn inspiration from great forms of living art to create versions suitable for practical use. There is a niche between the artist and the artisan, to be occupied by the manual laborer, the blacksmith, the engineer, or whoever is able to exploit the most powerful means available. But no great era of art can arise unless a society is capa-

ble of accepting and assimilating a new style. The mere availability of models or aesthetic objects is not enough. A crucial pedagogical role must be taken up by the creators of models and individuals capable of finding a practical application for the principles embodied in the dominant style. But industrial stylists are sorely mistaken if they believe they can use their own sense of judgment to determine the forms of a modern utilitarian style. It is artists and the public — the final arbiters of common values — who will ultimately decide the success or failure of the movement. It is not professional stylists, mechanically and talentlessly imitating contemporary art, who will define the style of our times. Artists cannot do it on their own. It is not a matter of adapting forms to fit objects; it is a question of creating objects in light of contemporary art but not by simple transference. We are still waiting for the Jean d'Udine, the Berain, the Oppenordt, and the Boucher of tomorrow. For an era to have its defining style or art, there must be creators and a public. The education of one group requires the education of the other. In the past, artists always settled where circumstances were most favorable. For this reason, the true artistic creators of this century from around the world have set their sights on Paris.

Today it is often said that times have changed, that other artistic centers have usurped the place once held by Paris. Viénot himself had no qualms about writing that France had been outstripped by Italy, Sweden, the United States, Holland, and Switzerland. I do not share that opinion at all. There do not seem to be several modern art movements today. Until now, all trends, without exception, have been inspired by the Paris school, even if some results are superior to similar French creations, precisely because they are derived from principles — born in Parisian circles — that gave rise to the great modern representational forms. Wright and Aalto built on representational precepts that emanated from

the impressionists, the cubists, and the abstractionists, who, how-
ever varied their origins, embraced theories that could only have
been nurtured in France.

*Foreign Doctrines: Industrial Design*
As I examine the attitudes that have supplanted Parisian doctrines,
I cannot help but be struck by their weakness. It is primarily in
England and America that the movements comparable to the
Industrial Aesthetic have developed. The theoretical and practical
question that arises is, What is there that genuinely arouses our
enthusiasm?

In England, artistic, literary, and social movements have tended
to have a broader impact than in France. England is the country of
the two-party system and mass movements. Hence it is easier to
reach a consensus there than in a country like France, where there
is a flurry of opposing opinions. England is, moreover, a country
where doctrines are applied across the board. Once accepted, a
decision tends to be long-standing. In the eighteenth century,
England rallied behind the Adam style, which represented the tri-
umph over international Palladianism and whose golden rule was
the general adaptation of all handicrafts to fit a single composi-
tional and decorative blueprint. The Adam style is a good exam-
ple of artists' adopting a uniform principle of taste and applying it
to what was, if not a truly industrial production, at least mass pro-
duction. It is a prime example of decorative functionalism, pro-
moting a uniform appearance among all of the products of an era,
from the house to the saucer. Even today, Adam-style ideals influ-
ence design on the other side of the Channel, namely, Industrial
Design, the glory of contemporary industrial aesthetics.

Each form of the Adam style followed in succession, without
undergoing substantial change, from the middle of the eighteenth
century. In the nineteenth century, English faith was stirred by

the great movement headed by Ruskin and Morris, which, as we have seen, sought to bring art face-to-face with industrialization. The Adam style was the epitome of handicraft style from the first period of the Industrial Revolution, interpreted by John Nef. In its final forms, it was the very symbol of a closed social class living in supreme luxury, as opposed to the extreme impoverishment of the masses. Morris and Ruskin led the struggle on two fronts: on the one hand, they extolled sentimental values, as opposed to academic rules; and, on the other hand, they sought to enable a large stratum of society to partake of aesthetic objects. This dual movement gave rise to a taste linked to the international style, which was more literary than plastic, serving as a large source of inspiration behind art nouveau. The English decorative style, or Studio style, whose name was taken from the magazine that helped promote it between 1890 and 1920, is floral. It has affinities with the French Métro and Gallé styles, the modern Belgian style of Horta, the Munich style, and the Viennese *Sezession* style. Ultimately, it was a logical outgrowth of the functionalist doctrine as it was spread, through differing perspectives, by Ruskin and Viollet-le-Duc around 1860–80. Its guiding principle is that art must abandon academic conventions and conform to Nature.

Then it became apparent that the aesthetic theories that took shape around 1925, on the heels of the success of Industrial Design, had not, in fact, deviated from this principle. The British Institute of Industrial Art, founded in 1920; the Council of Industrial Design, which publishes a sleek monthly review titled *Design*; the Faculty of Royal Designer for Industry, created in 1936 — all follow the same doctrine, based on the natural affinity and common origin of every form of beauty. It was a very official movement that led to some great exhibitions: Britain Can Make It in 1946 and the Festival of Britain in 1951. The goal was, first, to harmonize perfectly the products manufactured by an industrial firm,

ranging from the safety pin to the locomotive, from the wrapper — or packaging, as it is more commonly called — for a bar of soap to everyday accessories, furniture, curtains, stationery, and so on. The watchwords in the imaginations of the "stylists" were *eclecticism* and *natural*. We are still firmly in Morris's and Ruskin's realm of functionalism and naturalism, where everything is inspired by decorative concepts. Hidden structures are supplanted by standard forms, defined by an ideal of Beauty derived from Nature. Furthermore, class distinctions are obscured: the worker and the engineer, the lord and the bus driver drink the same milk from the same hygienic package, covered in the same chlorophyll color that helps plants breathe and appeases social discontent.

At the other end of the Anglo-Saxon spectrum, there is a well-known theorist of the American industrial aesthetic named Antonin Heythum, a Harvard professor who teaches that "analytical design," which holds the key to future beauty when practiced with intelligence and sensitivity, leads to the creation of rational forms and a style, although that is not the actual goal. His students are given exercises that consist, for example, in examining the structure of a spiderweb in order to analyze its natural and rational principles of organization. Beauty is always found in Nature, even if the ordinary individual does not recognize it at first glance. The artist is there only to reveal it for use by his contemporaries. In short, the idea of creation is always replaced by the act of discovery.

Although it is difficult to speak of successful breakthroughs, since there is no absolute norm of taste that makes it possible to determine universally what is beautiful and what is not, it is possible to criticize principles. I would note, first of all, that Industrial Design — like the Industrial Aesthetic — promotes applying a standard formula to all objects. Although it calls for applying a form that suits the structure or mechanism, it amounts, in each

case, to the mere adornment of the product. In the past, the prin-ciples of a style, such as arabesque in the Renaissance, served as the basis for numerous figurative forms, creating variety within an overall unity. In contrast, Industrial Design's or Heythum's objec-tive is to impose uniformity. Style no longer generates varied fig-ures; it is the sum or the average of the common elements of an imposed production. Be it a washing machine, an electric razor, an automobile, a box of detergent, or an airplane, a single princi-ple ultimately prevailed: aerodynamism.

It can be validly said that this universal taste for smooth, non-angular forms and polished or lacquered surfaces, and for large panels of vivid colors or large block letters, was inspired less by economic concerns than by the strictly aesthetic triumph of cer-tain forms venerated by the avant-garde. From this perspective, the Industrial Aesthetic movement does not at all adhere to its doctrine; rather, it bears out the idea that the success of a style in an era can be attributed to the creation of artistic forms. The predilection for curving, enfolding forms and tactile surfaces was exhibited by artists like Laurens, Brancusi, and Lipschitz prior to engineering experiments in aerodynamics. Obviously, it cannot be argued that engineers were inspired by artists to analyze how objects move in the air. In fact, artists, like engineers, were prompted to discover new forms when they began to focus on the material and tactile problems of objective sensations. Ideas such as block units and envelopment appeared simultaneously in purely theoretical disciplines such as mathematics. Underlying these experiments was the notion, shared by all men of the twen-tieth century, that materials should be shaped not randomly but by exercising a demiurgical power.

The Industrial Design movement was most creative when it sought to lay down a series of forms that transcended the specific utilitarian end of each object. It is not, therefore, the movement's

desire to impose uniformity on an era's total output that is cause for apprehension; rather, it is the movement's claim to have decoded forms supposedly revealed in nature.

Such an attitude is not limited to Anglo-Saxon countries. It is found among many technologists in France as well. Sometime ago, an article — which I have already cited — written by the noted French scientist Georges Combet appeared in a journal on technical training: *Technique, Art, Science: Revue de l'enseignant technique.* Under the title "Esthétique et economie," the author advanced theories that bore similarities to the British "poverty style," which had surfaced during the war years. It is true that underlying some of the most beautiful creations are rules stipulating the most concise, the most frugal economy in the use of resources. It is true that the Greek temple and the Gothic cathedral were constructed according to simple, geometric rules, in conjunction with the most generalized mathematical knowledge of the period. However, we should avoid succumbing to fallacies, such as the contention that the work of a painter like Léger grows from a fundamental simplicity and economy in the use of resources. This kind of thinking presumes that the work of art obeys a structured plan external to itself. We may indeed speak of an economy of resources as regards the program pursued by the artist himself but not of an absolute economy vis-à-vis the richness of nature. Here, we come dangerously close to confusing impoverishment, or a stripping away, with creation. There is not a stripping away but a conciseness of expression. There is, too, a richness and plenitude of form and not merely an elimination of superfluousness. Combet himself wrote several insightful pages on the relationship between the economy of means and the aesthetic use of materials in an era. He rightly saw the Industrial Aesthetic as involving the discovery of a complex equation or, rather, a homogeneous equation, whose variables were the economy of materials, of design, and of forms.

It is unfortunate that Combet's essay then veered off toward a mystical vision of beauty. In his view, a civilization's industrial products should imitate the forms in the life stages of a plant! The flower then the fruit. Thus one would pass naturally and genetically — to use a word that is now fashionable — from the begonia to the airplane engine, well encased under the fuselage, from the tulip to the chronometer or the electric train, entirely covered by its shell. Almost inadvertently, Combet touches on an infinitely more complex problem, one that contrasts open and closed forms. It is a question that cannot be geared to serve naturalist ends — a philosophical and aesthetic concept worthy of the Ruskinian age.

Having said that, it is surprising to see Combet return to much sounder ideas when he cites, for example, the precedence of the research unit over the material-fatigue unit in the preparation of the slightest industrial product — opening the way for incorporating art in industrial production. In light of naturalist-based doctrines that sought to revive timeworn precepts discredited by such disasters as art nouveau, which failed to give rise to valid forms (because Beauty was considered immanent in reality, while man was merely a "decipherer" of the secrets of the gods), and in light of speculations on man's intellectual and sensorial nature, as revealed by the prodigious demiurgical rise of industry, there was a strengthening of the ties between art and economic, social, and industrial activities. There can never be a direct transfer of an attribute from one order of activity to another. The laws governing plant growth cannot generate laws on machine production. Genesis in nature and in society is not uniform; nor, in either case, does it obey an established structure. There are no independent values that might be imposed reciprocally on art and technology or brought to their lowest common denominator. There can only be an intellectual comparison or parallelism — never a direct application — between the elements of each series. The

only common reality is the human mind, not the modes of adaptation that are falsely presented as the final outcome worked toward. Lest we forget, it is not technology as such but intellectual and practical values — such as efficiency or economy — that are identified with or contrasted to art through techniques that are as predetermined as art itself. Although art influences technology insofar as art, too, is a means of transforming materials, art should not be confused with technology nor set against it in an implacable opposition. Here, at the heart of the problem of the Industrial Aesthetic, we touch on the fundamental question of the nature of art, which is perceived as an autonomous activity of the creative imagination.

It still seems impossible to embrace the theories advanced by those who see the great artist as the embodiment of the mind-set of his era, which he brings to light through his exceptionally developed technical abilities. Nor is it possible to embrace the theories of those who would have us believe in the dream of mass-produced art, a dream that would be realized by applying industrial principles to art — that is, by paradoxically adapting the machine to serve naturalist ends, ends that art would detect and materialize Whether art is seen as emanating from the collective soul of societies or as revealing the world's hidden secrets, we are confronted with the notion of man face-to-face with Nature, as if he finds himself before a Reality in which he cannot actively participate but which he must explore without ever actually penetrating. To the contrary: art, like industry, is an activity, one that is not exercised independently of, nor in opposition to, other mental and manual activities.

*Stylists and Style*
The international Industrial Aesthetic movement has still other characteristics. I shall consider, in particular, its relationship to

the theories inspired by Gropius's earlier Bauhaus — theories that affirmed the need for an art inextricably linked to the social context of modern civilization. Gropius's approach, which was presented earlier, stands in stark contrast with the attitude prevailing in France and Anglo-Saxon countries, which stressed a commitment to an ultimate purpose or aesthetic imperative. However that may be, it is surprising that the final results are no more impressive. The Bauhaus did not establish a uniform taste among its followers, nor did its output possess artistic qualities that embodied a style expressing modern life. Indeed, the best of intentions or principles alone did not suffice to inspire artistic creation. The error apparent in the variants of the Industrial Aesthetic is that, in determining the forms of contemporary art, it considers art a transcendent value that is automatically implied in other technical and significant values but it does not address *artists*. A draftsman, or "stylist," will never create a form. He will merely transpose conventions borrowed from contemporary works of art without grasping their rationality. The men of the Middle Ages, the Renaissance, and the seventeenth century were able to establish an impressive uniformity throughout the most humble and modest works because they belonged to art and not to industry. Not all great artists are able to adapt their creativity to utilitarian purposes. A selection must be made. A period's style is a combination of the efforts of the technologists who handle materials and the technicians of style — who are not popularizers but artists. Engineers and psychologists alone will not reestablish the link between living art and manufactured objects. The Industrial Aesthetic movements will gradually peter out unless not only industrialists but genuine, forward-thinking artists are called on to consider the problems posed by the production of contemporary objects.

The movements that claim to be inspired by the Industrial

Aesthetic help us to situate the relationship between modern artistic and nonartistic techniques. At present, they have not, and will not, be able to bring about the hoped-for alliance between the artistic and mechanized activities of our era. As a consequence, there is a curious lag in public awareness of the forms of contemporary art. Paradoxically, but understandably, the lively arts reach the public more rapidly than the applied arts. Although the general public responds enthusiastically to artists like Picasso and Matisse, the objects it adopts for daily use — say, enveloping and polished forms — represent a single category from among the various creative forms in our era. Aristide Maillol's style triumphed in the age of Matisse and abstract art. In other words, it is far easier to imagine a marriage between the arts and utilitarian industrial forms than to pinpoint which aspects of the modern mechanized world are likely to serve as the basis for contemporary style. Only one thing is certain: such a marriage cannot be brought about by enlisting the creative services of stylists and technologists and by soliciting manufacturers — or the public — in the cause of the Industrial Aesthetic. Rather, we must discover who, *among artists*, has defined a twentieth-century style.

The distinction within art between imaginative speculation and technique has surfaced in every era — and not without creating internal conflict. Essentially, the distinction has its origins in what might be called art's dual nature. On the one hand, artistic merit is measured according to the quality of execution, and, from this perspective, it is essentially a technique. On the other hand, art conveys a meaning or message, and, from this perspective, it exhibits figurative values. As such, it straddles two domains: as a language, art is subject to laws governing not only mental processes but also manual technique; yet it also possesses an inherent transcendence, which some perceive, albeit erroneously, as its entire nature.

## Art's Dual Technical and Figurative Nature

To examine art's dual nature more closely and discover how it is subtly connected to other technical, symbolic, or practical activities — the ultimate goal of this study — I need first to compare it with another form of higher-order mental activity.

## The Encounter Between the Real and the Imaginary in Mathematics

Mathematics, it hardly need be pointed out, is a key science. I have no direct, advanced understanding in this area, but as it happens, it is mathematicians, who, alongside artists, have been most preoccupied by the psychological conditions underlying their discipline. Moreover, in the past twenty years, there has been a great epistemological movement devoted to mathematical science, to the point that it has taken off as fast as the figurative arts.

A forerunner in mathematics and other domains, Henri Poincaré promulgated the taste for analysis among mathematicians, who, like artists, are both technicians and creators of figurative symbols. Today, there are few great mathematicians who do not take epistemological questions into account, either explicitly in essays, as did Poincaré, or as an important part of their mathematical speculations, in keeping with their desire to delve into basic mental processes. As it did with the Greeks, mathematics is becoming a practical approach to logical problem solving — not that it ever stopped being just that. Having met with extraordinary success, following the discovery of the general principles governing sets or structures or following breakthroughs in topology that revolutionized the question of dimensions, mathematics is considered as much a science as an operative technique.

The beginning of the twentieth century therefore stands out as a great era in the history of scientific thought, comparable to the greatest eras of human history; yet our era sometimes does

itself an injustice, downplaying the fact that it will one day be seen as a golden age of human knowledge in which men became aware of the secret powers of existence.

As theories successively pierced the universe of invisible rays — from electricity to waves — and then the universe of the atom, inspired by hypotheses that posited a new ordering of matter, every field simultaneously modified the mathematical explanation of daily human problems, adapting them to fit the dialectical concepts and purely intellectual logic underlying each new conception. In this way, the great conflict over the axiomatic came to the attention of all mathematicians, who formed camps for or against a problem that had affinities with the problem of abstract art.

Here is how the most brilliant representatives of axiomatic theories characterized their attitude: "The notion of functions dominated nineteenth-century mathematical thought. Derived from a geometric representation (the analogy between the curve and an analytic formula on a Cartesian plane), this idea of a correspondence between two or more variables was progressively simplified to 'the replacement of calculations by ideas' (Peter Dirichlet), and, little by little, the correspondence between variables became independent of any specific forms of expression. Then, in the eyes of many mathematicians, even specific functions seemed less interesting than the collective study of a family of functions (Paul Montel). This effectively blurred the initial, somewhat empirical idea of a one-to-one correspondence between two tables of numeric values (logarithmic tables). Functionality theorists gladly viewed numeric values as living beings with their own specific physiognomy, family relationships, and kinships and sometimes even entailing practically social relationships like parasitism and symbiosis." In short, the development of mathematics was for a while influenced by the biological sciences,

which introduced the concept of a guiding, purposive action modeled after the explanation of living structures.

"Little by little, axiomatic research of the nineteenth and twentieth century also led to a unitive concept, which replaced the initial mental construct evoking a multitude of mathematical entities — which at first were envisioned as ideal abstractions of sense perceptions that preserved the diversity of such experience. Gradually, all mathematical constructs were identified with the notion of the whole number, then, in a second step, with the notion of a set. Sets, which had long been considered makeshift and indefinable, sparked endless debates due to their extreme generality and the vague mental images they evoked. The disputes did not subside until the notion of the set itself disappeared (and with it, all of the metaphysical pseudo constructs that had given rise to mathematical beings), in the wake of studies on logical formalism. Under this new concept, mathematical structures became the only mathematical objects per se."

Already we begin to see striking similarities between this evolution and the evolution of modern art, insofar as the latter also led to the notion of the abstract object in the sense of a formalized sign detached from man's everyday experience. But the similarities do not stop there. The axiomatic stage of modern mathematics has become outmoded, under attack by newer systems of interpretation.

Without detracting from earlier accomplishments, a more recent movement has sprung up in reaction to the rush toward abstraction, condemning in particular its exclusion of sensorial experience. This set off an effort once again to draw on mathematical intuition to gain a better appreciation of the concrete original. The pursuit of the abstract became unacceptable when it led to the total exclusion of sensorial experience. The idea is not without intellectual interest, although its practicality and validity

seem limited. From the heights of logical speculation, one should not forget that the starting point for all mathematical theory is an operative activity intended to resolve real-life human problems.

The issue of realism in contemporary mathematics has been addressed in several impressive publications, where it was treated not only as a matter of high-level theory, by Arnaud Denjoy, but also as part of a conscious examination of the underlying conditions of mathematical thought, by Georges Buligand. Both refused to consider mathematics a purely operative discipline involving fictional constructs, and they both claimed that the purpose and even the nature of the discipline dealt with concrete reality. Behind formulas, they always perceived tangible, practical realities. While accepting the substitutions and transfers intended to situate mathematics as a coherent speculative activity in its own right, they vehemently argued that the validity and reality of every operative activity are linked to its relationship to reality, that is, ultimately, to all of man's operative and practical activities.

As is the case with the evolution of art, the evolution of thought and the practice of mathematical sciences correspond to a certain level of civilization. Theory is never very far ahead or behind the capacity for human action and man's organizational abilities within society. Mathematical progress, like artistic progress, is linked to the transformation of man's creative imagination and to the transformation of his concrete or representational capacities. To understand mathematical progress, and represent it, one must examine reality as it is shaped in the course of man's most general activities. Scientific and artistic realism rules out any theorization that is not linked to a concrete form of apprehending life. Art, like mathematics, springs, on the one hand, from human experience and, on the other, from man's daily practices in his human environment — an environment that is always considered natural even by those who help bring about its trans-

formation. Although each activity has a specific character and each is informed by a different set of experiences, no body of knowledge can be treated separately. Each affects the other, because the fundamental impression that gives rise to interpretative and figurative processes is the same — although it may vary from one period to the next — and because the general modes of comparison across activities are similar among contemporaries, in spite of differences in techniques and motivations.

Every intellectual and practical activity begins with a questioning of the environment. The nature of the questions and the means employed to resolve them are necessarily different from one society to the next. One human group will view space, time, and causality differently from a neighboring group. However, there is more in common between contemporary groups that engage in different activities than there is between groups engaging in the same activity but in a different place or time. In Bouligand's words, the universe that men explore is a network. No component can be entirely isolated. Moreover, the exploration involves a technique distinct from the final mode of presentation.

It should be apparent, then, that, contrary to accepted opinion, technique is, to a certain extent, the most permanent element of every intellectual or representational activity. The mathematician more closely resembles the Greeks in the essence of his discipline than he does a sculptor, and vice versa. What changes is not so much the network of behaviors as the phenomena to which they are applied and the systems of integration, which ultimately give research its human value.

Such a concept contradicts the basic theses of the Vienna Circle — whose exponents were Rudolf Carnap and Ernst Cassirer — which held that every discipline and explanatory system is distinct and closed. This helps us see the point where various speculative activities converge, either on shared points or by their

objectivism. It prevents us from falling into a new system of ideo-logical Categories and provides insight into the relationships between art and reality as well as between other disciplines.

Nevertheless, it is not enough simply to note how a symbolic system may extract itself from concrete experience to assume the role played by techniques in the development of a logical and operative language. Guided by its specific techniques, artistic or mathematical intuition remains dualistic. The experimental phase — in which phenomena are observed and facts are subjected to critical tests or described generally — is necessarily followed by synthesis, in which the problems posed are developed into a general theory, in the case of mathematics, or a style, in the case of artistic representation.

When art passes from the operative and experimental level to the stage of synthesis, problems arise regarding the coherence and the validity of the proposed system. I have already shown, in effect, that what was considered valid above all in an aesthetic system was its coherence and generality. The same is true for mathematical systems. Although Euclid's precepts are based on principles that today have been extensively expanded, they are nonetheless the first systematic attempt to regroup the diverse conceptions of continuum and the infinite division of space. The new systems that supersede or supplement Euclid's precepts do not detract from their extraordinary beauty, especially considering that it took dozens of centuries to surpass them; and, even today, they offer man a useful hypothesis and mode of representation. Similarly, a figurative system like that of the Greeks remains one of the most intellectually satisfying means of expressing man's quest to define human action in relation to the irrational forces of nature. Progress takes place through a series of historical changes that "incorporate" earlier principles without totally eliminating them. That is why civilization must be seen as the accumulated

effort of generations and why we should reject the idea that aes-
thetic creation is inspired either solely by age-old sources or by a
sudden intellectual revolution overturning all values. As we have
already seen, technology is imbued with conservative values that
tend to ensure the continuity of systems within a renewed intel-
lectual framework.

There is a dual notion, underlying both the image and scien-
tific speculation, that treats visualization as a fictional construct —
to borrow a particularly appropriate expression from Philippe
Malrieu. While studying the child's formation of mental visual
images, Malrieu demonstrated that visualization reflects a desire
both to fix — that is, to preserve — reality and to imitate it, that is,
to anticipate and grasp it. An image is the product of behaviors
that are part ritual and part inventive or gamelike. Hence, it has a
twofold ambiguous relation to reality, being both a resemblance
and a distortion. Bouligand describes how this dual relation to
reality is achieved in mathematical speculation — which, like the
image, simultaneously generates a positive and a symbolic repre-
sentation of reality. In both cases, there is a desire to fix known
types and to create others, without rejecting prior experience.

In 1903, in an article in *Revue de métaphysique* on the intrinsic
objectivist nature of mathematics, Pierre Boutroux wrote, "It is as
if, alongside the sensory world, there is an imaginary world of
perfect mathematical constructs. And in the same way that the
physicist analyzes the sensory world to describe its laws, the alge-
brist analyzes the mathematical world and sets down its proper-
ties through symbols that are always imprecise but are continually
refined. Applied science is a reconstruction of the real universe;
pure mathematics is, as it were, the reconstruction of an ideal
world." Spinoza had already written that "human understanding,
by drawing on innate forces, forges the intellectual means neces-
sary to enhance its capacity to carry out other mental operations,

on the basis of which it develops other faculties, that is, the power to inquire even further, and in this way it continues to progress until it attains the height of wisdom."

Other areas parallel this idea taken from mathematics. A few years ago, M. David referred to cuneiform writings to establish parallels between writing and certain forms of thought. A basic support is needed to formulate all valid thinking. Independently of language, writing is one such support, among the many others in the figurative arts. All writing presupposes both a technically based activity and a reliance on a form of memory that combines visual perception, manual dexterity, and conceptualization. Writing, like art and mathematics, has aspects that are linked to concrete action and to a system. Like the image, writing reflects both an experience — fixed by memory and transformed from randomness to a symbolic or meaningful repetition — and an established sign. Like all systems of this order, writing or an image links Nature — which is not immutable but related to privileged institutional behaviors — with individual or collective activity. Like art, writing attempts, according to Malrieu, to transform the world into a system of distortions. In truth, there is no ambiguity as to the nature of the correspondence. The user is fully aware of how to distinguish between the signifier and the signified. The symbolic function underlies all forms of physically recorded phenomena as well as all thought processes. Art is not an isolated phenomenon, although it has specific qualities.

Art's specificity consists of the solutions it proposes and not of its general form of representation. Moreover, the technique of art is an aspect among all other human techniques, and, as a result, art subscribes to laws common to all techniques; on the figurative level, art is one of the human languages. In both cases, it participates in the ordinary course of activities. It is specific but, contrary to what is often thought, not divergent.

308

*Approaches to the Plastic Object: Formalism and Intuition*
Once we acknowledge art's duality, its situation between the real and the imaginary, it is easy to determine its role in the current world and its real influence. But this is true only in theory, for, in reality, when we look at contemporary works of art, we are biased by deep-seated prejudices emanating from a well-ingrained critical tradition based on a concept of Nature and artistic aims that differs dramatically from our own. For this reason, before assessing contemporary works and interpreting their meaning, I will examine the different movements that have come on the scene in the last half century by making a two-part survey of contemporary utilitarian and figurative objects. I shall leave it to future decades to deliver modern art from the realm of polemics into the realm of history. That task will require the participation of individuals trained in various disciplines. All that I can hope to indicate in this work — which is concerned with the theoretical links between the arts and technology — is a method intended to serve as a starting point.

In the domain of aesthetics, as in all other domains, the last half century has been especially fecund. Since 1900, more theories have been formulated on the work of art than in the previous three hundred years. Speed has also played a greater role in human life. Not only is modern man transforming the human environment at a greater pace, he is just as rapidly modifying his theoretical interpretation of phenomena. However, it may be possible to point out several general tendencies from among the systems vying for the favor of critics.

At the turn of the century, aesthetics was dominated by Hippolyte-Adophe Taine, the first to suggest the objective analysis of the relationship between the work of art and the historical or social context from which it sprang. In contrast, a strong Germanic movement advocated a so-called scientific aesthetic, based on the analysis of measurable psychophysiological reactions. A

highly controversial dual determinism was at the center of both movements. Taine tended to minimize the importance of talent and personality and saw the artist merely as a voice echoing his era. Despite the vehement attacks on his doctrine, this view emphasizing the influence of social factors on the creator is still alive and well today — for better or worse. On the one hand, we continue to examine the artist in relation to his environment — and God knows that the penchant for biographical criticism is strong. On the other hand, certain historical situations are treated as markers that seem to signal, almost automatically, traits of contemporary art. An entire sociology of art has followed this trend. And I have already pointed up the misreading that results from taking a given social or historical situation as a basis for deducing the values underlying an individual work. The pseudo-sociological arguments of George Lukács, Frederick Antal, and Arnold Hauser are untenable. By reducing man's effective role to that of a penholder, they suggest that art is the materialization of collective thought at a fixed moment in history.

At the same time, there is a second, equally dangerous movement spreading: the pseudoscientific method of analyzing works of art. It, too, has led to some extravagant claims. To cite only one, there are Albert Michotte's studies on the enigma of linear perspective. By positing an unsolvable enigma of art, his studies provided a fixed and passive perception of man for those who sought to unlock the "secrets" of man through procedures conceived as universally valid. The antirealist and antihistorical conception of man has, unfortunately, inspired numerous works, particularly in the fields of child psychology and music. The rejection of a specifically aesthetic method followed the rejection of a specific conception of art. There are those who suffer from a true blindness when it comes to the plastic arts; and one often has the impression that they should not have the final say on art.

Others dream, in vain, of eventually transferring to art methods from the scientific domain. However, they are the first to denounce the utter delusion of trying to transfer, say, the methods of astronomy to physics, or vice versa. Any attempt to understand art scientifically, and thus objectively, must involve a recognition of the specific and representational nature connecting it with other human institutions. But one may not pass directly from the realm of the institutional to the realm of the imagination.

At the start of the twentieth century, two other great schools of art criticism appeared, led by Heinrich Wölfflin and Benedetto Croce. The incontestable merit of the former is to have considered aesthetics the starting point for the direct examination of artworks. Unfortunately, Wölfflin went on to add some highly disputable arguments. Refusing to take into account anything but the plastic sign, he ultimately removed the work from its human context. For him, art developed merely as the interplay of forms, each engendering another through a kind of historical parthenogenesis. His view of art is thus wholly exterior to man and concerned entirely with spatial qualities. Taken to its extreme, we arrive at the absurd views of Eugenio d'Ors, the inventor of aeons as purely rational entities that give rise to quasi-deified mental constructs. D'Ors was the protective Joseph of a strange mystical offspring: a population of imaginary beings lacking persona and substance. But Wölfflin himself eventually argued in defense of an anonymous history of art, in which the creator was, in short, merely a medium that lacked material substance. In the final analysis, the world of forms was deemed to be governed by cyclic laws of development, with declines and renewals. Wölfflin's theory was grounded in a metaphysics of aesthetic creation, inspired by an earlier romanticism that had been revived by the various symbolisms, Nietzcheisms, and Wagnerisms of the nineteenth century. Method was bogged down by doctrine, often for

reasons that were more polemical – if not political and nationalist – than aesthetic or humanist.

The work of Croce came as a healthy reaction against Wölff-linism and its offshoots. In Italy, it was more than popular; it took on national proportions. In France, it is not widely known. It suffered from a certain German-style dogmatism, as well as from a focus on historical or literary analyses. Several talented disciples, notably Lionello Venturi, made bold efforts to reinvigorate it through lively examinations of works of art but failed adequately to renew its principles. In contrast to Wölfflin's position, which essentially amounted to formalism, Croce offered a "philological" interpretation. By that he meant an analysis that was more than merely spatial. In opposition to what Carlo Ludovico Ragghianti appropriately termed puro-visibilism, derived from Wölfflin, he offered the examples of leading lights in the history of art. In opposition to anonymous history – that is, Wölfflin's faceless, nameless history – he proposed a view of history that only acknowledges works of art and men. The work of art is, in his view, a technique. There is a history to its genesis, revealing the mind of its creator. Thus, behind great works, there are, above all, great men, whose minds have followed an intellectual evolution that may eventually be traced. In that effort to historicize individual thought resided the only genuine approach to works of art.

Whereas Wölfflinism logically culminated in an entirely formal history that stripped art of its human context, Croceism led to a glorification of the artist's personality. In the end, it did not really consider the work's spatial treatment, that is, its technical aspects. Artists appeared, if not randomly, almost as miracles of nature. To stress their distinctive genius, Croce asks us to believe that it was by sheer happenstance that artists like Donatello and Ghiberti were contemporaries, since what stands out in their work is not what they have in common but their originality. And

so we arrive at a concept that, ultimately, ascribes artistic genius to emotion or thought and all but obscures the work of art and history. It is as if artistic progress can be traced from man to man, from genius to genius, without being affected by actual events. There is a privileged closed circle of great minds that transcend all times and all countries. The miracle of art is to create a bridge that spans civilizations and centuries while setting up a direct dialogue on eternal values among the great thinkers. Eventually, a number of rhetoricians, like André Malraux, would come forward to explain that art is the measure of the absolute. Although this doctrine rarely dealt directly with works of art, it popularized certain minor aspects of Croceism in France

After it had gained wide currency, the Croce-inspired movement encountered a third great movement of the last half century: intuitionism. Its sources are primarily Anglo-Saxon; or, more precisely, its most brilliant proponents were in the Anglo-Saxon world. Its great exponent is Bernard Berenson. Pleasure, Berenson argued — perhaps too facilely — is the sole access to works of art. *In principio era la divinazione*. The world of art exists solely in the consciousness; it is a universe of potentialities and qualities, a realm of imagined satisfactions. Thus the artist is most creative when he gives free rein to his faculties, with no intention of teaching or preaching. A single path — the royal road — lay open to true creation: the Greco-Roman road, from which the totalitarian Church and the baroque monarchies in turn had strayed, after the Renaissance had managed to get back on course. The route was taken up once more, somewhat feebly, and defended — in the name of pleasure rather than creation — by the incomparable Anglo-Saxon freedom, the freedom of culture! For some, Queen Victoria was not dead. But the international reputation of the extraordinary inventor of tactile values — which reflected the sensuality of the collector who wanted to touch in order to pos-

sess, using this sense to compensate for the weaknesses of his imagination — is worth noting in this strange and naive doctrine.

Intuitionism, in truth, is the basis of a whole category of infinitely weightier doctrines that mainly spread throughout the Anglo-Saxon world following the great migration of Jewish intellectuals after 1933. Susanne Langer's book *Philosophy in a New Key* best summarizes the strengths and weaknesses of this important movement, which helped to coalesce the theory of the symbol. Recognizing the common mental and symbolic qualities of all expressive activity, Langer examines the place of art among society's symbolic systems. The great merit of intuitionism is that it reintroduced the arts into the family of verbal and nonverbal languages, whereas other doctrines had attempted to exclude them. It would be unfair not to point out the ingenuity of this entirely novel attempt to examine symbolic systems in order to distill their common essence. Unfortunately, Langer's book is based more on a rehashing of speculative works than on the direct analysis of the works that exemplify the symbolic systems she refers to. As was the case with Sir Herbert Read's work on the role of art in education, hers was more an attempt to reconcile and synthesize doctrines than to address distinct representational modes in an original way. In fact, Langer's study is directly built on her outright adoption of a philosophical doctrine — namely, Whitehead's — that is closely related to the doctrine of Carnap and the Vienna Circle. In her view, the formal conditions of truth reside in various closed interpretive systems. Hence, mental processes and constructs are always at the forefront of the universe, barely subject to the effects of time and space. She absolutely disregards everything we have been taught about representational systems in the ethnological works of Marcel Granet and Marcel Griaule, who refuse to limit man's functions as a creator or user of art to his exercising an innate capacity that has no link to social

and technological development. However that may be, Langer's study is by far the best of its kind, even if it suffers from a lack of objectivity.

The lack of objectivity is so blatant that it is astonishing — and that is no exaggeration — to discover that, when she examines the symbolic content of painted images, Langer actually uses a photograph (*Philosophy in a New Key*, p. 57)! This altogether bizarre approach, which crops up on several occasions (p. 75, for example), is the very crux of her work. As a result, it is difficult to discuss a doctrine that reveals such a profound disregard for technical understanding. By the bluntness of her method, Langer helps us to see through numerous theories that, at first glance, are rather surprising but have in common with Langer's work a radical misunderstanding of the nature of artistic experience. According to Langer, all images express the same relationship between parts, regardless of the technique used to execute them, because, beneath the diversity of forms, there is a common concept of the figurative object. What is misunderstood is that the artist invents as he draws, and the technique he uses always imposes a discriminating order of relationships. Painting, moreover, is presented as supremely static and capable only of representing a momentary state. It can suggest, but not represent, a story. That widely held opinion also violated the physical laws of vision concerning the extraordinary powers of the eye, which supposedly scanned across the figurative field faster than any human means of measurement could detect, making it impossible for physiologists and physicians to register any truly static phenomena. In effect, Langer's theory defies the opinion of not only the artistic community but the scientific community as well.

Furthermore, figurative art could not be discursive. Only words, it was felt, could be combined in such a way as to evoke not only basic concepts but also relationships, that is, situations.

Although Langer recognized that the eyes and the ears obey their own logic, and that language is not the only articulated system, she ultimately set up two opposing orders of expression: discursive forms and presentational forms. Her opinion, which is set forth with the greatest precision (p. 75), is that language possesses its own vocabulary and syntax, whereas art comprises elements that do not have a fundamental logical unity, insofar as each component is a discrete object that does not possess an independent meaning. In her view, language comprises words that are equivalent to other combinations of words, creating a potentially infinite variety of expressions that can be derived from the same terms — in other words, the dictionary. Furthermore, different words can have the same meaning, which is not the case with painting. This all meant that, in contrast with language, which is capable of discursive and analytic tasks or creative combinations, representational art is relegated to a limited and entirely separate realm, as much out of convenience as in view of the nature of representable phenomena. That is, the arts inhabit the realm of the inexpressible, the ineffable. To be sure, there is a degree of rationality underlying every mental process, but this rationality exists on several levels, and only language permits man to step outside his immediate concerns and express himself freely. When creating images, on the other hand, man remains in the realm of the unconscious and presences.

Obviously, this was not meant to deny that painting and music convey concepts that language cannot, and vice versa. However, it seems that their differences are somewhat exaggerated, and so a closer examination of plastic and verbal language is necessary. Music does not have to be seen solely as a key to the deepest recesses of our being, as if it were the path to awakening what lies dormant in our consciousness. Nothing says that the study of art can take the form only of a philosophy and not of a philology. On

this point, the Croce school's failure to consider the daily practical life of so many historians, art critics, and philosophers borders on the scandalous. Art is not merely an autonomous power to create one's own universe detached from all contingencies and all dialectical rigors. In this regard, Langer avoids, unjustifiably, any treatment of the question of architecture and sculpture, much like Berenson, who does not address architecture because, as he puts it, it is not representational! Whether in Langer's realm of pure sensations or Berenson's realm of imagined pleasures, we remain squarely in intuitionism, the culminating point of all theories that address art without objectively considering its claims and modalities. Failing to see its practical reality, these thinkers relegate art to the realm of the ineffable, the vague, and the subconscious. At bottom, we are faced with a massive defensive from societies that, over generations, have played a minor role in artistic creation. It is yet another offensive launched against "Cartesian mentality" — the expression is from Charles Morris, who demonstrates his optimistic outlook when, after writing that the iconic sign is ill adapted to describe space and time (*Signs, Language, and Behavior*, p. 194), he goes on to state that the strength of this secondary form of expression resides in the fact that art presents its meaning clearly, while its shortcoming is that it can only signify what is "like itself," that is, within its exclusive domain.

The assumptions that art diverges from other forms of practical and meaning-defining activities and that it contradicts intuitive evidence have attracted intuition theorists and psychophysiologists bent on developing a pseudoscientific aesthetic based on the idea that plastic signs are perfectly accessible to everyone.

Having examined the place of art in contemporary society and attempted to explain its extraordinary public success, my goal becomes rather precarious insofar as I am living in a period of change, caught up in one of those rare moments in history when,

under humankind's demiurgical impulse, the social and representational frameworks have come apart on all sides — without falling away completely and without the public having wholly rejected earlier forms. Nor have artists entirely lost sight of their heritage or abandoned attitudes that have marked them for generations. As creator of both forms and imaginary images, the artist today, like the artist of yesterday, engages in an activity and sets down speculative thought. It is only natural that he is divided between the practical and the imagined.

We have seen the difficulties that arise from the attempt to associate an artist's style with the products of contemporary technology and industry, even when this association is desired by both manufacturers and artists. I have noted that a style can only arise from an active collaboration between artists and technologists and cannot be brought about merely by the initiatives of technologists who borrow forms from contemporary art. I have also noted that although art stands halfway between the real and the imaginary, it shares this characteristic with all thought processes that lead to the creation of a language. Having acknowledged that the question of the function of art in contemporary society requires a closer examination of the symbolic nature of the image, I showed that most contemporary aesthetic criticism is colored by intuitionism or metaphysics, causing art to be considered free and complete in itself, detached from the material world; and it is only through a state of grace that man calls on art in order to enter directly into contact with the supreme, universal realities that lie outside time and space, in an ahistorical absolute. Thus, at the very moment that the general public has become intrigued by art forms, the individuals who took it upon themselves to initiate their contemporaries into the realm of aesthetics now wish to divert their attention away from the practical realities of plastic creation. They turn art into a refuge, a symbol attesting to eternal

and abstract man in perpetual revolt against the servitude of matter — hence the belief in the perversity of any attempt to give expression to modern man's experience. What has resulted is the idea of a natural opposition between modern life — evil incarnate — and Beauty, which is viewed as something serene, immutable, and ever threatened.

CHAPTER EIGHT

# Eternal Art and the Work of Art

The aim of this book has been to show the need for, and the implications of, taking a historical stance on aesthetics, in order to make a useful critical study of modern art. In so doing, I have not lost sight of another issue: the relationships, in fact and in theory, between artistic development and a civilization that considers itself essentially technological. Having established that art, like all other fundamental activities, is inherently technical, as regards both manual skills and intellectual processes that lead the artist to create transmittable, enduring representational systems, I believe I have shown that the current antinomy between Art and Technology is a false opposition — one that eventually distorts thinking as well as works of art. An opposition cannot be set up between phenomena that are not of the same nature or, if you prefer, that are always complementary. In art, there are always techniques — material and intellectual — and in fact no opposition exists between the specific form of current artistic techniques and the equally specific form of other human techniques, be it those involved in producing the objects that have totally transformed our activities or in the mental processes used to organize experience in order to facilitate man's understanding and exploitation of materials. I could add that, in the broadest sense, it is technolo-

321

gies that, pragmatically, bring together the individuals of a society. Not only do technologies cause them to become users of the same objects, they set up deep spiritual affinities between individuals as different as mathematicians and painters, or sculptors and mechanics. A similar way of assimilating sensations, a similar conception of operative space, a shared belief in a system for associating images — these all create a sense of oneness among individuals whose abstract ideas or vocations would otherwise render them totally alien to one another. At bottom, the notion of technology underlies the idea of the natural milieu — keeping in mind that the environment in which all societies evolve is always fabricated, precisely as a result of the network of material and figurative technologies.

Nowadays, it is not technology as such that stands in opposition to traditional or even avant-garde art. The true opposition is of a different order. Living in the same surroundings, trained in the same disciplines, steeped, whether they realize it or not, in the same principles used to explain and relate phenomena, potentially able to act on the world in the same way, engaging in the same general activities, confronting each other on common ground, which they shape by their collective actions and where they are subject to the same constraints, men are most truly at odds not when assessing what *is* but when imagining what could be. It is not on the level of technologies but on the level of the imagination that they clash. That is no doubt the source of man's greatness, for his power to anticipate the future and contemplate the unreal allows him to embark on new ventures and to create. As a result, the true opposition is not between art — considered as a form of human creativity — and technology, but between certain momentary objectives materialized in art and other imaginative forms materialized through mechanized technology. As I have also shown, it is not possible to conceive of the absolute, free exercise

of the technological function outside a pragmatic plan of action that is determined not merely by the sheer mastery of mechanical construction but also by objectives that reflect imaginative input. Just as there is an artistic impulse, there is an engineering impulse, which is sated only when it yields a system that produces a certain effect. The difference is that the sound engineer is satisfied when he has constructed a machine that emits waves into the air, without wondering about the quality of the sounds produced, without the slightest concern for noises that might result. Radio technologists have observed the existence of a sonar space, but, paradoxically, they disregard it and search for a mean — which practically eliminates the quality of the tones transmitted. It is therefore a matter not of technology but of the technologist's judgment. An engineer who creates optical devices is interested only in the size of magnification and not in the image reproduced. What distinguishes the artist from the technologist is not technology but the final objective. The artist and the engineer make choices, but they make them differently. Their choice is not conditioned by the fact that one exercises a power over matter and the other over intangible realities. They are both, each in his own way, technologists and organizers of non-technological values. To take an example from music, the entire aesthetic of the past few centuries is summed up in the doctrine of *The Well-Tempered Harpsichord* which is a measured empirical creation, inspired by a system of analogies and intellectual compromises. Radio of today is also based on a hierarchical selection from among partial solutions, but neither harmony nor the variety of expression is the deciding factor. It is solely the search for power — acoustic relationships and their expressive capacity apart. In both cases, a technology helped to achieve an overall harmony or a smoothing over of nuances, as it were.

Technology does not create a society's values; it serves them

and materializes them. What is in conflict in the modern world are the forces of selection and organization and the forces of violence. The clash involves, on the one hand, an artistic tradition based on selectivity and the organization of sensations and, on the other hand, a technology placed at the service of violent individuals who seek to achieve an immediate effect in the here and now.

It would be a grave error to associate contemporary art theories with this destructive movement, which will devastate the planet. Unfortunately, today's technology has fallen into the hands of uncultured individuals who have done the least to foster the blossoming of humankind and who despise, in equal measure, commitments and constraints. Those who liken modern theories on painting to doomful existential delirium have mistakenly bought into the theories advanced by critics, primarily Anglo-Saxon, who present themselves as prophets of spontaneous art. A dazzling explosion does not a living art make — at least not in its original forms. All too often, the imitators of the Paris school have simply given vent to the rash and unbridled violence that characterizes their circle, awkwardly imitating its liveliest forms.

As Ragghianti has shown, the discovery of photography, toward the middle of the nineteenth century, overturned naturalist aesthetics. There is the fear that, for a long time to come, another fundamental misconception will link art to intuition. The success of the expressionist and surrealist movements in representational art seems to lend further credence to these theories. Expressionism is the modern form of programmed painting. It was a milestone in the projection of literary intentions onto the plastic arts. It has been successful because a large part of the public looks not for strictly formal values but for values in subjects or empathizes with written emotions. The vague outlines of iconography have begun to take shape, and it risks being confused with art, as emotionalism takes precedence over substance in contemporary art.

324

Automatism has replaced readability, preventing the public from discerning true aesthetic values.

If we relegate art to the obscure depths of consciousness, it becomes impossible to recognize its ties with other practical activities. While a number of individuals are today trying to introduce a little art, order, and quality to practical activities, they are offered works wholly inspired by romantic ideology and outdated metaphysics.

As long as art is considered a reflection of a real but eternal world or as a generator of illusions, it will be impossible to reconcile practical activities with contemporary art. The world's industrial aesthetics will merely attempt to superimpose borrowed elements onto forms derived from technological rationalism. Intentionality will continue to be taken for creation. A metaphysics of ideal Beauty will continue to be applied in this age when man has become conscious of his demiurgical creative power, when the masters of representational art are abandoning Renaissance modes (just as they had abandoned the modes of the Middle Ages five centuries ago) and not representing objects that reflect enduring values or spatial appearances that are based solely on the eye's field of vision, as man reinterprets optical perceptions and the forces that determine the human order of phenomena — space, time, causality — and his capacity to dominate nature, including color and material. Given that current art affects the creation of materials and perceptions, it cannot be applied in outmoded forms to contemporary products.

Above all, we cannot forget that art is not fortuitous. It does not come by chance after repeated, empirical trial and error. All artistic creation is born of clear-sightedness and application. Natural talent alone is not enough to create a work of art. At best, it can help to prepare a rough plan. But there is no such thing as a consummate work of art that has not been carefully honed and

325

brought to its final form. Clearly, it would be a grave mistake to compare the artist's outlook with the engineer's or the mathematician's. Their outlooks and approaches are different; but for each, repeated effort is the absolute rule behind every valid endeavor brought to fruition. Every discovery presupposes a controlled manner of behavior. Art is certainly not a transfer of intentionality, but it is always purposeful.

Moreover, the artist always attaches primary importance to what he executes. What matters most to him is not so much thinking as creating. Intentionality, while necessary, is never entirely sufficient. Success is determined on the basis not of intention but of the final outcome, that is, the Form. We are not far from Croce's most authentic insight. Is Croce right to state that art is the product of an individual activity that informs the material and is an inherent part of the creative process? Or, can we agree that it exists within the mind of the individual, who creates Forms, as well as in the work, the product of his unique and strictly individual activity? Can the Beautiful — that most ephemeral form of judgment in history — be dissociated from Art, the act of creation? Should we say only that each object has a potential form but does not necessarily have a Form, that is, a quality that reflects the personality of its creator? Here, we confront a number of obvious discrepancies: the autonomy of art; the ahistoricism and absoluteness of creation; the opposition between unformed material and the art that informs it; the subjectivity of artistic creation and the objectivity of both the material and the social environment; and a return to a plurality of mental faculties.

The great merit of Croce's work is that it placed new emphasis on the role of a work of art as an oeuvre. Art does not simply involve the exercise of an abstract faculty. But Croce went too far in his identification of a work of art with an activity subject to sheer artistic inspiration. The material informed by the artist puts

up resistance and imposes its own qualities. The artist is not be-
fore a neutral, anonymous, and inert material; nor are his materi-
als specific to him. To the contrary: he uses the same materials as
his contemporaries and follows laws that govern his acts, physi-
cally and conceptually. As a result, artistic creation cannot be
thought of as simply involving the projection of an individual's
whimsical dreams onto a material universe.

The true artist is no more free from the constraints of his cen-
tury than he is from those imposed by materials. It is impossible
to imagine a Phidias or a Raphael in the age of the pyramids or in
our own era. Freedom consists not of the artist's detachment
from reality but of his capacity to discover relationships that tran-
scend collective experience, without disregarding it. The true
artist is not touched by divine inspiration, and there is no imagi-
nary paradisiacal realm where great minds remain eternally, above
contingency, in a serene sphere of abstract values waiting to be
inscribed in the catalog of beautiful thoughts. All values are tran-
sitory. Through art, we discover the practical wisdom of genera-
tions, not the products of solitary dreams.

However, it is undeniable that the work of art does not gener-
ally exceed either the consciousness of the creator or the knowl-
edge and understanding of the environment that produced it.
Hence another essential aspect of the problem: the parallels be-
tween the progression of mathematical thought and the nature of
the image. Like mathematics, the work of art is, first of all, a set of
problems to be solved. The artist first attempts to resolve a tech-
nical problem. It is as if he is conducting an experiment. He suc-
ceeds when he finds an initial solution. Then, on the basis of that
solution, he attempts to repeat his experiment by expanding on it
and addressing new, representational problems. The problems
faced by the artist involve, first, exploiting and elaborating a
medium — blending and mixing colors, cutting stones, casting and

forging metal — then interpretability. A work of art is not created in isolation. There is always a link between the works of one artist and those of his rivals. Art is not an isolated activity carried out in solitude, face-to-face with the general destiny of humankind. To the contrary: it is above all a technique but not, as Croce argued, a technique guided by an artistic inspiration that conveys a sensibility. It is, rather, a practical technique that draws on earlier accomplishments and contemporary methods. As I have shown, the artist works sometimes on abstract models, sometimes on concrete models. It is precisely that alliance of intellectual and manual activities that gives rise to the work of art — enriched by both rational and material qualities, which determine its value and efficacy.

From work to work, the artist encounters problems, leading him to develop, alternately, his creativity and his technical skills, helping him gain mastery over his medium of expression. The contemporary or successive works by different artists are aimed at testing the same hypotheses, just as the postulates advanced by mathematicians build the body of mathematical science. From these individual and joint works, the value of and the general assumptions about certain problems are laid down for a given period. New ideas are thus discovered, and art is ready to start off again in search of empirical solutions to new problems. What Croce misunderstood was that art is not only problem oriented but operative, a notion that, in fact, goes to the very heart of its nature.

Finally, contrary to what Croce suggests, the work of art is not a checklist or the sum of individual techniques or experiments but, rather, the creation of a model. A work of art, like all images, incorporates diverse qualities, while also suggesting new paths. And so it possesses, by definition, qualities that stimulate the imagination of its author and its viewers.

If a plastic form surpasses the intentions of its creator — if it possesses a surplus of meaning — it is because an element of reality is attached to Form. To return to a point raised earlier in this book, the plastic object, like all objects, responds to needs and generates others. As I have said, if Form were the realization of an artistic ideal, there would be only one way to that perfection. But in fact, the more successful a form, the more it lends itself to imitations and replicas. It possesses a dialectical quality that ensures art will endure for generations. An image embodies the practical and speculative experiences of an era. Moreover, it also serves as a prototype, a model that generates new procedures and hypotheses. Its reality consists of its representational character, since, much like speech, it can stimulate others to action. Be it a figurative object or an image, art is built on common data that suggest new experiments.

The pseudo conflict between art and technology is thus resolved theoretically and practically. And we now see how modern taste was defined in spite of the obstacles created by the public's lack of enthusiasm or the false theories advanced by critics. The now widely accepted idea that art, as opposed to technology, can best help man save himself from the horrors of reality is unfounded. The rehabilitation of modern man through the arts, especially if such rehabilitation involves the systematization of forces that obscure the self, is an illusion. The era of Ruskin is behind us. And there is nothing to prove that the Victorian era held the key to happiness, charity, or human greatness. Let us leave these reveries behind. There is no room in our era for gentlemen aesthetes who are connoisseurs — and, if need be, destroyers — of their neighbors' art.

I believe I have shown that certain strains of modern art have a remarkable affinity with contemporary scientific and technological discoveries. There is an art of today. It has had difficulty filter-

ing into daily reality because it is in full expansion — and under persistent siege — and also because an impoverished theory has slowed up its convergence with the practical world. Science and art reflect the total renewal in human life. Art did not reach this mature stage on its own. During the nineteenth century, there was a rift between the arts and the mechanized production of everyday objects. Following social and technological revolutions, artists took refuge in escape. In conflict with wealthy or official art lovers, who were entrenched in outmoded aesthetic values that they deemed inseparable from the social and spiritual values then being threatened, they first presented themselves as defenders of all freedoms. However, toward the end of the century, they set out to embody intellectual values. It was then that an entire school, the Paris school, laid the groundwork for an entirely new technique that revolutionized the material and representational conditions of all of the arts. The revolutionary impact of this art cannot be overstated. Ultimately, the public will accept a new object if it proposes procedures that will simplify practical problems. It is far more reluctant to accept a new representational object, precisely because this object — when it is really good and possesses a surplus meaning that does not derive from the tacked-on aesthetic element so dear to Mauss and many other theorists — more deeply affects its capacity to act in and interpret the world. In spite of many more or less outmoded doctrines, the openness of our civilization has favored the extraordinary expansion of contemporary art because, in a stable and well-organized society, mediocre inventions are quickly hampered by the forces of preservation. By challenging the status quo, they clash with numerous interests, and, as a result, society is opposed to technological progress of any kind. However, a society that seeks to overturn the established order or institute a new one looks to technological and artistic development to aid its efforts. If France became

the center of the greatest aesthetic experiments of the nineteenth and twentieth centuries, it was because of the ideas stirred up. If there is no sign of a state of calm on the horizon, we should at least learn to look objectively and with an open mind at the extraordinary, unprecedented changes in forms and values. We should recognize that, although the world of tomorrow may not be any more just than the world of today, there is nonetheless the possibility, linked to the destiny of art, that the future will bring about new forms of beauty that will be incorporated into works that both are practical and affect all equally. It is a world that cannot come about unless there is a convergence of all techniques, which will enable man to reshape the practical and representational order of the universe.